ANTHEM FOR DOOMED YOUTH

Twelve Soldier Poets
of the First World War

JON STALLWORTHY

Published in association with the Imperial War Museum

CONSTABLE • LONDON

Constable & Robinson Ltd
3 The Lanchesters
162 Fulham Palace Road
London W6 9ER
www.constablerobinson.com

First published in the UK in 2002 by Constable,
an imprint of Constable & Robinson Ltd,
in association with the Imperial War Museum

This paperback edition published by Constable in 2005.

A copy of the British Library Cataloguing in Publication Data is
available from the British Library

ISBN 1-84529-221-9 (pbk)
ISBN 0-84119-635-5 (hbk)

Printed and bound in Spain

1 3 5 7 9 10 8 6 4 2

Contents

Introduction 5

Rupert Chawner Brooke 10
Julian Henry Francis Grenfell 22
Charles Hamilton Sorley 32
Francis Edward Ledwidge 46
Siegfried Loraine Sassoon 62
Robert von Ranke Graves 82
Wilfred Edward Salter Owen 96
Edmund Charles Blunden 116
Philip Edward Thomas 130
Ivor Bertie Gurney 146
Isaac Rosenberg 160
David Jones 176

Further Reading 188
Acknowledgements and Credits 191
Index of Poem Titles and First Lines 192

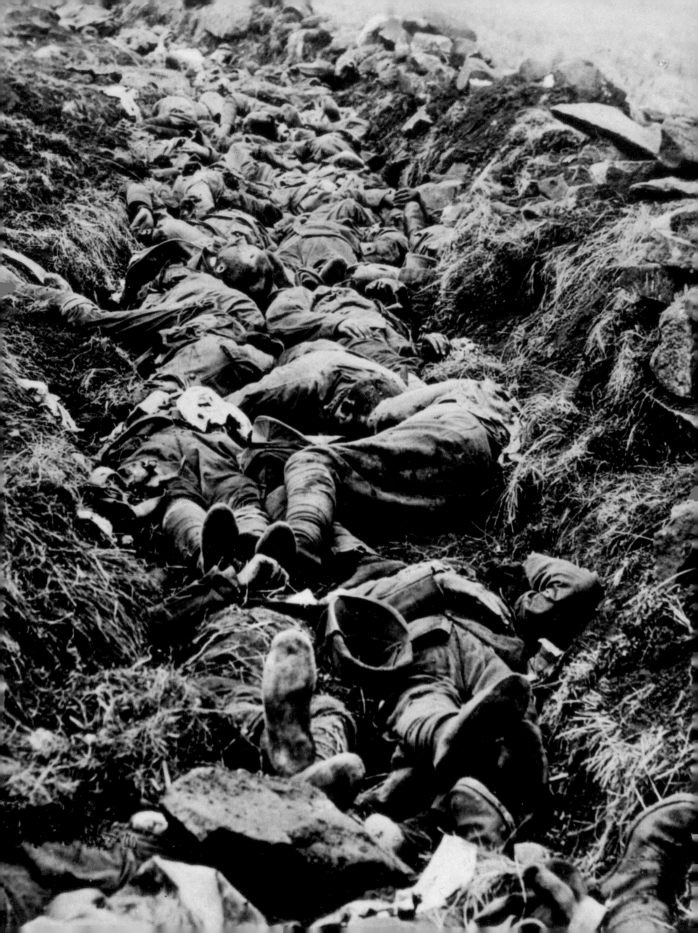

Introduction

More has been written about the First World War than about any other war in history but, inevitably, many of the questions it raises remain – and will remain – unanswered. It may be appropriate, therefore, to begin an introduction to some of the soldier poets of that war with a question: when and where were the following stanzas from Herbert Cadett's poem, 'The Song of Modern Mars', written?

> Three miles of trench and a mile of men
> In a rough-hewn, slop-shop grave;
> Spades and a volley for one in ten –
> Here's a hip! hurrah! for the brave.
> [. . .]
> Crimson flecks on a sand-coloured mound,
> Like rays of the rosy morn,
> And splashes of red on a khaki ground,
> Like poppies in fields of corn.

The answer is not London or Flanders, 1915, but London or South Africa, 1900. The war still known – so many wars later – by the epithet 'Great' made such an impact on the consciousness of Western Europe that it erased from folk-memory the scars of former conflicts. War poetry 'began and ended with the First World War', wrote a reviewer in *The Times Literary Supplement* (September 1972). He went on: 'There were poems written about earlier wars but they were battle-pieces, not war poems in the 1914–18 sense.' Paul Fussell, the American author of what is, in many ways, the most searching and satisfying study of writing about that war, *The Great War and Modern Memory*, supports this view. 'The war will not be understood in traditional terms,' he says; 'the machine gun alone makes it so special and unexampled.' Yet, over the 'mile of men' in their South African mass-grave, sounds

> [. . .] The rat-tat-tat of the Maxim gun –
> A machine-made funeral knell.

In his excellent study of the poetry of the Anglo–Boer War, *Drummer Hodge*, Malvern van Wyk Smith has shown how in Britain, at the start of that war in 1899, militarist and pacifist doctrines were clearly defined and opposed. Because of the Education Acts of 1870 and 1876, the army that had sailed for South Africa was the first literate army in history, and the British Tommy sent home letters and poems that poignantly anticipate those his sons and nephews were to send back from Gallipoli and the Western Front in the Great War.

British soldiers killed in the battle at Spion Kop, January 1900

Those factual and often bitter accounts of combat had been forgotten by 1914, when the Great War was greeted, in many quarters, with the curious gaiety and exhilaration that Philip Larkin captured so vividly in his poem 'MCMXIV' (Roman numerals, as seen on war-memorials, denoting 1914; letters that now seem almost as remote as the hieroglyphs in tombs of the pharaohs). Larkin's camera focuses on the queues outside the recruiting offices:

> Those long uneven lines
> Standing as patiently
> As if they were stretched outside
> The Oval or Villa Park,
> The crowns of hats, the sun
> On moustached archaic faces
> Grinning as if it were all
> An August Bank Holiday lark;

Rupert Brooke caught the mood of that moment in a sonnet to which he gave the paradoxical title of 'Peace'. It begins:

Recruits of the Lincolnshire Regiment in training, September 1914

> Now, God be thanked Who has matched us with His hour,
> And caught our youth, and wakened us from sleeping,
> With hand made sure, clear eye, and sharpened power,
> To turn, as swimmers into cleanness leaping,

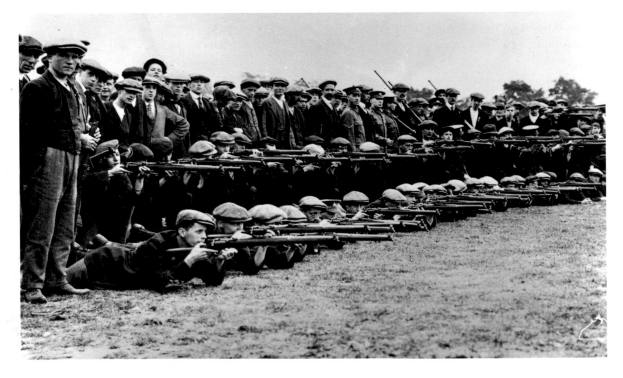

Glad from a world grown old and cold and weary,
 Leave the sick hearts that honour could not move,
And half-men, and their dirty songs and dreary,
 And all the little emptiness of love!

Brooke's first line – 'Now, God be thanked Who has matched us with His hour' – and the 'hand' and the 'hearts' that follow reveal one of his sources to be the hymn, and ironically a hymn that has been translated from the German, beginning

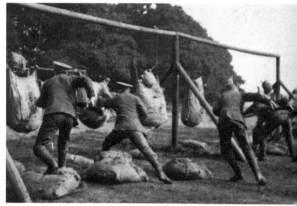

 Now thank we all our God
 With heart, and hands and voices.

In times of war and national calamity, large numbers of people seldom seen in church or bookshop will turn for consolation and inspiration to religion and poetry. Never was the interaction of these two more clearly demonstrated than in the Great War.

Men of the Honorable Artillery Company at bayonet practice, 1914

On Easter Sunday 1915, the Dean of St Paul's preached in the Cathedral to a large congregation of widows, parents and orphans. Dean Inge gave as his text *Isaiah* 26: 19. 'The dead shall live, my body shall arise. Awake and sing, ye that dwell in the dust.' He had just read a poem on this subject, he said, 'a sonnet by a young writer who would', he ventured to think, 'take rank with our great poets – so potent was a time of trouble to evoke genius which must otherwise have slumbered.' He then read aloud Rupert Brooke's 'The Soldier' (see pp. 20–21), and remarked that 'the expression of a pure and elevated patriotism had never found a nobler expression.' So Brooke the soldier-poet was canonized by the Church, and many other poets, soldiers and civilians alike found inspiration for their battle hymns, elegies, exhortations, in *Hymns Ancient and Modern*:

Recruits at Whitechapel Recruiting Office, 1914

 For a Europe's flouted laws
 We the sword reluctant drew,
 Righteous in a righteous cause:
 Britons, we WILL see it through!

 R. M. Freeman, from 'The War Cry'

Many of the first poets to respond in print to the events of 1914 and 1915 had left their public schools with a second, secular source of poetic inspiration. This was the public-school song, itself derived from the hymnal of the established Church. It can be heard behind R. E. Vernède's poem 'The Call':

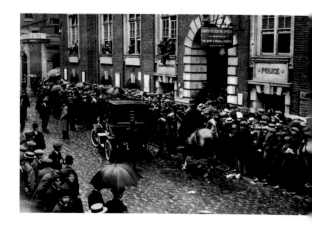

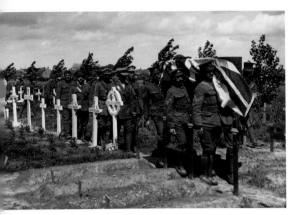

Lad, with the merry smile and the eyes
 Quick as a hawk's and clear as the day,
You who have counted the game the prize,
 Here is the game of games to play.
 Never a goal – the captains say –
Matches the one that's needed now:
 Put the old blazer and cap away –
England's colours await your brow.

Vernède's lines carry all the poignancy of the period in their imagery: 'the prize', 'a goal', 'the captains', 'the old blazer and cap', and, most piercing of all, his final exhortation: 'England's colours await your brow'. By 'colours', does he mean anything more than the coloured velvet, braided and tasselled, of the football international's 'cap'? He may well not have thought of two other meanings: colours in the sense of 'regimental colours', the Union Jack that by tradition drapes the British soldier's coffin; a second to be used three bitter years later by Wilfred Owen, writing of the crippled soldier in his poem 'Disabled': 'He's lost his colour very far from here.'

Military funeral at Poperinghe in August 1917

Men of the Liverpool Regiment at Church Parade before going into the trenches

Hundreds of what came to be called 'war poets' saw their work in print between 1914 and 1918, and others – including some of the best – were not published until after the war. It remains an unsatisfactory label: Freeman and Vernède, for example, have little in common with Owen and Sassoon, whose poems of

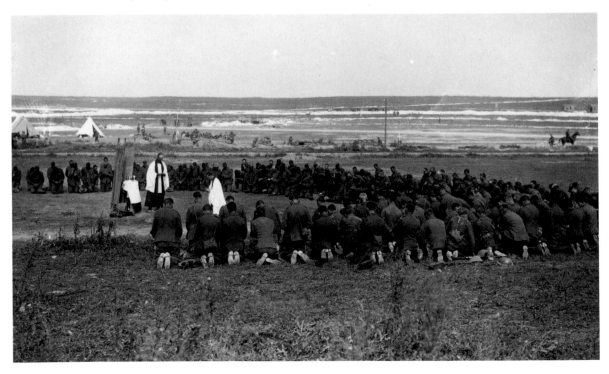

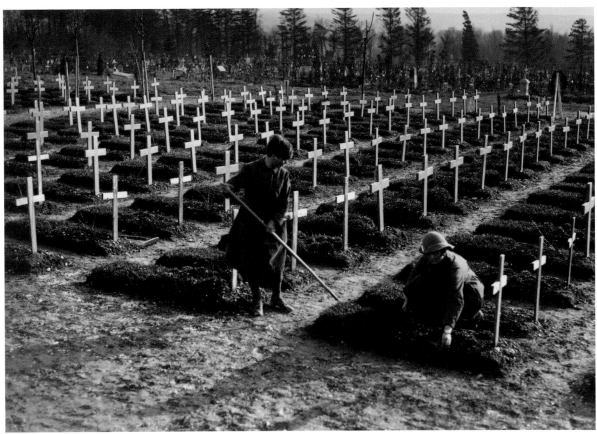

passionate indignation are a far cry again from Edward Thomas's bleak and oblique rural ruminations.

We can now see that most of the 'war poets' – like most 'peace poets' before and since – were bad, vapid poets, but there were also a number of good, true poets; and 'the true Poets', wrote Wilfred Owen, 'must be truthful'. The following pages give a brief account of the life and work of twelve who were true to their different forms of experience. There were others: Vera Brittain, May Wedderburn Cannan, E.E. Cummings, Elizabeth Daryush, Ford Madox Ford, Thomas Hardy, Rudyard Kipling, Robert Nichols, Herbert Read. These should not be forgotten, nor should the speechless millions of whom and for whom they spoke:

W.A.A.C.s tending British graves at Abbeville in February 1918

> Battalions and battalions, scarred from hell;
> The unreturning army that was youth;
> The legions who have suffered and are dust.

> Siegried Sassoon, 'Prelude: The Troops'

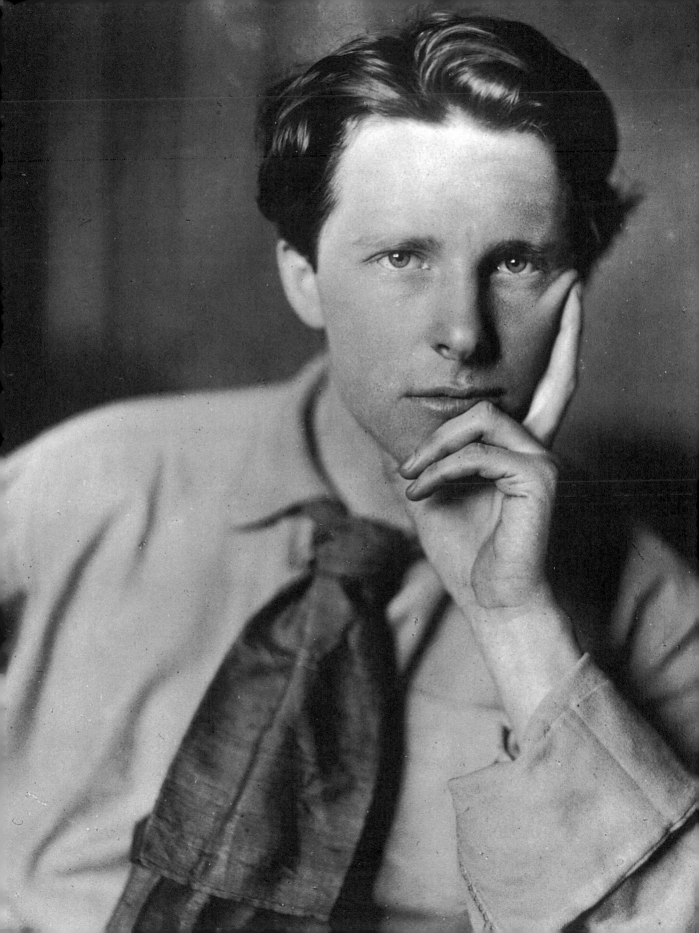

Rupert Chawner Brooke

Rupert Brooke was born on 3 August 1887. His father was a housemaster at Rugby School, and Rupert and his two brothers grew up in the comfortable security of a home dedicated to the ideals of 'godliness and good learning'. Having discovered the power of poetry – from a chance reading of Browning – at the age of nine, Rupert entered his father's school in 1901. From the start he did well both in the classroom and on the playing field; for although early on he adopted the pose of the decadent aesthete, winning the school poetry prize in 1905, he found time to play in the cricket XI and the rugby XV.

Just under six feet tall, Brooke was strikingly handsome, with a mane of red-gold hair. People would turn in the street to watch him pass. His physical presence was matched by a sharpness of intellect, a charm and vitality of manner that affected everyone he met. Popular and successful at Rugby, he was even more so at King's College, Cambridge, where he went as a scholar in 1906. He read more voraciously than ever; he threw himself into acting (playing the parts of Mephistopheles in Marlowe's *Dr Faustus* and the Attendant Spirit in Milton's *Comus*) and into the activities of the University Fabian Society, of which he became president. His circle of friends soon included Frances Cornford, E. M. Forster, Hugh Dalton, George Leigh Mallory, Geoffrey and Maynard Keynes, and Virginia Stephen (later to make her name as Virginia Woolf). When Henry James visited Cambridge in 1909, he too fell under the spell of the golden-haired young man who punted him down the Cam, although the pole was unfortunately allowed to fall on the Master's bald head. Told that Rupert Brooke wrote poetry, but that it was no good, he replied: 'Well, I must say I am relieved, for with that appearance if he had also talent it would be too unfair.'

Talent, however, there was. With this and his unswerving dedication to poetry, Brooke was soon producing poems in which a modern voice was making itself heard through the period diction:

Dawn
(From the train between Bologna and Milan, second class)

Opposite me two Germans snore and sweat.
　　Through sullen swirling gloom we jolt and roar.
We have been here for ever: even yet
　　A dim watch tells two hours, two aeons, more.
The windows are tight-shut and slimy-wet
　　With a night's fœtor. There are two hours more;
Two hours to dawn and Milan; two hours yet.
　　Opposite me two Germans sweat and snore. . .

One of them wakes, and spits, and sleeps again.
　　The darkness shivers. A wan light through the rain
Strikes on our faces, drawn and white. Somewhere
　　A new day sprawls; and, inside, the foul air
Is chill, and damp, and fouler than before. . . .
　　Opposite me two Germans sweat and snore.

Having gained a second class in the Cambridge Classical Tripos, Brooke established himself in Granchester at the Old Vicarage (afterwards made famous by his poem 'Granchester') and began to work at a dissertation on Webster and the Elizabethan dramatists. This pastoral existence, however, was interrupted by an unhappy love affair with Katharine (Ka) Cox, and in 1912 he travelled through France and Germany searching for peace of mind. Partially recovered, he returned to England and was elected to a Fellowship at King's. He divided his time between Cambridge and London, where, through Eddie Marsh, a prominent civil servant with literary tastes, he met such poets as Lascelles Abercrombie, Wilfrid Gibson and John Drinkwater, and made friends in social and political circles centred around Violet Asquith, the Prime Minister's brilliant and attractive daughter.

Falling in love again, this time with the actress Cathleen Nesbitt, Brooke decided that he needed a change of scene while considering what to do with his life, and in May 1913 he sailed for America. He had been commissioned by the *Westminster Gazette* to write a series of articles on his impressions of the United States and Canada, and over the coming months he sent back a dozen dispatches. His friends also received a stream of vivid, entertaining, and frequently ribald letters that showed the poet revelling in his role of Byronic self-exile. Christmas 1913 found him in New Zealand, reached by way of Hawaii, Samoa and Fiji, and a month later he was in Tahiti. This he decided was 'the most ideal place in the world', and, finding in this Pacific paradise an Eve (called Taatamata), he wrote a number of happy poems:

Taü here, Mamua,
Crown the hair, and come away!
Hear the calling of the moon,
And the whispering scents that stray
About the idle warm lagoon.
Hasten, hand in human hand,
Down the dark, the flowered way,
Along the whiteness of the sand,
And in the water's soft caress,
Wash the mind of foolishness,
Mamua, until the day.
Spend the glittering moonlight there
Pursuing down the soundless deep

Limbs that gleam and shadowy hair,
Or floating lazy, half-asleep.
Dive and double and follow after,
Snare in flowers, and kiss, and call,
With lips that fade, and human laughter,
And faces individual,
Well this side of Paradise! . . .
There's little comfort in the wise.

It seems that, when Brooke left Tahiti, Taatamata may have been pregnant with his child (a girl who was to die in or about 1990). He knew nothing of this, and the question of her paternity was never resolved. Returning to England in June 1914, he was in a music-hall two months later when a scribbled message was thrown across the screen.

'War declared with Austria. 11.9.' There was a volley of quick low handclapping — more a signal of recognition than anything else. Then we dispersed into Trafalgar Square, and bought midnight war editions, special. All these days I have not been so near tears. There was such tragedy, and such dignity, in the people.

Brooke was commissioned into the Royal Naval Division (R. N. V. R.), and in mid-October 1914 took part in its brief and abortive expedition to Antwerp. This he described in a letter to Cathleen Nesbitt:

The sky was lit by burning villages and houses; and after a bit we got to the land by the river, where the Belgians had let all the petrol out of the tanks and fired it. Rivers and seas of flame leaping up hundreds of feet, crowned by black smoke that covered the entire heavens. It lit up houses wrecked by shells, dead horses, demolished railway stations, engines that had been taken up with their lines and signals, and all twisted round and pulled out, as a bad child spoils a toy. And there we joined the refugees, with all their goods on barrows and carts, in a double line, moving forwards about a hundred yards an hour, white and drawn and beyond emotion. The glare was like hell. We passed on, out of that, across a pontoon bridge, built on boats. Two German spies tried to blow it up while we were on it. They were caught and shot. We went on through the dark. The refugees and motor-buses and transport and Belgian troops grew thicker. After about a thousand years it was dawn.

Letter to Cathleen Nesbitt, 17 October 1914

On leave in December Brooke wrote the five 'war sonnets' that were to make him famous – 'Peace', 'Safety', two called 'The Dead', and 'The Soldier' (pp. 16–21) – and on 1 March 1915 embarked with the Hood Battalion on a troopship destined (though they did not know it) for Gallipoli. He wrote to Violet Asquith:

Do you think perhaps the fort on the Asiatic corner will want quelling, and we'll land and come at it from behind and they'll make a sortie and meet us on the plains of Troy? [. . .]

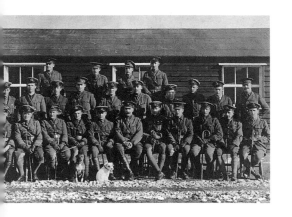

Rupert Brooke (second row, second from left) in the Hood Battalion, 1914

I've never been quite so happy in my life, I think. Not quite so pervasively happy; like a stream flowing entirely to one end. I suddenly realize that the ambition of my life has been – since I was two – to go on a military expedition against Constantinople.

On the troopship, he and his friends read Homer to each other (in Greek) until, contracting first heatstroke, then dysentery, and finally blood-poisoning, Rupert Brooke died on 23 April. His friends buried him that evening under a Greek epitaph, on the island of Skyros, supposedly the childhood home of Achilles. In due course another friend, the poet Frances Cornford, was to speed the transition of the man into myth – man into marble – with her quatrain:

A young Apollo, golden-haired,
Stands dreaming on the verge of strife,
Magnificently unprepared
For the long littleness of life.

England at that time needed a focal point for its griefs, ideals and aspirations, and the Valediction that appeared in *The Times* over the initials of Winston Churchill, the First Lord of the Admiralty, sounded a note that was to swell over the months and years that followed:

The thoughts to which he gave expression in the very few incomparable war sonnets which he has left behind will be shared by many thousands of young men moving resolutely and blithely forward into this, the hardest, the cruellest, and the least-rewarded of all the wars that men have fought. They are a whole history and revelation of Rupert Brooke himself. Joyous, fearless, versatile, deeply instructed, with classic symmetry of mind and body, he was all that one would wish England's noblest sons to be in days when no sacrifice but the most precious is that which is most freely proffered.

Brooke's *1914 and Other Poems* was published in June 1915 and over the next decade this volume and his *Collected Poems* sold 300,000 copies.

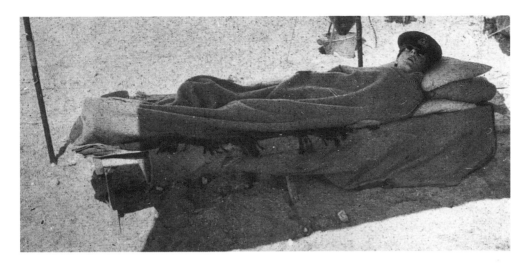

*Brooke lies sick
at Port Said,
2 April 1915*

He has sometimes been criticized for not responding to the horrors of war, but it should be remembered that in 1914 Wilfred Owen was himself writing (in 'The Women and the Slain'):

> O meet it is and passing sweet
> To live in peace with others,
> But sweeter still and far more meet,
> To die in war for brothers.

Brooke may have seen himself and others of his generation turning, at the outbreak of war, 'as swimmers into cleanness leaping', but he was not alone in envisioning an exhausted civilization rejuvenated by war. Isaac Rosenberg ended *his* poem 'On Receiving News of the War' (Cape Town, 1914):

> O! ancient crimson curse!
> Corrode, consume.
> Give back this universe
> Its pristine bloom.

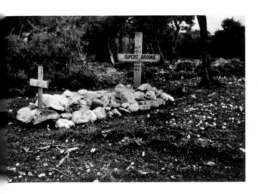

Had Brooke lived to experience the Gallipoli landings or the trenches of the Western Front, it is hard to imagine that the poet of 'Dawn' (see pp. 11–12) would not have written as realistically as Owen and Rosenberg. Like them he is a soldier poet but, unlike them, he is not a war poet. He is a poet of peace, a celebrant of friendship, love and laughter.

*Brooke's
original grave
on the island of
Skyros*

15

Peace

Now, God be thanked Who has matched us with His hour,
 And caught our youth, and wakened us from sleeping,
With hand made sure, clear eye, and sharpened power,
 To turn, as swimmers into cleanness leaping,
Glad from a world grown old and cold and weary,
 Leave the sick hearts that honour could not move,
And half-men, and their dirty songs and dreary,
 And all the little emptiness of love!

Oh! we, who have known shame, we have found release there,
 Where there's no ill, no grief, but sleep has mending,
 Naught broken save this body, lost but breath;
Nothing to shake the laughing heart's long peace there
 But only agony, and that has ending;
 And the worst friend and enemy is but Death.

1914

Safety

Dear! of all happy in the hour, most blest
 He who has found our hid security,
Assured in the dark tides of the world that rest,
 And heard our word, 'Who is so safe as we?'
We have found safety with all things undying,
 The winds, and morning, tears of men and mirth,
The deep night, and birds singing, and clouds flying,
 And sleep, and freedom, and the autumnal earth.

We have built a house that is not for Time's throwing.
 We have gained a peace unshaken by pain for ever.
War knows no power. Safe shall be my going,
 Secretly armed against all death's endeavour;
Safe though all safety's lost; safe where men fall;
And if these poor limbs die, safest of all.

1914

Brooke writing in the garden of the Old Vicarage, Granchester

17

The Dead (I)

Blow out, you bugles, over the rich Dead!
 There's none of these so lonely and poor of old,
 But, dying, has made us rarer gifts than gold.
These laid the world away; poured out the red
Sweet wine of youth; gave up the years to be
 Of work and joy, and that unhoped serene,
 That men call age; and those who would have been,
Their sons, they gave, their immortality.

Blow, bugles, blow! They brought us, for our dearth,
 Holiness, lacked so long, and Love, and Pain.
Honour has come back, as a king, to earth,
 And paid his subjects with a royal wage;
And Nobleness walks in our ways again;
 And we have come into our heritage.

1914

The Dead (II)

These hearts were woven of human joys and cares,
 Washed marvellously with sorrow, swift to mirth.
The years had given them kindness. Dawn was theirs,
 And sunset, and the colours of the earth.
These had seen movement, and heard music; known
 Slumber and waking; loved; gone proudly friended;
Felt the quick stir of wonder; sat alone;
 Touched flowers and furs and cheeks. All this is ended.

There are waters blown by changing winds to laughter
And lit by the rich skies, all day. And after,
 Frost, with a gesture, stays the waves that dance
And wandering loveliness. He leaves a white
 Unbroken glory, a gathered radiance,
A width, a shining peace, under the night.

1914

The Soldier

If I should die, think only this of me:
 That there's some corner of a foreign field
That is for ever England. There shall be
 In that rich earth a richer dust concealed;
A dust whom England bore, shaped, made aware,
 Gave, once, her flowers to love, her ways to roam,
A body of England's, breathing English air,
 Washed by the rivers, blest by suns of home.

And think, this heart, all evil shed away,
 A pulse in the eternal mind, no less
 Gives somewhere back the thoughts by England
 given;
Her sights and sounds; dreams happy as her day;
 And laughter, learnt of friends; and gentleness,
 In hearts at peace, under an English heaven.

1914

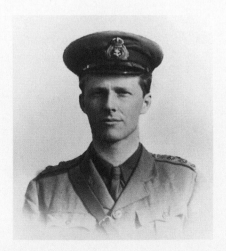

HOOD BATTALION,
2nd NAVAL BRIGADE,
BLANDFORD,
DORSET.

(5)

The Soldier.

If I should die, think only this of me:
 That there's some corner of a foreign field
That is for ever England. There shall be
 In that rich earth a richer dust concealed;
A dust whom England bore, shaped, made aware,
 Gave, once, her flowers to love, her ways to roam,
A body of England's, breathing English air,
 Washed by the rivers, blest by suns of home.

And think, this heart, all evil shed away,
 A pulse in the eternal mind, no less
 Gives somewhere back the thoughts by England
 given,
Her sights and sounds; dreams happy as her day;
 And laughter, learnt of friends; and gentleness,
 In hearts at peace, under an English heaven.

Julian Henry Francis Grenfell

Julian Grenfell was born in London on 30 March 1888. He was the eldest son of William Henry Grenfell, first Baron Desborough, and his beautiful wife, Ethel (always known at 'Ettie'), a woman of formidable charm and considerable social distinction. Their son was educated at Summerfields preparatory school in Oxford, then Eton, and Balliol College, Oxford, which he entered as a 'commoner' in 1906.

An Oxford contemporary would later recall his whirlwind arrival at university:

Julian did everything and shone in them all. He rowed, and he hunted; and he read, and he roared with laughter, and he cracked his whip in the quad all night; he bought greyhounds from the miller of Hambledon, boxed all the local champions; capped poetry with the most precious of the dons, and charmed everybody from the Master of Balliol to the ostlers at the Randolph [Hotel]. And he was the best of friends and the dearest of men. The only things he couldn't stand were pose or affectation, and he could be a terror to the occasional [aesthete] still to be met with at Oxford [. . . .]

Over six feet tall, Grenfell was a man of prodigious energy; boxing for the University, rowing at Henley, winning college steeplechases, and hunting with his favourite dog, Slogbottom, the subject of a poem 'To a Black Greyhound':

> Shining black in the shining light,
> Inky black in the golden sun,
> Graceful as the swallow's flight,
> Light as swallow, winged one;
> Swift as driven hurricane –
> Double sinewed stretch and spring,
> Muffled thus of flying feet,
> See the black dog galloping
> Hear his wild foot-beat.
>
> See him lie when the day is dead,
> Black curves curled on the boarded floor.
> Sleepy eyes, my sleepy-head –
> Eyes that were aflame before.
> Gentle now, they burn no more;
> Gentle now, and softly warm,
> With the fire that made them bright

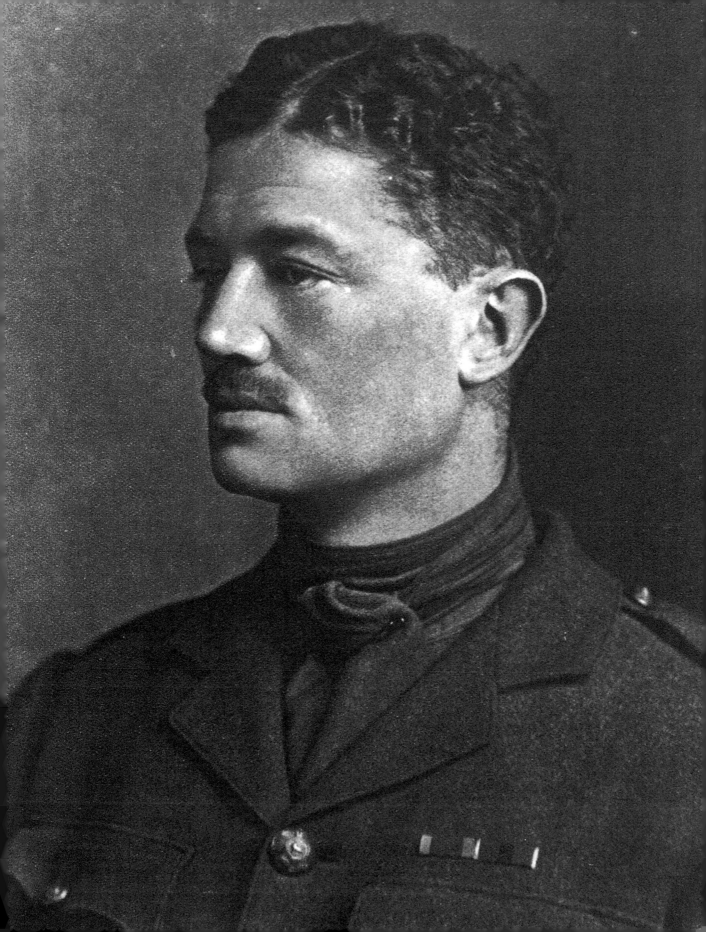

Hidden – as when after storm
 Softly falls the night.

God of Speed, who makes the fire –
 God of Peace, who lulls the same –
God who gives the fierce desire,
 Lust for blood as fierce as flame –
God who stands in Pity's name –
 Many may ye be or less,
Ye who rule the earth and sun:
 Gods of strength and gentleness
 Ye are ever one.

Grenfell's sketch
of a greyhound

The poet's clear identification with his greyhound's 'fierce desire,/Lust for blood as fierce as flame' reveals a ferocity in the man recognized by other of his contemporaries who were *not* his friends. Aesthetes, in particular, felt the lash of his tongue and feared that of his Australian stock-whip. One who had suffered from both threatened legal action, but was warned by the Master of Balliol that, if he proceeded with this, he would have to leave the college.

Grenfell was ostensibly studying Classics and Philosophy at Oxford, but was easily distracted from the prescribed Latin and Greek texts and, in his third year, began to write a book of his own. A collection of seven interrelated essays – 'On Conventionalism', 'Sport', 'On Individuality', 'On Calling Names by their Right Things', 'Divided Ideals', 'Selfishness, Service and the Single Aim' and 'Darwinism, Theism and Conventionalism' – this amounted to an attack on the values of English society in general, and his mother's social circle in particular. Much as he adored her, he resented the company she kept, 'the 101 princes of the blood', as he called the young men competing for her favours. Predictably, Ettie and her entourage hated his book; his friends were, at best, perplexed by it; and he consigned the typescript, bitterly, to the bottom of a tin trunk where it lay unread for many years.

Pigsticking,
a sketch in
Grenfell's
'game book'

Their response to his writing and ideals contributed to a mood of near-suicidal depression into which he slipped in the autumn of 1909. He was rescued from this, the following summer, by a passionate love affair with Pamela Lytton, wife of the 3rd Earl of Lytton. Realizing that they could have no future together, Grenfell decided to join the Army and in October 1910 was posted to India. As a subaltern in a cavalry regiment, the Royal Dragoons, he spent his time there drilling on the parade ground, playing polo, or pigsticking, a sport that produced the following poem:

Hymn to the Fighting Boar

God gave the horse for man to ride
 And steel wherewith to fight,
And wine to swell his soul with pride
 And women for delight:
But a better gift than all these four
Was when he made the fighting boar . . .

As in his poem 'To a Black Greyhound', Grenfell salutes a fellow hunter, praising each for a prowess that he shares: the greyhound for its running, the boar for its *fighting* (a favourite verb for a favourite activity).

The royal Dragoons left India for South Africa in 1911, returning to England shortly after the outbreak of war in 1914. On leave in England, Grenfell noted in his 'game book' that he shot 105 partridges at Panshangar in early October. His next two entries read: 'November 16th: 1 Pomeranian' [soldier]; 'November 17th: 2 Pomeranians'. By then, the Royal Dragoons, separated from their horses, were reinforcing the infantry at the first Battle of Ypres. Grenfell was in his element, writing home: 'I adore war. It's like a big picnic without the objectlessness of a picnic. I've never been so well or so happy.' The fighting excitement revitalizes everything – every sight and word and action. One loves one's fellow man so much more when one is bent on killing him.' He specializes in stalking his fellow men, and in fact did this so successfully that he was awarded the DSO.

Frances Cornford's 'young Apollo', Rupert Brooke, died on 23 April 1915. One month later, Julian Grenfell was lying in a French hospital with a shell-splinter in his head. Hearing of this, his parents obtained permission from the Admiralty to cross the Channel on an ammunition boat. At his bedside, his mother saw 'how a shaft of sunlight came in at the darkened window and fell across his feet'. He smiled at her and said 'Phoebus Apollo'. Next day *The Times* carried, with the news of his death, his poem, 'Into Battle', which was to become – for the duration of the war and for some time after – almost as famous as Brooke's sonnet, 'The Soldier'.

Human society has no place in this poem. The speaker's milieu is the natural world:

Hunting Pomeranians, from Grenfell's 'game book'

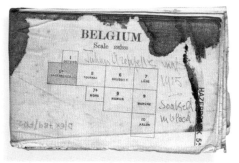

*Grenfell's
bloodstained
map*

The naked earth is warm with Spring,
And with green grass and bursting trees
Leans to the sun's gaze glorying
And quivers in the sunny breeze;
And life is colour and warmth and light
And a striving evermore for these;

a celebration of vitality followed by two dismayingly paradoxical statements:

And he is dead who will not fight;
And who dies fighting has increase.

In what sense, one must ask, is such a man *increased* – rather than diminished – by his loss of contact with the natural world? The answer is not really an answer:

The fighting man shall from the sun
Take warmth, and life from the glowing earth;
Speed with the light-foot winds to run,
And with the trees to newer birth;
And find, when fighting shall be done,
Great rest, and fullness after dearth.

*British troops
at Ypres,
October 1914*

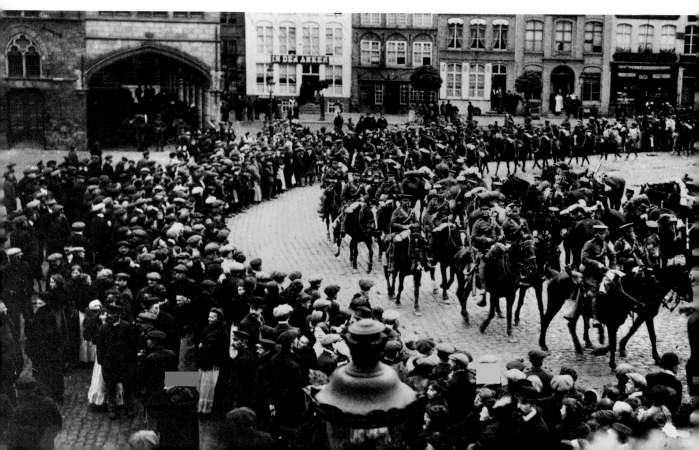

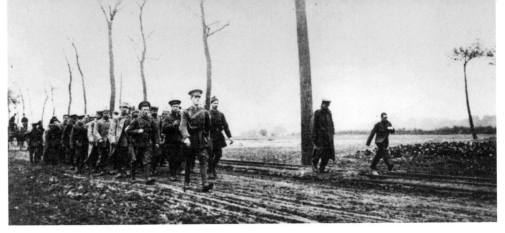

The fighting man finds exhilaration in battle and, afterwards, what *increase* does he find? 'Great rest, and fullness after dearth.' The word 'dearth' – particularly when rhymed with 'birth' – sounds like a euphemism for 'death', and this association would seem to link with what follows:

> All the bright company of Heaven
> Hold him in their high comradeship,
> The Dog-Star and the Sisters seven,
> Orion's belt and sworded hip.

The stars that guide the fighting man on patrol share his predatory inclinations: the Dog-Star (Grenfell took three greyhounds with him to France) and Orion the huntsman. His friends are the inhuman stars, other predators (kestrel and owl), the blackbird that urges him to sing, and those animals associated with heroism and warfare long before they gave their name to chivalry:

> The horses show him noble powers;
> O patient eyes, courageous hearts!

At last, the fighting man discovers the 'joy of battle', but the reader has still to discover the nature of the 'increase' he obtains if he dies fighting. We are never told explicitly what it is – because, I think, Grenfell assumes we will know and will agree that increase it is. The answer is surely 'glory'; Grenfell's ambition being essentially the same as the ambitions of Hector or Beowulf. This is in many ways a horrifying poem and, like the poems of Brooke, Vernède, and countless other public-school poets, it illustrates the hypnotic power of a long cultural tradition; the tragic outcome of educating a generation to face not the future but the past.

Grenfell's last letter to his mother

Prayer for Those on the Staff

Fighting in mud, we turn to Thee
 In these dread times of battle, Lord,
To keep us safe, if so may be,
 From shrapnel, snipers, shell and sword.

Yet not on us – (for we are men
 Of meaner clay, who fight in clay) –
But on the Staff, the Upper Ten,
 Depends the issue of the day.

The Staff is working with its brains
 While we are sitting in the trench;
The Staff the universe ordains
 (Subject to Thee and General French).

God, help the Staff – especially
 The young ones, many of them sprung
From our high aristocracy;
 Their task is hard, and they are young.

O Lord, who mad'st all things to be
 And madest some things very good
Please keep the extra ADC
 From horrid scenes, and sights of blood

1915

*Cloth Hall and
Cathedral,
Ypres, 1915*

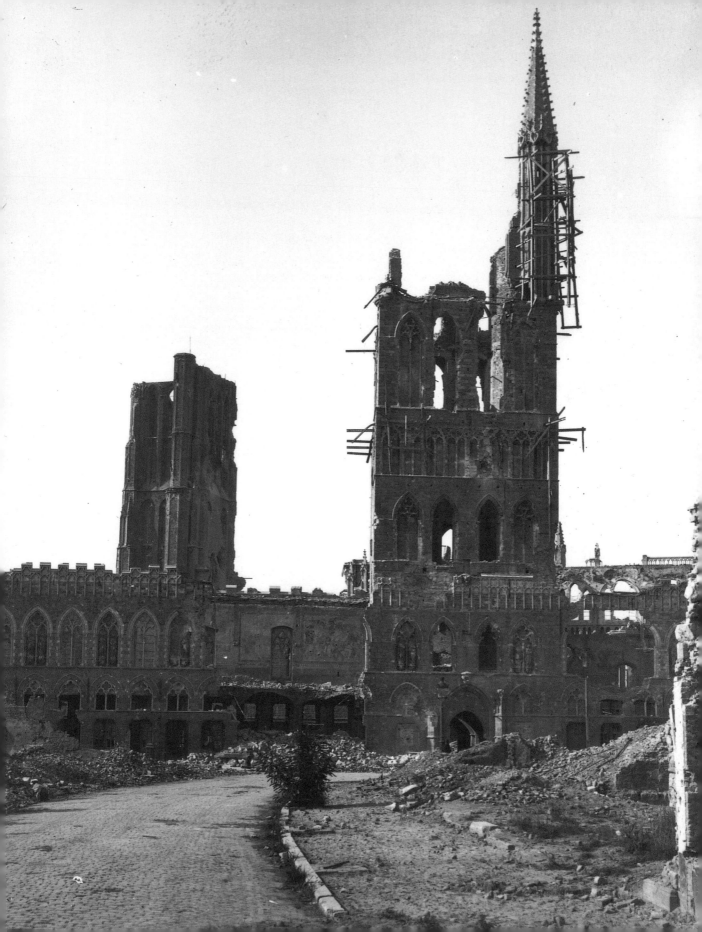

Into battle.

The naked earth is warm with spring,
And with green grass and bursting trees
Leans to the sun's kiss glorying,
And quivers in the loving breeze;
And Life is Colour and Warmth and 'Light',
And a striving evermore for these;
And he is dead who will not fight;
And who dies fighting, has increase.

The fighting man shall from the sun
Take warmth, and life from the glowing earth,
Speed with the light-foot winds to run
And with the trees a newer birth;
And when his fighting shall be done,
Good rest, and fullness after dearth.

The woodland trees that stand together,
They stand to him each one a friend;
They gently speak in windy weather,
They guide to valley and ridge's end.

All the bright company of heaven
Hold him in their high comradeship —
The Dog-star and the Sisters Seven
Orion's belt and sworded hip.

The kestrel hovering by day,
And the little owls that call by night,
Keen hunters cunning after prey Bid him be swift and keen as they,
Bid him be keen of sound and sight As keen of sound as swift of sight.

And the blackbird sings to him "Brother, brother,
If this be the last song you shall sing,
Sing well, for you will not sing another,
Sing, Brother! Sing!"

And when the line of battle stands,
When in the air Death moans and sings,
The Day shall clasp him in strong hands,
The Night shall fold him in soft wings.

In dreamy doubtful waiting hours
Before the braven frenzy starts
The horses show him nobler powers —
O ~~Poor~~ patient eyes, ~~brave~~ ardent hearts!
 Courageous

And when the burning moment breaks,
And all things else are out of mind,
And joy of battle only takes
Him by the throat and makes him blind —

Through joy and blindness he shall know,
Not caring much, to know, that still
 reach him so
Nor lead nor steel shall ~~lay him low~~ shall reach him so
~~Unless it be~~ the Destined Will. That it be not the Destined Will.

The thundering line of battle stands,
And in the air Death moans and sings;
But ~~Day~~ shall clasp him with strong hands,
And Night shall fold him in soft wings.

 Julian Grenfell.

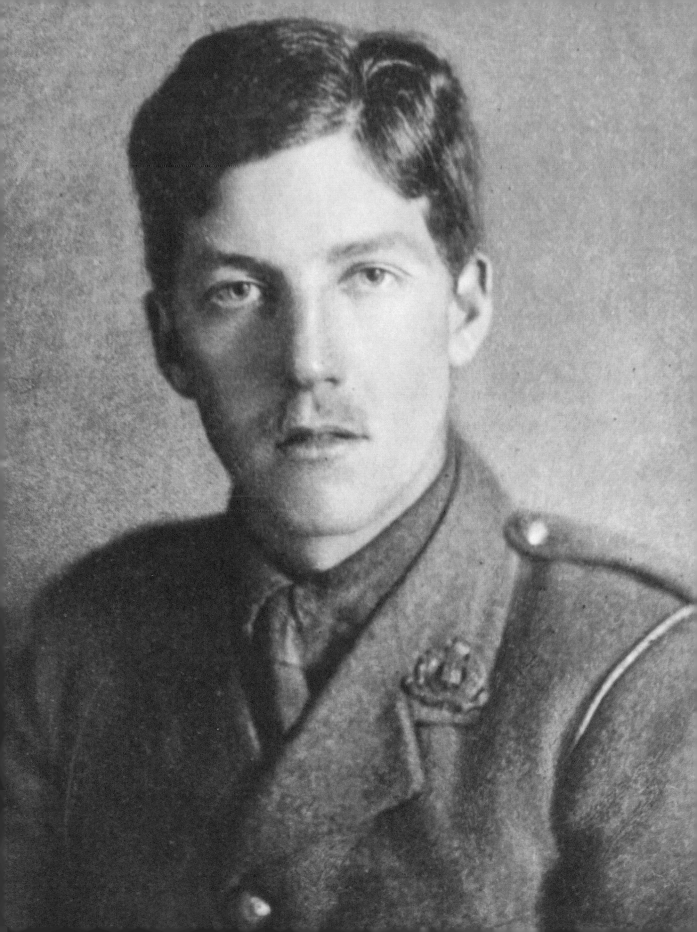

Charles Hamilton Sorley

Charles Sorley was born in Aberdeen on 19 May 1895, the elder twin son and third surviving child of William Ritchie Sorley, Professor of Moral Philosophy at Aberdeen University, and his wife Janetta. When Charles was five, his father was appointed Professor of Moral Philosophy at Cambridge, and there the boy was brought up. He went to King's College Choir School (his father being a Fellow of that college), and absorbed from its compulsory Chapel service a knowledge of the Bible that would influence the language of his poems. In 1908, he won a scholarship to Marlborough College, where he developed a passion – like Grenfell's – for cross-country running and wrote a number of poems. One of the earliest, 'Barbury Camp', a pre-Roman hill-fort on the Marlborough downs, begins:

> We burrowed night and day with tools of lead,
> Heaped the bank up and cast it in a ring
> And hurled the earth above. And Caesar said,
> 'Why, it is excellent. I like the thing.'
> We, who are dead,
> Made it, and wrought, and Caesar liked the thing.

In this, one sees the imagination of another public-schoolboy stamped with the martial insignia of a classical education. A later stanza employs a phrase – a concept – curiously close to Grenfell's 'joy of battle', but uses it in a very different context:

> So, fighting men and winds and tempests, hot
> With joy and hate and battle-lust, we fell
> Where we fought. And God said, 'Killed at last then? What!
> Ye that are too strong for heaven, too clean for hell,
> (God said) stir not.
> This be your heaven, or, if ye will, your hell.'

The ghosts of Sorley's Roman soldiers live on in their native landscape as, he imagines in a later poem, will the soldiers marching to a later war.

In his last year at Marlborough, Sorley won prizes for English and for public reading, and a scholarship to Oxford. However, before going to university, he decided to spend some months in Mecklenburg acquiring German – and independence. He acquired both. Out on a walk in February 1914, he heard a group of German soldiers singing 'something glorious and senseless about the Fatherland'.

And when I got home, I felt I was a German, and proud to be a German: when the tempest of the singing was at its loudest, I felt that perhaps I could die for Deutschland – and I have never had an inkling of that feeling about England, and never shall.

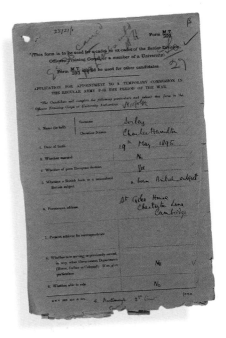

That emotion died with the cessation of the singing, but the affection and admiration he had acquired for the Germans continued after they became 'the enemy'. He recognized, however, that he had to choose between the two countries, and seems to have had no hesitation in making his choice.

The singing of the German soldiers may have merged in Sorley's imagination with the singing of British soldiers, prompting an untitled poem he wrote shortly after the outbreak of war. It begins:

> All the hills and vales along
> Earth is bursting into song,
> And the singers are the chaps
> Who are going to die perhaps.

Sorley's landscape is as vibrantly animate as that of Grenfell's poem 'Into Battle' (see pp. 30–1), but it is a *peopled* landscape. It, too, has a song, but it is far from being the song of a blackbird instructing a solitary poet:

> the singers are the chaps
> Who are going to die perhaps.

There is no 'high comradeship' with heavenly bodies here, but a sense of identification with more lowly 'chaps'. The stanza ends:

> O sing, marching men,
> Till the valleys ring again.
> Give your gladness to earth's keeping,
> So be glad, when you are sleeping.

Sorley's application for a temporary commission in the army

A strange circularity is set up, whereby the marching men are urged to give their gladness, their song, to the earth where they can reclaim it later. This ambiguous consolation becomes less ambiguous in what follows:

> Cast away regret and rue,
> Think what you are marching to.
> Little live, great pass,
> Jesus Christ and Barabbas
> Were found the same day.
> This died, that went his way.
>> So sing with joyful breath,
>> For why, you are going to death.
>> Teeming earth will surely store
>> All the gladness that you pour.

Earth that never doubts nor fears,
Earth that knows of death, not tears,
Earth that bore with joyful ease
Hemlock for Socrates,
Earth that blossomed and was glad
'Neath the cross that Christ had,
Shall rejoice and blossom too
When the bullet reaches you.
 Wherefore, men marching
 On the road to death, sing!
 Pour your gladness on earth's head,
 So be merry, so be dead.

At first sight this could be taken for irony, but a letter from Sorley, in which he wrote 'The earth even more than Christ is the ultimate ideal of what man should strive to be', suggests that it is not.

No doubt, in part because of his conflicting feelings about Germany, Sorley was critical of anything that smacked of 'jingoism'. 'England –' he writes, 'I am sick of the sound of the word. In training to fight for England, I am training to fight for that deliberate hypocrisy, that terrible middle-class sloth of outlook and appalling "imaginative indolence" that has marked us out from generation to generation.' He was particularly critical of the jingoistic strain in Rupert Brooke's poetry, and a letter to his mother about Brooke's death in 1915 highlights the principal difference between them:

That last sonnet-sequence of his, of which you sent me the review in the Times Lit. Sup.*, and which has been so praised, I find (with the exception of that beginning 'Their hearts were woven of human joys and cares. . .' which is not about himself) overpraised. He is far too obsessed with his own sacrifice, regarding the going to war of himself (and others) as a highly intense, remarkable and sacrificial exploit, whereas it is merely the conduct demanded of him (and others) by the turn of circumstances, where the non-compliance with this demand would have made life intolerable. It was not that 'they' gave up anything of that list he gives in one sonnet: but that the essence of these things had been endangered by circumstances over which he had no control and he must fight to recapture them. He has clothed his attitude in fine words: but he has taken the sentimental attitude.*

As this shows, Sorley was himself far from sentimental. Brooke had also lived in Germany before the war, but whereas his most famous sonnet, 'If I should die', invokes

Letter to his aunt Mary from the trenches, 17 August 1915

British troops returning from the Battle of Loos, 1915

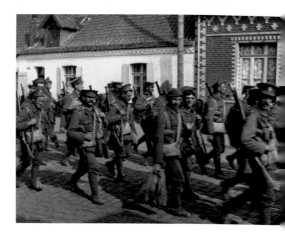

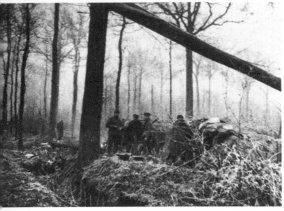

*Trenches in
Ploegsteert
Wood, 1915*

the noun England no less than four times, Sorley writes a sonnet (some months earlier) entitled 'To Germany'. It begins:

> You are blind like us. Your hurt no man designed,
> And no man claimed the conquest of your land.

The sestet moves from present blindness to a prophetic vision of future sight that has an interesting relation to the piercing recognition and reconciliation of Englishman and German in Owen's poem 'Strange Meeting' (see pp.112–13). Sorley is much more optimistic:

> When it is peace, then we may view again
> With new-won eyes each other's truer form
> And wonder. Grown more loving-kind and warm
> We'll grasp firm hands and laugh at the old pain,
> When it is peace. But until peace, the storm
> The darkness and the thunder and the rain.

Much as one may admire the attitudes expressed in this poem, it has to be said that its impact is diminished by the euphemistic metaphor with which it ends,

> But until peace, the storm
> The darkness and the thunder and the rain.

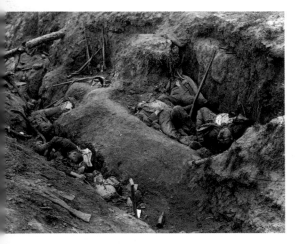

*German front-
line trench filled
with German
dead, 1916*

One remembers other poems in which he writes exultantly of wind and rain – what Robert Graves was to call 'Sorley's Weather'. There are no such euphemisms, however, in the sonnet found in his kit after his death on the Western Front in October 1915. He was twenty years old.

> When you see millions of the mouthless dead
> Across your dreams in pale battalions go,
> Say not soft things as other men have said,
> That you'll remember. For you need not so.
> Give them not praise. For, deaf, how should they know
> It is not curses heaped on each gashed head?
> Nor tears. Their blind eyes see not your tears flow.
> Nor honour. It is easy to be dead.
> Say only this, 'They are dead.' Then add thereto,
> 'Yet many a better one has died before.'
> Then, scanning all the o'ercrowded mass, should you

Perceive one face that you loved heretofore,
It is a spook. None wears the face you knew.
Great death has made all his for evermore.

Sorley was one of the first poets to get the numbers right – there are '*millions of the mouthless dead*' – and, responding perhaps to Brooke's 'If I should die' (one of those sonnets he had criticized for their excessive concern with self), there is no first-person pronoun, no 'I', in his poem. Where Brooke had urged his reader to 'think only this of me', Sorley tells us to

Say not soft things as other men have said,
That you'll remember. For you need not so.

Those negatives are followed by others, as with unsparing irony he punctures the platitudes of consolation:

Give them not praise. For, deaf, how should they know,
It is not curses heaped on each gashed head?
Nor tears. Their blind eyes see not your tears flow.
Nor honour. It is easy to be dead.

In November 1914, writing to the Master of Marlborough, Sorley had quoted a line from the *Iliad*, spoken by Achilles – 'Died Patroclus too who was a far better man than thou' – adding 'no saner and splendider comment on death has been made'. As his last sonnet enters its sestet, he echoes that Homeric line with another instruction to his reader:

Say only this, 'They are dead.' Then add thereto,
'Yet many a better one has died before.'

Sorley's dead are blind, deaf, gashed. They are not heroic Homeric shades, garlanded with glory, but an indistinguishable 'o'ercrowded mass'. He did not live long enough to acquire the technical skills of an Owen or a Sassoon, but he understood the truth about the war before they did, and found words for it before them. He stands as an attractive transitional figure between the first wave of poets and those of the second wave soon to follow them.

Telegram notifying Professor W. R. Sorley of his son's death

To Germany

You are blind like us. Your hurt no man designed,
And no man claimed the conquest of your land.
But gropers both through fields of thought confined
We stumble and we do not understand.
You only saw your future bigly planned,
And we, the tapering paths of our own mind,
And in each other's dearest ways we stand,
And hiss and hate. And the blind fight the blind.

When it is peace, then we may view again
With new-won eyes each other's truer form
And wonder. Grown more loving-kind and warm
We'll grasp firm hands and laugh at the old pain,
When it is peace. But until peace, the storm
The darkness and the thunder and the rain.

1914

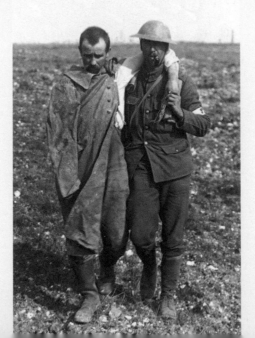

[A hundred thousand million mites we go]

A hundred thousand million mites we go
Wheeling and tacking o'er the eternal plain,
Some black with death – and some are white with woe.
Who sent us forth? Who takes us home again?

And there is sound of hymns of praise – to whom?
And curses – on whom curses? – snap the air.
And there is hope goes hand in hand with gloom,
And blood and indignation and despair.

And there is murmuring of the multitude
And blindness and great blindness, until some
Step forth and challenge blind Vicissitude
Who tramples on them: so that fewer come.

And nations, ankle-deep in love or hate,
Throw darts or kisses all the unwitting hour
Beside the ominous unseen tide of fate;
And there is emptiness and drink and power.

And some are mounted on swift steeds of thought
And some drag sluggish feet of stable toil.
Yet all, as though they furiously sought,
Twist turn and tussle, close and cling and coil.

A hundred thousand million mites we sway
Writhing and tossing on the eternal plain,
Some black with death – but most are bright with Day!
Who sent us forth? Who brings us home again?

1914

Two Sonnets

I Saints have adored the lofty soul of you.
Poets have whitened at your high renown.
We stand among the many millions who
Do hourly wait to pass your pathway down.
You, so familiar, once were strange: we tried
To live as of your presence unaware.
But now in every road on every side
We see your straight and steadfast signpost there.

I think it like that signpost in my land,
Hoary and tall, which pointed me to go
Upward, into the hills, on the right hand,
Where the mists swim and the winds shriek and blow,
A homeless land and friendless, but a land
I did not know and that I wished to know.

II Such, such is Death: no triumph: no defeat:
Only an empty pail, a slate rubbed clean,
A merciful putting away of what has been.

And this we know: Death is not Life effete,
Life crushed, the broken pail. We who have seen
So marvellous things know well the end not yet.

Victor and vanquished are a-one in death:
Coward and brave: friend, foe. Ghosts do not say,
'Come, what was your record when you drew breath?'
But a big blot has hid each yesterday
So poor, so manifestly incomplete.
And your bright Promise, withered long and sped,
Is touched, stirs, rises, opens and grows sweet
And blossoms and is you, when you are dead.

1915

In Memoriam
S.C.W. V.C.

There is no fitter end than this.
No need is now to yearn nor sigh.
We know the glory that is his,
A glory that can never die.
Surely we knew it long before,
Know all along that he was made
For a swift ~~glorious~~ radiant morning, for
A sacrificing swift night-shade.

8/9/15

[I have not brought my Odyssey]

I have not brought my Odyssey
With me here across the sea;
But you'll remember, when I say
How, when they went down Sparta way,
To sandy Sparta, long ere dawn
Horses were harnessed, rations drawn,
Equipment polished sparkling bright,
And breakfasts swallowed (as the white
Of eastern heavens turned to gold) –
The dogs barked, swift farewells were told.
The sun springs up, the horses neigh,
Crackles the whip thrice – then away!
From sun-go-up to sun-go-down
All day across the sandy down
The gallant horses galloped, till
The wind across the downs more chill
Blew, the sun sank and all the road
Was darkened, that it only showed
Right at the end of the town's red light
And twilight glimmering into night.

The horses never slackened till
They reached the doorway and stood still.
Then came the knock, the unlading; then
The honey-sweet converse of men,
The splendid bath, the change of dress,
Then – O the grandeur of their Mess,
The henchmen, the prim stewardess!
And O the breaking of old ground,
The tales, after the port went round!
(The wondrous wiles of old Odysseus,
Old Agamemnon and his misuse

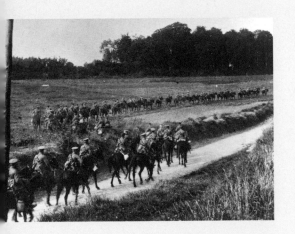

Of his command, and that young chit
Paris – who didn't care a bit
For Helen – only to annoy Pa
He did it really, κ. τ. λ.)

But soon they led amidst the din
The honey-sweet ἀοιδός in,
Whose eyes were blind, whose soul had sight,
Who knew the fame of men in fight –
Bard of white hair and trembling foot,
Who sang whatever God might put
Into his heart.
 And there he sung,
Those war-worn veterans among,
Tales of great war and strong hearts wrung,
Of clash of arms, of council's brawl,
Of beauty that must early fall,
Of battle hate and battle joy
By the old windy walls of Troy.
They felt that they were unreal then,
Visions and shadow-forms, not men.
But those the Bard did sing and say
(Some were their comrades, some were they)
Took shape and loomed and strengthened more
Greatly than they had guessed of yore.

And now the fight begins again,
The old war-joy, the old war-pain.
Sons of one school across the sea
We have no fear to fight, for we
Have echo of our deeds in you
We have our ἀοιδός too.

And soon, O soon, I do not doubt it,
With the body or without it,

We shall all come tumbling down
To our old wrinkled red-capped town.
Perhaps the road up Ilsley way,
The old ridge-track, will be my way.
High up among the sheep and sky,
Look down on Wantage, passing by,
And see the smoke from Swindon town;
And then full left at Liddington,
Where the four winds of heaven meet
The earth-blest traveller to greet.
And then my face is toward the south,
There is a singing on my mouth:
Away to rightward I descry
My Barbury ensconced in sky,
Far underneath the Ogbourne twins,
And at my feet the thyme and whins,
The grasses with their little crowns
Of gold, the lovely Aldbourne downs
And that old signpost (well I knew
That crazy signpost, arms askew,
Old mother of the four grass ways).
And then my mouth is dumb with praise,
For, past the wood and chalkpit tiny,
A glimpse of Marlborough ἐρατεινή!
So I descend beneath the rail
To warmth and welcome and wassail,
And you, our minstrel, you our bard,
Who makes war's grievous things and hard,
Lightsome and glorious and fair
Will be, at least in spirit, there.
We'll read your rhymes, and we will sing
The toun o' touns till the roofs ring.
And if you'll come among us, then
We shall be most blest of men,
We shall forget the old old pain,

Remember Marlborough again
And hearken all the tales you tell
And bless our old ἀοιδός.
 Well,
This for the future. Now we stand
Stronger through you, to guard our land,
I do but give the thanks of each
(Thanks far far greater than my speech)
Of those who knew or did not know
(For all knew you) not long ago
In places that we see in sleep
Our eyes are dry but our hearts weep
Warm living tears that memory dear
Calls up the moment that we hear
(For we do hear it) your kind voice
Who understood us, men and boys.
So now and for the ages through
We are all dead and living too.
Our common life lies on your tongue
For as the bards sang, you have sung.

This from the battered trenches – rough,
Jingling and tedious enough.
And so I sign myself to you:
One, who some crooked pathways knew
Round Bedwyn: who could scarcely leave
The Downs on a December eve:
Was at his happiest in shorts,
And got – not many good reports!
Small skill of rhyming in his hand –
But you'll forgive – you'll understand.

12 July 1915

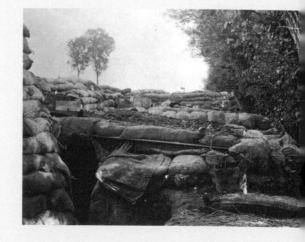

Francis Edward Ledwidge

Francis Ledwidge was born on 19 August 1887 in the village of Slane, County Meath, Ireland. The eighth child of an evicted tenant-farmer, Patrick Ledwidge, he would later claim to be 'of a family who were ever soldiers and poets'. The Ledwidges' cottage now carries a commemorative plaque, which had originally been placed on the Slane Bridge over the River Boyne. Seamus Heaney, Ledwidge's most eloquent champion, has said:

That the plaque appeared on the bridge first rather than the house has a certain appropriateness also, since the bridge, like the poet, was actually and symbolically placed between two Irelands. Upstream, then and now, were situated several pleasant and potent reminders of an anglicized, assimilated country: the Marquis of Conyngham's parkland sweeping down to the artfully wooded banks of the river, the waters of the river itself pouring their delicious sheen over the weir; Slane Castle and the big house at Beauparc; the canal and the towpath – here was an Irish landscape in which a young man like Ledwidge would be as likely to play cricket (he did) as Gaelic football (which he did also). The whole scene was as composed and historical as a topographical print, and possessed the tranquil allure of the established order of nineteenth-century, post-union Ireland. Downstream, however, there were historical and prehistorical reminders of a different sort which operated as a strong counter-establishment influence in the young Ledwidge's mind. The Boyne battlefield, the megalithic tombs at Newgrange, Knowth and Dowth, the Celtic burying ground at Rosnaree – these things were beginning to be construed as part of the mystical body of an Irish culture which had suffered mutilation and was in need of restoration.

Ledwidge's father died when his son was four, and his widow worked constantly, cleaning houses and in the fields, to support the family until the children were grown up. Leaving school at twelve, Frank wrote his first recorded poem at sixteen. His mother had sent him to work as a grocer's apprentice in Rathfarnham. He was desperately homesick there and one night composed 'Behind the Closed Eye'. Its memories of home so moved him that he quit his job and walked through the dark the thirty miles to Slane, pausing to rest at each milestone along the way.

He grew into a handsome and popular young man, muscular from navvying on the roads and in the coppermines of Beaupark, a job from which he was dismissed for organizing a strike against bad working conditions. An independent, combative streak led him into fights at football matches and, later, into local prominence as a trade unionist, a member of Navan Rural Council, and, in 1914, as secretary of the Slane corps of Irish Volunteers.

His poems, meanwhile, were appearing in the *Drogheda Independent* and, in June 1912, he sent some to Lord Dunsany, a local landlord, himself a recognized poet of the Celtic revival. Dunsany was 'astonished by the brilliance of that eye that had looked at the fields of Meath and seen there all the simple birds and flowers, with a

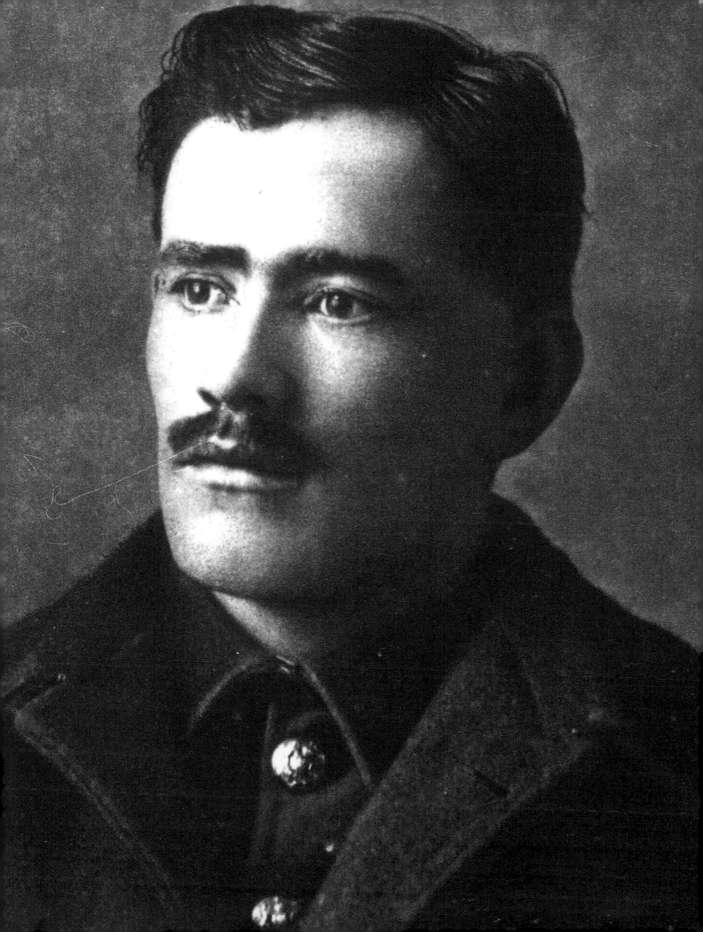

vividness that made those pages like a magnifying glass, through which one looked at familiar things seen thus for the first time'. He gave Ledwidge comments and suggestions on his poems and, more importantly, introduced him to the work of such of his contemporaries as Padraic Colum, AE (George Russell), Oliver St John Gogarty, Thomas McDonagh, Katherine Tynan, James Stephens and W. B. Yeats. Under their influence, Ledwidge began to prune the archaisms and poeticisms then encumbering his poems, but he had still to find a subject more compelling than second-hand versions of pastoral.

This presented itself, painfully, on 20 September 1914 when, as Auden said of Yeats, 'Mad Ireland hurt [him] into poetry.' In an epoch-making speech that day at Woodenbridge, County Wicklow, John Redmond pledged the Irish Volunteers to support the British war effort 'wherever needed'. This split the movement: the majority, possibly 150,000 men (naming themselves 'National Volunteers') followed Redmond; the minority of 3,000–10,000 held to the original Irish Republican Brotherhood (IRB)-influenced Irish Volunteer position. Ledwidge, a nationalist but not a member of Sinn Fein, initially sided with the hard-line minority. He came under intense pressure, revealed in a transcript of a Navan Rural Council meeting in October:

Letter to his friend Matty McGoona from barracks in Dublin in 1915

MR BOWENS: The young men of Meath would be better off fighting on the fields of France for the future of Ireland. That was his opinion, and he would remark that he was sorry to see there in the town of Navan – and probably in the village of Slane where Mr Ledwidge came from – . . . a few Sinn Feiners that followed the tail end of MacNeill's party. There was nothing but strife in the country as long as these people had anything to do with the country …What was England's uprise would be also Ireland's uprise.

[Applause]

MR LEDWIDGE: England's uprise has always been Ireland's downfall.

MR OWENS: …What was he [Mr Ledwidge]? Was he an Irishman or a pro-German?

MR LEDWIDGE: I am an anti-German and an Irishman.

Five days later, in agony of spirit, he enlisted in Lord Dunsany's regiment, the Royal Inniskilling Fusiliers. His decision may have been influenced by the news that Ellie Vaughey, the woman he loved, was to marry another man, but there is no reason to doubt his own explanation: 'I joined the British Army because she stood between Ireland and an enemy common to our civilization and I would not have her say that she

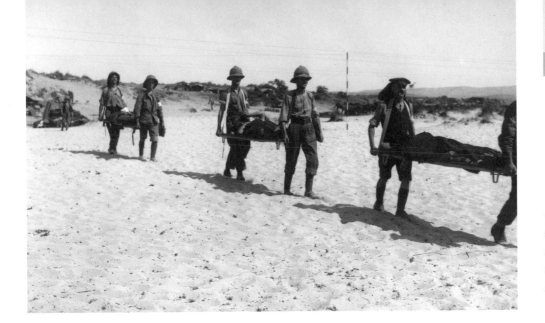

Carrying the wounded down to the jetty for transfer to hospital ships at Gallipoli

defended us while we did nothing at home but pass resolutions.' In June 1915, when the Fifth Inniskillings were preparing to depart for Gallipoli, Ledwidge heard that Ellie had died and wrote the first of several elegies for her:

To One Dead

> A blackbird singing
> On a moss-upholstered stone,
> Bluebells swinging,
> Shadows wildly blown,
> A song in the wood,
> A ship on the sea.
> The song was for you
> And the ship was for me.
>
> A blackbird singing
> I hear in my troubled mind,
> Bluebells swinging
> I see in a distant wind
> But sorrow and silence
> Are the wood's threnody
> The silence for you
> And the sorrow for me.

Dugout in the cliff face at Gallipoli

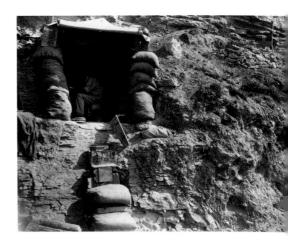

'The ship' reached Gallipoli on 6 August and Ledwidge fought from its scorching trenches until, at the end of September, the Inniskillings were transferred, first to the island of Lemnos and then to the Serbian Front. There,

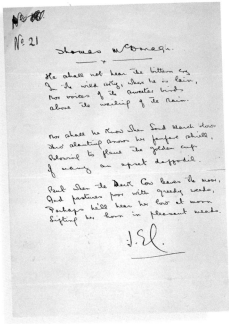

*The manuscript
of Ledwidge's
'Lament for
Thomas
McDonagh'*

dug into a freezing mountain ridge and subsisting on starvation rations, he heard that his book of poems, *Songs of the Field*, assembled with Dunsany's help in the peaceful summer of 1914, had been published.

Ledwidge was back in Slane on sick leave, after a punishing retreat march to Salonika, when on Easter Monday 1916 his former comrades of the Irish Volunteers, combining with units of the Citizen Army, launched the Dublin Easter Rising. It was bloodily suppressed, and Ledwidge's feelings can be imagined when, in early May, the fifteen ring-leaders faced a firing-squad wearing the uniform he had himself elected to wear as an act of Irish patriotism. He tried to dull the pain with drink, reported late for duty, and was court-martialled for making offensive remarks to superior officers. His distress, however, was to find a more productive outlet in his 'Lament for Thomas McDonagh', one of three poets to face the firing-squad:

> He shall not hear the bittern cry
> In the wild sky, where he is lain,
> Nor voices of the sweeter birds
> Above the wailing of the rain.
>
> Nor shall he know when loud March blows
> Thro' slanting snows her fanfare shrill,
> Blowing to flame the golden cup
> Of many an upset daffodil.
>
> But when the Dark Cow leaves the moor,
> And pastures poor with greedy weeds,
> Perhaps he'll hear her low at morn
> Lifting her horn in pleasant meads.

His grief at his friend's death, perhaps an intimation of his own (his elegy can be read as a 'Lament' for himself), and his guilt at what must have seemed his betrayal of the Nationalist cause, all combined to bring his pastoral vividly to life – and death; that polarity is adumbrated in the bitter-sweet (bittern . . . sweeter) overture of the opening stanza. The Easter Rising was to 'hurt him into poetry' more than the Great War.

April 1917 found him in action again, this time on the Western Front, from where he wrote to Edward Marsh (see p. 12), who had published him in his *Georgian Poetry* volumes:

If you visit the front, don't forget to come up the line at night to watch the German rockets. They have white crests which throw a pale flame across no-man's-land and white bursting into green

and green changing into blue and blue bursting and dropping down in purple torrents. It is like the end of a beautiful world.

On 31 July, when by a cruel irony he was at work building a road through mud (as, years before, he had done in Meath), he was killed by a stray shell.

Three months later, his second book, *Songs of Peace*, appeared, to be followed by his *Last Songs*, which ends with 'A Soldier's Grave' (possibly a memory of the shell-swept slopes of the Gallipoli peninsula):

> Then in the lull of the midnight, gentle arms
> Lifted him slowly down the slopes of death,
> Lest he should hear again the mad alarms
> Of battle, dying moans, and painful breath.
>
> And where the earth was soft for flowers we made
> A grave for him that he might better rest.
> So, Spring shall come and leave it sweet arrayed,
> And there the lark shall turn her dewy nest.

Mudros harbour, Lemnos, with the French camp in the foreground

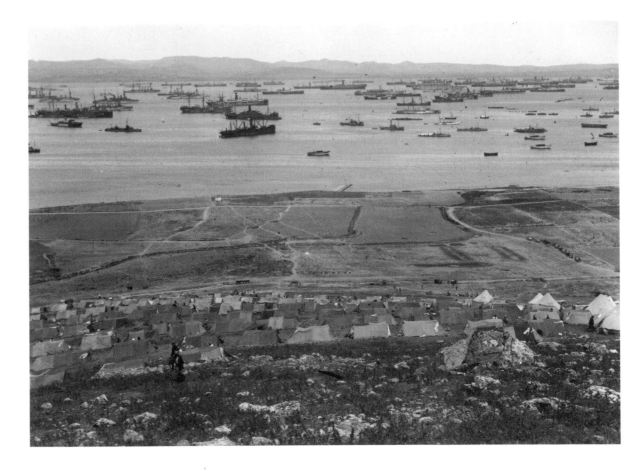

Ledwidge had called himself a 'poor bird-hearted singer of a day' and, like the lark and blackbird, his song is distinctive and beautiful but narrow in its range. He speaks, nevertheless, for 200,000 of his countrymen who enlisted in the British Army – 27,000 of whom died – because they believed England 'stood between Ireland and an enemy common to our civilization'. It is fitting that he and they should be commemorated by a greater poet, Seamus Heaney, whose elegy 'In Memoriam Francis Ledwidge' ends:

From a letter to Katherine Tynan from the Western Front

I think of you in your Tommy's uniform,
A haunted Catholic face, pallid and brave,
Ghosting the trenches like a bloom of hawthorn
Or silence cored from a Boyne passage-grave.

It's summer, nineteen-fifteen. I see the girl
My aunt was then, herding on the long acre.
Behind a low bush in the Dardanelles
You suck stones to make your dry mouth water.

It's nineteen-seventeen. She still herds cows
But a big strafe puts the candles out in Ypres:
'My soul is by the Boyne, cutting new meadows . . .
My country wears her confirmation dress.'

'To be called a British soldier while my country
Has no place among nations . . .' You were rent
By shrapnel six weeks later. 'I am sorry
That party politics should divide our tents.'

In you, our dead enigma, all the strains
Criss-cross in useless equilibrium
And as the wind tunes through this vigilant bronze
I hear again the sure confusing drum

You followed from Boyne water to the Balkans
But miss the twilit note your flute should sound.
You were not keyed or pitched like these true-blue ones
Though all of you consort now underground.

Night scene in the trenches, Western Front, 1916

War

Darkness and I are one, and wind
And nagging thunder, brothers all.
My mother was a storm. I call
And shorten your way with speed to me.
I am love and Hate and the terrible mind
Of vicious gods, but more am I,
I am the pride in the lover's eye,
I am the epic of the sea.

1916

Serbia

Beside the lake of Doiran
I watched the night fade, star by star,
And sudden glories of the dawn
Shine on the muddy ranks of war.

All night my dreams of that fair band
Were full of Ireland's old regret,
And when the morning filled the sky
I wondered could we save her yet.

Far up the cloudy hills, the roads
Wound wearily into the morn.
I only saw with inner eye
A poor old woman all forlorn.

1916

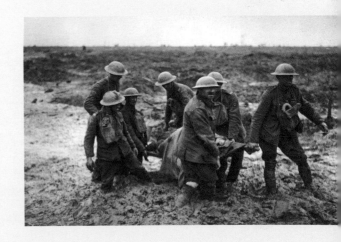

In a Café

Kiss the maid and pass her round,
Lips like hers were made for many.
Our loves are far from us to-night,
But these red lips are sweet as any.

Let no empty glass be seen
Aloof from our good table's sparkle,
At the acme of our cheer
Here are francs to keep the circle.

They are far who miss us most –
Sip and kiss – how well we love them,
Battling through the world to keep
Their hearts at peace, their God above them.

1916

At Evening

A broad field at a wood's high end,
Daylight out and the stars half lit,
And let the dark-winged bat go flit
About the river's wide blue bend.
But thoughts of someone once a friend
Shall be calling loud thro' the hills of Time.

Wide is the back-door of the Past
And I shall be leaving the slated town.
But no, the rain will be slanting brown
And large drops chasing the small ones fast
Down the wide pane, for a cloud was cast
On youth when he started the world to climb.

There won't be song, for song has died.
There won't be flowers for the flowers are done.
I shall see the red of a large cold sun
Wash down on the slow blue tide,
Where the noiseless deep fish glide
In the dark wet shade of the heavy lime.

1916

In France

The silence of maternal hills
Is round me in my evening dreams,
And round me music-making bills
And mingling waves of pastoral streams.

Whatever way I turn I find
The path is old unto me still.
The hills of home are in my mind,
And there I wander as I will.

1916

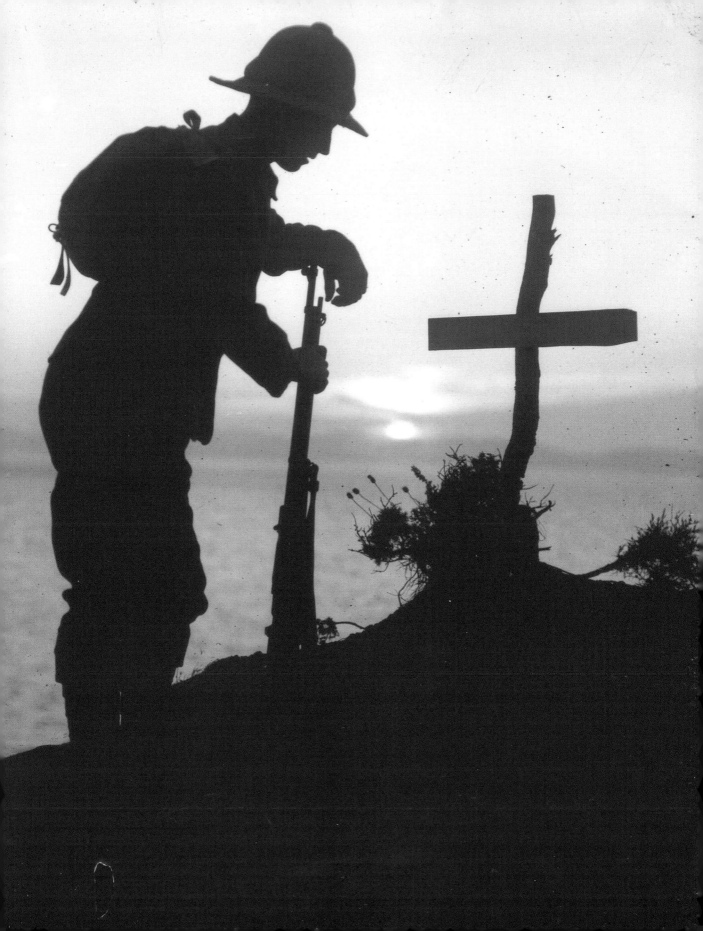

After Court Martial

My mind is not my mind, therefore
I take no heed of what men say,
I lived ten thousands years before
God cursed the town of Nineveh.

The Present is a dream I see
Of horror and loud sufferings,
At dawn a bird will waken me
Unto my place among the kings.

And though men called me a vile name,
And all my dream companions gone,
'Tis I the soldier bears the shame,
Not I the king of Babylon.

1916

The Irish in Gallipoli

Where Aegean cliffs with bristling menace front
The threatening splendour of that isley sea
Lighted by Troy's last shadow, where the first
Hero kept watch and the last Mystery
Shook with dark thunder, hark the battle brunt!
A nation speaks, old Silences are burst.

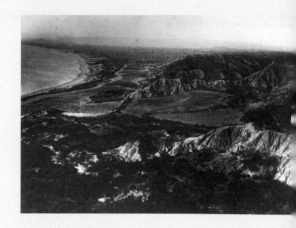

Neither for lust of glory nor new throne
This thunder and this lightning of our wrath
Waken these frantic echoes, not for these
Our Cross with England's mingle, to be blown
On Mammon's threshold; we but war when war
Serves Liberty and Justice, Love and Peace.

Who said that such an emprise could be vain?
Were they not one with Christ Who strove and died?
Let Ireland weep but not for sorrow. Weep
That by her sons a land is sanctified
For Christ Arisen, and angels once again
Come back like exile birds to guard their sleep.

1917

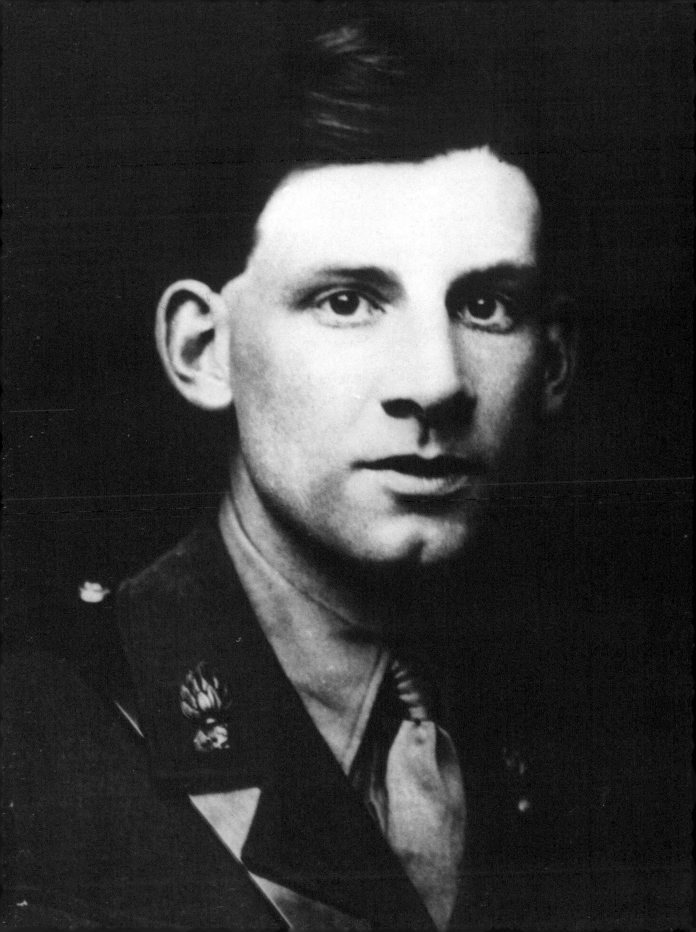

Siegfried Loraine Sassoon

Siegfried Sassoon was born on 8 September 1886. Descended from those 'jewelled merchant ancestors', the banker Sassoons, he was brought up by his mother; his father having left his wife when their son was five. The dominant presences of his childhood and youth were female: his nanny, his grandmother, the elegant socialite Mrs Sassoon, and a regiment of devoted domestics. In his *Memoirs of a Fox-Hunting Man*, he would depict himself as a lonely child, adding: 'as a consequence of my loneliness, I created in my childish day-dreams an ideal companion.' His life can be seen as a quest for that ideal companion. When he was old enough to go to Marlborough, he shuttled between all-male and all-female worlds, and grew up with the constricted emotions of his class. Discovering at Cambridge that he was homosexual, he lived briefly with one 'ideal companion', David Thomas (whose death on the Western Front in March 1916 would prompt such poems as 'The Last Meeting' and 'A Letter Home'), but university did not appeal to him and he left without taking a degree.

There being no pressure on him to choose a career or to earn a living, Sassoon spent his days in the saddle or on the golf-links and his evenings at the ballet, the opera, or his London club. From 1906, when he published his first, privately printed *Poems*, he began to move in literary circles and by August 1914 was acquainted with writers like Edmund Gosse and Edward Marsh, Rupert Brooke and W. H. Davies. As if acknowledging some subconscious need for more demanding employment, he had himself medically examined for the Army on 1 August 1914 and was wearing his ill-fitting khaki on the first morning of the Great War. He fought with the Royal Welch Fusiliers at Mametz Wood and in the Somme Offensive of July 1916 with such conspicuous courage that he acquired the Military Cross and a nickname, Mad Jack.

His first 'war poem', written in mid-1915, was called 'Absolution':

> The anguish of the earth absolves our eyes
> Till beauty shines in all that we can see.
> War is our scourge, yet war has made us wise,
> And, fighting for our freedom, we are free.
>
> Horror of wounds and anger at the foe,
> And loss of things desired; all these must pass.
> We are the happy legion, for we know
> Time's but a golden wind that shakes the grass.
>
> There was an hour when we were loth to part
> From life we longed to share no less than others.
> Now, having claimed this heritage of heart,
> What need we more, my comrades and my brothers?

Its title suggests a religious theme, but far from having anything to do with the forgiveness of sins, Sassoon's 'Absolution' involves the freeing of the eyes – 'Beauty shines in all that we can see'. In confusing contradiction, the speaker acknowledges

> Horror of wounds and anger at the foe,
> And loss of things desired

(hardly a prophetic reckoning of the cost of the years 1914–18) but, he consoles himself, 'all these must pass'. In the meantime, 'We are happy legion' – another echo of the public-school classroom – and 'What need we more, my comrades and my brothers?' When his own brother, Hamo, was killed at Gallipoli, his elegy 'To My Brother' ended with a similarly optimistic – and, it must be said, confused – blending of pagan classical and Christian:

> Your lot is with the ghosts of soldiers dead,
> And I am in the field where men must fight.
> But in the gloom I see your laurell'd head
> And through your victory I shall win the light.

The title of Sassoon's first poem to be written from experience of the trenches, 'The Redeemer', again seems to promise a Christian theme, an expectation fulfilled this time by the second stanza:

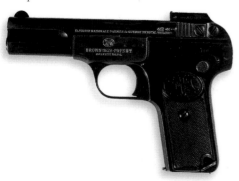

Sassoon's automatic pistol

> I turned in the black ditch, loathing the storm;
> A rocket fizzed and burned with blanching flare,
> And lit the face of what had been a form
> Floundering in mirk. He stood before me there;
> I say that He was Christ; stiff in the glare;
> And leaning forward from His burdening task,
> Both arms supporting it; His eyes on mine
> Stared from the woeful head that seemed a mask
> Of mortal pain in Hell's unholy shine.
>
> No thorny crown, only a woollen cap
> He wore – an English soldier, white and strong,
> Who loved his time like any simple chap,
> Good days of work and sport and homely song;
> Now he has learned that nights are very long,
> And dawn a watching of the windowed sky.
> But to the end, unjudging, he'll endure
> Horror and pain, not uncontent to die
> That Lancaster on Lune may stand secure.

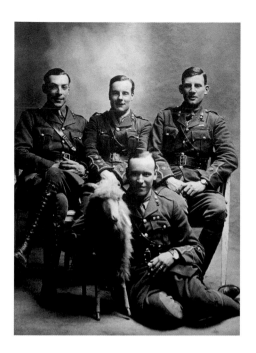

This 'Redeemer' is a powerful image, but the longer we look at it, the less convincing it becomes. Like countless other represent-ations of the infantryman as Christ laying down his life for his friends — a representation that appeared at the time not only in poems but in sermons and newspaper articles — the similarity dissolves as we remember that infantrymen carry more than planks (suggestive of a cross), and that Christ endorsed the commandment 'Thou shalt not kill.' We sense some suppressed recognition of this when, in the last stanza, Sassoon's speaker repeats his assertion: 'I say that He was Christ.' He seems to protest too much:

Sassoon (seated right), brother officers and their regimental mascot

He faced me, reeling in his weariness,
Shouldering his load of planks, so hard to bear.
I say that He was Christ, who wrought to bless
All groping things with freedom bright as air,
And with His mercy washed and made them fair.
Then the flame sank, and all grew black as pitch,
While we began to struggle along the ditch;
And someone flung his burden in the muck,
Mumbling: 'O Christ Almighty, now I'm stuck!'

For all its bad theology, the poem does have a certain dramatic force — much of it derived from the explosive colloquialism of the last line. This use of direct speech, learnt from Sassoon's reading of his admired Thomas Hardy in 1914, brings us literally down to earth, whereas the ending of 'Absolution' had left us uncomfortably in the air.

Both the character and the perception of the war changed with the opening of the Battle of the Somme on 1 July 1916. That morning, thirteen divisions of British and French infantry went 'over the top' into No Man's Land, expecting to occupy German trenches pulverized by a massive artillery bombardment. The Allied staff officers, however, had not allowed for the depth of those dugouts, from which German machine-gunners emerged to mow down wave after wave of attackers. By early afternoon, the survivors were back in the trenches from which they had clambered that morning, and the British Army had suffered the heaviest loss sustained by any army on any day in the First World War: 19,000 men killed and 38,000 wounded.

Sassoon was one of the survivors, and it is instructive to compare 'The Redeemer', written *before* 1 July 1916, with a poem written shortly *after*. 'Christ and the Soldier' begins:

The straggled soldier halted – stared at Him –
Then clumsily dumped down upon his knees,
Gasping, 'O blessed crucifix, I'm beat!'
And Christ, still sentried by the seraphim,
Near the front-line, between two splintered trees,
Spoke him: 'My son, behold these hands and feet.'

The soldier eyed Him upward, limb by limb,
Paused at the Face; then muttered, 'Wounds like these
Would shift a bloke to Blighty just a treat!'
Christ, gazing downward, grieving and ungrim,
Whispered, 'I made for you the mysteries,
Beyond all battles moves the Paraclete.'

*Page from
Sassoon's
wartime diary*

This is incomparably more dramatic. The figure on the Crucifix is seen through the eyes of the astonished soldier, '*sentried* by the seraphim', and the immeasurable distance between the two speakers is brilliantly – satirically – captured by their two dictions:

> 'Wounds like these
> Would shift a bloke to Blighty just a treat!'
> Christ, gazing downward, grieving and ungrim,
> Whispered, 'I made for you the mysteries,
> Beyond all battles moves the Paraclete.'

Background
image:
*British artillery
bombarding
trenches at
Beaumont
Hamel, July
1916*

Christ should have known that the soldier could not distinguish a Paraclete (advocate) from a parachute.

In the second part of the poem, when the infantryman says; 'O Christ Almighty, stop this bleeding fight!'

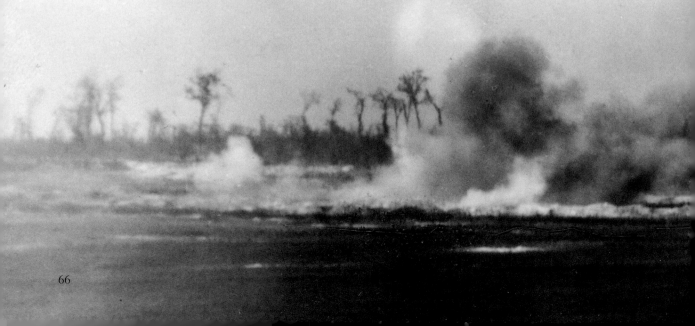

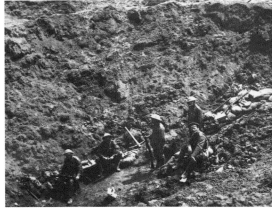

Christ asked all pitying, 'Can you put no trust
In my known word that shrives each faithful head?
Am I not resurrection, life and light?'

In part three, at the third time of asking, the soldier says:

'But be you for both sides? I'm paid to kill
And if I shoot a man his mother grieves.
Does that come into what your teaching tells?'

Not surprisingly, the figure on the Cross is silent and the
soldier has the last word:

'Lord Jesus, ain't you got no more to say?'
Bowed hung that head below the crown of thorns.
The soldier shifted, and picked up his pack,
And slung his gun, and stumbled on his way.
'O God,' he groaned, 'why ever was I born?'...
The battle boomed, and no reply came back.

*British troops
resting in a
captured mine
crater, June
1916*

 The indignation that, like an electrical current, generates the spark between the
positive and negative poles of this poem provides the power behind most of Sassoon's
better poetry of the war years. Almost all are built around a central dichotomy, and
frequently this involves the juxtaposition of innocent Young and guilty Old: the boys
and the Bishop in the scathingly anti-clerical 'They'; the boys and the General in the
anti-high Command 'The General'; the corpses and the chorus girls in the anti-Home
Front 'Blighters'; or this variant of the same polarization of men and women:

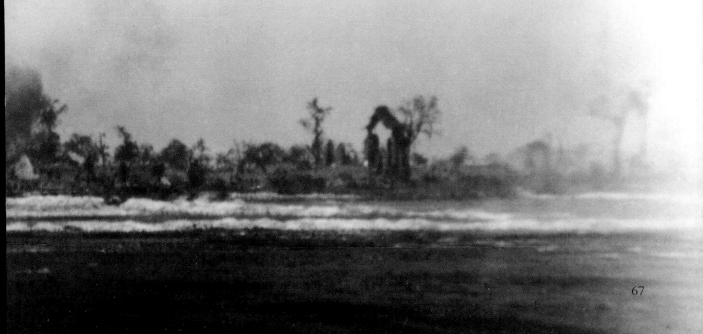

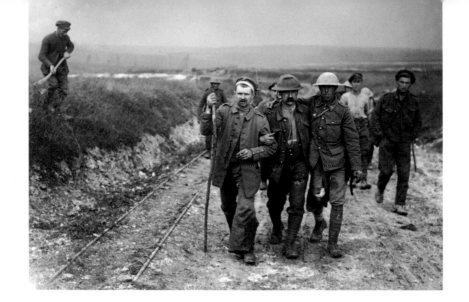

British and German wounded help each other to the dressing station

Glory of Women

You love us when we're heroes, home on leave,
Or wounded in a mentionable place.
You worship decorations; you believe
That chivalry redeems the war's disgrace.
You make us shells. You listen with delight,
By tales of dirt and danger fondly thrilled.
You crown our distant ardours while we fight,
And mourn our laurelled memories when we're killed.
You can't believe that British troops 'retire'
When hell's last horror breaks them, and they run,
Trampling the terrible corpses – blind with blood.
　　O German mother dreaming by the fire,
While you are knitting socks to send your son
His face is trodden deeper in the mud.

Like many of Sassoon's later war poems, this is launched at the reader like a hand-grenade. The sudden switch from British women to German mother detonates the brutal irony of the last sentence, whereby the one mother is knitting socks for a son already trodden into the mud by the feet of those presumably wearing socks knitted by the other mothers. The German mother is presented ambiguously: we sense that the speaker both pities her and blames her for the reasons that he blames the British women. He blames them for believing 'That chivalry redeems the war's disgrace.' Who invented chivalry, however, celebrated it, and taught women to celebrate it, but men. Sassoon may present the German mother ambiguously, but no such ambiguity attends his depiction of the German mother's son. In 'Christ and the Soldier' the soldier had asked the Son of God: 'be you for both sides?' He received no answer, but Sassoon leaves us in no doubt that he is for both sides; his tender concern is for the young victims of the old men on both sides.

Sassoon became a victim himself at the beginning of April 1917. Invalided back to England, he arrived with a sniper's bullet in his chest and a view of the war very different from that with which he left in 1914. On the lawns of Garsington Manor he met and mingled with Lady Ottoline Morrell's pacifist intellectual friends such as Bertrand Russell and Henry Massingham, editor of *The Nation*. Influenced by them, and with courage equal to any he had shown in action, he made public a statement sent to his commanding officer:

I am making this statement as an act of wilful defiance of military authority, because I believe that the war is being deliberately prolonged by those who have the power to end it.

I am a soldier, convinced that I am acting on behalf of soldiers. I believe that this war, upon which I entered as a war of defence and liberation, has now become a war of aggression and conquest. I believe that the purposes for which I and my fellow-soldiers entered upon this war should have been so clearly stated as to have made it impossible to change them, and that, had this been done, the objects which actuated us would now be attainable by negotiation.

I have seen and endured the sufferings of the troops, and I can no longer be a party to prolong these sufferings for ends which I believe to be evil and unjust.

I am not protesting against the conduct of the war, but against the political errors and insincerities for which the fighting men are being sacrificed.

On behalf of those who are suffering now I make this protest against the deception which is being practised on them; also I believe that I may help to destroy the callous complacence with which the majority of those at home regard the continuance of agonies which they do not share, and which they have not sufficient imagination to realise.

Although, to a certain extent, this 'act of wilful defiance' was successful, in that it formed the subject of a question asked in the House of Commons and received an airing – a hot airing – in the press, Sassoon's protest was eventually smothered. His friend Robert Graves (see p. 83 et seq.) made urgent representations to the military authorities, as well as to certain influential civilians, that Sassoon 'should not be allowed to become a martyr to a hopeless cause in his present physical condition.' The War Office was only too glad of an opportunity to hush matters up. A Medical Board was hastily convened and rigged: Captain Graves testified that his friend – who by now had thrown the ribbon of his Military Cross into the Mersey – suffered from hallucinations of a corpse-strewn Piccadilly and other such symptoms of shell-shock. Graves burst into tears three times while giving his statement. The Board duly found 2nd Lieutenant Sassoon in need of medical attention, and he was dispatched to Craiglockhart War Hospital outside Edinburgh. He arrived there, he says,

Official letter from military authority to the editor of The Nation *about Sassoon's poems*

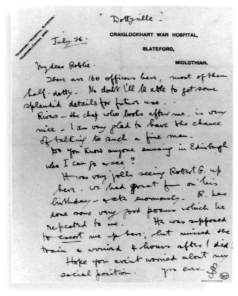

Letter from Sassoon to Robbie Ross, July 1917

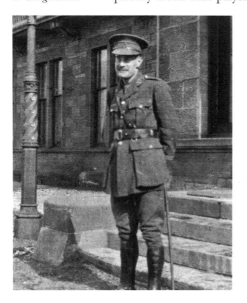

W. H. R. Rivers at Craiglockhart

still inclined to regard myself in the role of a 'ripe man of martyrdom.' But the unhistoric part of my mind remembered that the neurologist member of my medical board had mentioned someone called Rivers. 'Rivers will look after you when you get there.' . . . Rivers was evidently some sort of great man: anyhow his name had obvious free associations with pleasant landscapes and unruffled estuaries.

W. H. R. Rivers, a distinguished neurologist, becomes, over the five months of his patient's stay at the hospital, the most important of his 'ideal companions', a substitute for the father he never knew. Another important companion was Wilfred Owen (see p. 96 et seq.), a genuine shell-shock case who, with his strong religious background and beliefs, may have taken the would-be martyr further along the road to the Celestial City (to which Sassoon points the reader of his autobiographical *Sherston's Progress*, a title inviting comparison with Bunyan's *Pilgrim's Progress*). In the end, Sherston/Sassoon came to believe that a different form of martyrdom was required of him. He must return to his men and, if necessary, give his life for them.

Leaving Craiglockhart in early 1918, he decided that he could make his protest as a poet more effectively from the battlefield and, after a brief tour of duty in Palestine, rejoined his battalion in France. In June, his book *Counter-Attack and Other Poems*, made its appearance and its protest, but in July, returning from a dawn patrol, he was mistaken for a German and shot by one of his own men. He recovered quickly from that physical injury, but the psychological damage inflicted by the war years took much longer to heal. By 1926, however, he was able to begin work on the obsessive autobiographical enterprise which was to occupy him for the rest of his life. The first three volumes (later collected under the title, *The Memoirs of George Sherston*) were *Memoirs of a Fox-Hunting Man* (1928), *Memoirs of an Infantry Officer* (1930), and *Sherston's Progress* (1936). This trilogy was followed by two volumes covering his early life: *The Old Century and Seven More Years* (1938) and *The Weald of Youth* (1942). A final volume, *Siegfried's Journey* (1945), dealt with his literary activity during the Great War and after – a subject almost totally omitted from the Sherston trilogy. Other subjects he omitted emerged with the publication of three volumes of his diaries: a long period of tormented homosexuality, a marriage, the birth of a son, and the breakdown of his marriage.

Sassoon continued to write poetry, but his style altered after the 1914–18 War. At times, as in his *Satirical Poems* (1926) attacking society, his work still displayed a cutting edge, but never again did he achieve the pungency of the 'war poems' that made him famous. In 1957 he was received into the Roman Catholic Church, making what the old soldier called his 'unconditional surrender' to God. Always a spiritual man – even when in his thirties he had attacked the Church for what he saw as its cant and hypocrisy – he found at last a certainty and happiness he had not known before. If the devotional poems of his last years lack the vitality and power of those written during and after the Great War, that is because he was by nature a poet of polarity and protest rather than of union and acceptance. Taken together, nonetheless, his poems early and late can be seen to justify the label he attached to himself, writing to the nun who had guided him into the Roman Catholic Church – 'I am a religious poet.'

Sassoon's manuscript title-page for his Memoirs of an Infantry Officer

Sassoon in old age

71

The Redeemer

Darkness: the rain sluiced down; the mire was deep;
It was past twelve on a mid-winter night,
When peaceful folk in beds lay snug asleep;
There, with much work to do before the light,
We lugged our clay-sucked boots as best we might
Along the trench; sometimes a bullet sang,
And droning shells burst with a hollow bang;
We were soaked, chilled and wretched, every one;
Darkness; the distant wink of a huge gun.

I turned in the black ditch, loathing the storm;
A rocket fizzed and burned with blanching flare,
And lit the face of what had been a form
Floundering in mirk. He stood before me there;
I say that He was Christ; stiff in the glare;
And leaning forward from His burdening task,
Both arms supporting it; His eyes on mine
Stared from the woeful head that seemed a mask
Of mortal pain in Hell's unholy shine.

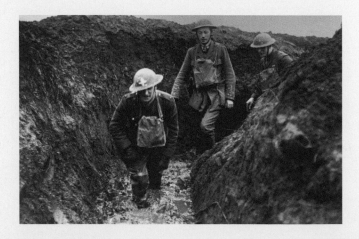

No thorny crown, only a woollen cap
He wore—an English soldier, white and strong,
Who loved his time like any simple chap,
Good days of work and sport and homely song;
Now he has learned that nights are very long,
And dawn a watching of the windowed sky.
But to the end, unjudging, he'll endure
Horror and pain, not uncontent to die
That Lancaster on Lune may stand secure.

He faced me, reeling in his weariness,
Shouldering his load of planks, so hard to bear.
I say that He was Christ, who wrought to bless
All groping things with freedom bright as air,
And with His mercy washed and made them fair.
Then the flame sank, and all grew black as pitch,
While we began to struggle along the ditch;
And someone flung his burden in the muck,
Mumbling: "O Christ Almighty, now I'm stuck!"

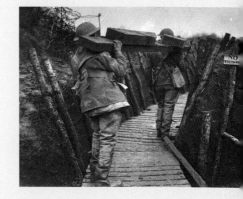

1915–16

Stand–to: Good Friday Morning

I'd been on duty from two till four.
I went and stared at the dug-out door.
Down in the frowst I heard them snore.
"Stand to!" Somebody grunted and swore.
 Dawn was misty; the skies were still;
 Larks were singing, discordant, shrill;
 They seemed happy; but *I* felt ill.
Deep in water I splashed my way
Up the trench to our bogged front line.
Rain had fallen the whole damned night.
O Jesus, send me a wound to-day,
And I'll believe in Your bread and wine,
And get my bloody old sins washed white!

1916

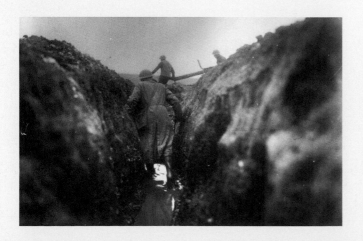

The Hero

"Jack fell as he'd have wished," the Mother said,
And folded up the letter that she'd read.
"The Colonel writes so nicely." Something broke
In the tired voice that quavered to a choke.
She half looked up. "We mothers are so proud
Of our dead soldiers." Then her face was bowed.

Quietly the Brother Officer went out.
He'd told the poor old dear some gallant lies
That she would nourish all her days, no doubt.
For while he coughed and mumbled, her weak eyes
Had shone with gentle triumph, brimmed with joy,
Because he'd been so brave, her glorious boy.

He thought how "Jack", cold-footed, useless swine,
Had panicked down the trench that night the mine
Went up at Wicked Corner; how he'd tried
To get sent home, and how, at last, he died,
Blown to small bits. And no one seemed to care
Except that lonely woman with white hair.

1916

"They"

The Bishop tells us: "When the boys come back
They will not be the same; for they'll have fought
In a just cause: they lead the last attack
On Anti-Christ; their comrades' blood has bought
New right to breed an honourable race.
They have challenged Death and dared him face to face."

"We're none of us the same!" the boys reply.
"For George lost both his legs; and Bill's stone blind;
Poor Jim's shot through the lungs and like to die;
And Bert's gone syphilitic: you'll not find
A chap who's served that hasn't found some change."
And the Bishop said: "The ways of God are strange!"

1916

Base Details

If I were fierce, and bald, and short of breath,
 I'd live with scarlet Majors at the Base,
And speed glum heroes up the line to death.
 You'd see me with my puffy petulant face,
Guzzling and gulping in the best hotel,
 Reading the Roll of Honour. "Poor young chap,"
I'd say – "I used to know his father well;
 Yes, we've lost heavily in this last scrap."
And when the war is done and youth stone dead,
 I'd toddle safely home and die – in bed.

1917

The General

"Good-morning, good-morning!" the General said
When we met him last week on our way to the line.
Now the soldiers he smiled at are most of 'em dead,
And we're cursing his staff for incompetent swine.
"He's a cheery old card," grunted Harry to Jack
As they slogged up to Arras with rifle and pack.

But he did for them both by his plan of attack.

1917

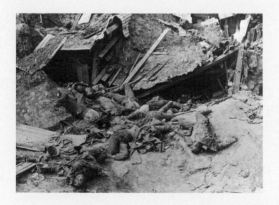

THE GENERAL.

'Good-morning; good-morning!' the General said
When we met him last week on our way to the Line.
Now the soldiers he smiled at are most of 'em dead,
And we're cursing his staff for incompetent swine.
 'He's a cheery old card', grunted Harry to Jack
 As they slogged up to Arras with rifle and pack.

 * * *

But he did for them both by his plan of attack.

1917.

Everyone Sang

Everyone suddenly burst out singing;
And I was filled with such delight
As prisoned birds must find in freedom,
Winging wildly across the white
Orchards and dark-green fields; on - on - and out
 of sight.

Everyone's voice was suddenly lifted;
And beauty came like the setting sun:
My heart was shaken with tears; and horror
Drifted away ... O, but Everyone
Was a bird; and the song was wordless; the singing will
 never be done.

1919

On Passing the New Menin Gate

Who will remember, passing through this Gate,
The unheroic dead who fed the guns ?
Who shall absolve the foulness of their fate, -
Those doomed, conscripted, unvictorious ones ?
 Crudely renewed, the Salient holds its own.
 Paid are its dim defenders by this pomp;
 Paid, with a pile of peace-complacent stone,
 The armies who endured that sullen swamp.

Here was the world's worst wound. And here with pride
'Their name liveth for ever', the Gateway claims.
Was ever an immolation so belied
As these intolerably nameless names ?
Well might the Dead who struggled in the slime
Rise and deride this sepulchre of crime.

1927–8

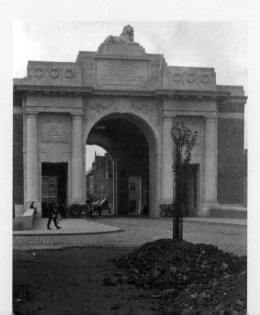

Robert von Ranke Graves

Robert von Ranke Graves was born in London on 24 July 1895, the eldest son and third of the five children of Alfred Perceval Graves, an inspector of schools, and his second wife, 'Amy', daughter of Heinrich von Ranke, a doctor. The family tree had Anglo-Irish, Danish, English, German, and Scottish roots, and had already borne literary fruit. The boy's maternal great-uncle was the distinguished German historian, Leopold von Ranke, and an eighteenth-century ancestor, Richard Graves, had written *The Spiritual Quixote*, a novel famous in its day.

Robert Graves was educated at various preparatory schools and Charterhouse, to which he went on a scholarship in 1907. He held his own there, in a community that valued athletic above intellectual prowess, by learning to box and winning both welter-weight and middle-weight cups (with, it must be said, a bottle of cherry brandy to inspire him) in the school competition. An independent-minded young man with a combative streak (that would prove useful in a turbulent career), he left Charterhouse in 1914 with a Classical scholarship to St John's College, Oxford. Having by then spent fourteen of his nineteen years studying Latin and Greek, he found depressing the thought of spending another three years doing the same, but was spared that fate by the outbreak of war.

Graves was staying at that time in his family's holiday-house in north Wales and, a week later, reported to the nearest depot that could accept him for training as an officer. Commissioned into the Royal Welch Fusiliers, he was posted to France in May 1915 and late that autumn was surprised to see, lying on a messroom table, *The Essays of Lionel Johnson* (a poet of the 1890s). He looked surreptitiously at the flyleaf and saw written there the name of Siegfried Sassoon (see p. 62 et seq.), whom he shortly discovered to be, like himself, a captain in the Royal Welch Fusiliers. So began a friendship that Graves would later celebrate in his poem, 'Two Fusiliers':

> By wire and wood and stake we're bound,
> By Fricourt and by Festubert,
> By whipping rain, by the sun's glare,
> By all the misery and loud sound,
> By a Spring day,
> By Picard clay.
>
> Show me the two so closely bound
> As we, by the wet bond of blood,
> By friendship blossoming from mud,
> By Death: we faced him, and we found
> Beauty in Death,
> In dead men, breath.

The last line may allude to the most traumatic and formative experience of Graves's years in the army.

Almost three weeks after the opening of the Battle of the Somme (see p. 65), the Royal Welch (now reduced to some 400 fighting men) were entrenched in the churchyard of the village of Bazentin, waiting to support the Scottish regiments then attacking the notorious High Wood, when the Germans began to shell their position. The barrage was so heavy that the Royal Welch were ordered to move back fifty yards 'in a rush'. As Graves began to run, there was a jarring explosion behind him.

Letter from Graves to his friend Hartmann, October 1914

One piece of shell went through my left thigh, high up, near the groin; I must have been at the full stretch of my stride to escape emasculation. The wound over the eye was made by a little chip of marble, possibly from one of the Bazentin cemetery head-stones. (Later, I had it cut out, but a smaller piece has since risen to the surface under my right eyebrow, where I keep it for a souvenir.) This, and a finger-wound which split the bone, probably came from another shell bursting in front of me. But a piece of shell had also gone in two inches below the point of my right shoulder-blade and came out through my chest two inches above the right nipple.

British reserves digging in, Mametz Wood, July 1916

He was stretchered to a dressing-station where, late that night, his Colonel came to see the wounded and was told that Graves was dead. His parents were informed and an obituary appeared in *The Times*, which was subsequently obliged to publish a correction: 'Officer previously reported died of wounds, now reported wounded. Graves, Captain R., Royal Welch Fusiliers.' The revenant used this as an epigraph to a poem written on 6 August, 'Escape', which begins:

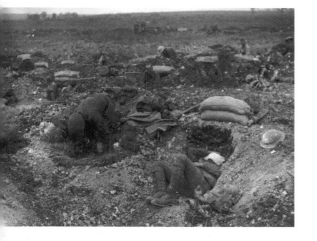

. . . But I was dead, an hour or more.
I woke when I'd already passed the door
That Cerberus guards, half-way along the road
To Lethe, as an old Greek signpost showed.

Like many another public-schoolboy, Graves had lost the Christian faith of his parents at school, and this poem shows the mythology of his classical education entering his imagination to fill the void. He saw himself descending to the underworld in the footsteps of Orpheus (pagan saint of poets), Homer, Virgil,

Dante, and returning privileged with vision. Certainly, the vision of the 'war poems' in his second book *Goliath and David* (late 1916) is more sharply focused than that of his first, *Over the Brazier* (May 1916), but rather too many are written under the influence of Sassoon. The title-poem of *Goliath and David*, for example, attempts to shock its readers with a reversal of their biblically informed expectations such as is achieved by Sassoon's 'Christ and the Soldier' (see p.66) or Owen's revision of the story of Abraham and Isaac, 'The Parable of the Old Man and the Young.' Unlike these two poems, Graves's 'Goliath and David' fails to shock. It signals its reversal in the transposed names of its title and in the lame couplet ending the first stanza:

> But . . . the historian of that fight
> Had not the heart to tell it right.

When he comes 'to tell it right' himself, his account has none of the economy, linguistic density, and syntactic variety he would achieve in his later poems:

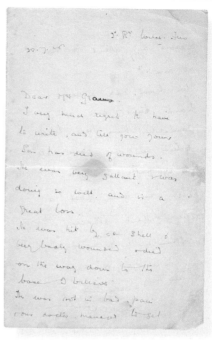

Letter to Graves's mother telling her of his death

> Scorn blazes in the Giant's eye,
> Towering unhurt six cubits high.
> Says foolish David, 'Curse your shield!
> And curse my sling! but I'll not yield.'
> He takes his staff of Mamre oak,
> A knotted shepherd-staff that's broke
> The skull of many a wolf and fox
> Come filching lambs from Jesse's flocks.
> Loud laughs Goliath, and that laugh
> Can scatter chariots like blown chaff
> To rout; but David, calm and brave,
> Holds his ground, for God will save.
> Steel crosses wood, a flash, and oh!
> Shame for beauty's overthrow!
> (God's eyes are dim, His ears are shut),
> One cruel backhand sabre-cut –
> 'I'm hit! I'm killed!' young David cries,
> Throws blindly forward, chokes …and dies.
> Steel-helmeted and grey and grim
> Goliath straddles over him.

Background image: *Mametz Wood, August 1916*

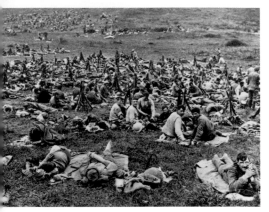

Royal Welch Fusiliers relieved from the trenches, Somme, July 1916

'Goliath and David' also lacks the anger and bitterness that propel the poems of Owen and Sassoon. This is surprising, since the David of Graves's poem was a close friend, as his epigraph indicates: '(*For Lieut. David Thomas, 1st Batt. Royal Welch Fusiliers, killed at Fricourt, March 1916*).' We know from other sources that he – like Sassoon (p. 63) – was greatly distressed by Thomas's death, but why this and his other early war poems show so little evidence of indignation is difficult to explain. Happy childhood holidays with relatives in Germany had left him with affection rather than hatred for their country, and his confused feelings about 'the enemy' were compounded by a certain emotional immaturity it would take him some years to overcome. Neither 'the enemy' nor his own emotions appear in perhaps the most successful of his wartime poems, 'Sergeant-Major Money' (1917):

It wasn't our battalion, but we lay alongside it,
 So the story is as true as the telling is frank.
They hadn't one Line-officer left, after Arras,
 Except a batty major and the Colonel, who drank.

'B' Company Commander was fresh from the Depôt,
 An expert on gas drill, otherwise a dud;
So Sergeant-Major Money carried on, as instructed,
 And that's where the swaddies began to sweat blood.

His Old Army humour was so well-spiced and hearty
 That one poor sod shot himself, and one lost his wits;
But discipline's maintained, and back in rest-billets
 The Colonel congratulates 'B' company on their kits.

The subalterns went easy, as was only natural
 With a terror like Money driving the machine,
Till finally two Welshmen, butties from the Rhondda,
 Bayoneted their bugbear in a field-canteen.

Well, we couldn't blame the officers, they relied on Money;
 We couldn't blame the pitboys, their courage was grand;
Or, least of all, blame Money, an old stiff surviving
 In a New (bloody) Army he couldn't understand.

The confident swing of this, the relaxed use of slang, and the surprise ending show the continuing influence of Sassoon but, at the same time, anticipate the cool,

classical voice of the mature Graves heard in his poem of the Second World War, 'The Persian Version':

> Truth-loving Persians do not dwell upon
> The trivial skirmish fought near Marathon.
> As for the Greek theatrical tradition
> Which represents that summer's expedition
> Not as a mere reconnaissance in force
> By three brigades of foot and one of horse
> (Their left flank covered by some obsolete
> Light craft detached from the main Persian fleet)
> But as a grandiose, ill-starred attempt
> To conquer Greece – they treat it with contempt;
> And only incidentally refute
> Major Greek claims, by stressing what repute
> The Persian monarch and the Persian nation
> Won by this salutary demonstration:
> Despite a strong defence and adverse weather
> All arms combined magnificently together.

Graves's 1917 application for a wound gratuity

By the time that poem was written in the 1940s, Graves had become a great survivor – of a Great War and its neurasthenic aftermath, an unhappy marriage, an accusation of attempted murder, divorce and emotional trauma that would have prostrated a less resilient man. Much of this he recounted in his autobiographical *Goodbye to All That* (1929), which would prove probably his most notable – certainly his most memorable – contribution to the literature of the First World War.

Leaving England in the year it was published, Graves spent most of the half century that remained to him in Majorca with his second wife and family. In the preface to his *Poems 1938–45* (1948), he announced: 'I write poems for poets, and satires or grotesques for wits. For people in general I write prose, and am content that they should be unaware that I do anything else.' 'People in general' did indeed know him mainly as a writer of historical novels, notably *I, Claudius* (1934), *Claudius the Great* (1934), *Count Belisarius* (1938), *Sergeant Lamb of the Ninth* (1940), *King Jesus* (1946), and *Homer's Daughter* (1955). He was a good classical and biblical scholar, if an eccentric one, and his interest in classical and biblical myth was closely related to his theory of poetry and poetic inspiration. This he expounded in *The White Goddess* (1948), a wide-ranging study of mythology that stands in something of the same relation to his poetry as *A Vision* does to Yeats's. They had other things in common: both were great love poets and, as literary critics, took pleasure in challenging academic orthodoxy.

In December 1985, Graves descended to the underworld from which he had escaped almost seventy years before.

The Dead Fox Hunter

*(In memory of Captain A L Samson, 2nd Battalion Royal
Welch Fusiliers, killed near Cuinchy, Sept 15th 1915)*

We found the little captain at the head;
 His men lay well aligned.
We touched his hand – stone cold – and he was dead,
 And they, all dead behind,
Had never reached their goal, but they died well;
They charged in line, and in the same line fell.

The well-known rosy colours of his face
 Were almost lost in grey.
We saw that, dying and in hopeless case,
 For others' sake that day
He'd smothered all rebellious groans: in death
His fingers were tight clenched between his teeth.

For those who live uprightly and die true
 Heaven has no bars or locks,
And serves all taste . . . or what's for him to do
 Up there, but hunt the fox?
Angelic choirs? No, Justice must provide
For one who rode straight and in hunting died.

So if Heaven had no Hunt before he came,
 Why, it must find one now:
If any shirk and doubt they know the game,
 There's one to teach them how:
And the whole host of Seraphim complete
Must jog in scarlet to his opening Meet.

1916

A Dead Boche

To you who'd read my songs of War
And only hear of blood and fame,
I'll say (you've heard it said before)
'War's Hell!' and if you doubt the same,
To-day I found in Mametz Wood
A certain cure for lust of blood:

Where, propped against a shattered trunk,
In a great mess of things unclean,
Sat a dead Boche; he scowled and stunk
With clothes and face a sodden green,
Big-bellied, spectacled, crop-haired,
Dribbling black blood from nose and beard.

1916

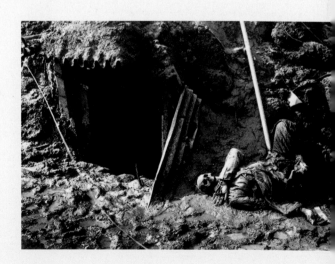

Goliath and David

*(For Lieut. David Thomas, 1st Batt. Royal Welch
Fusiliers, killed at Fricourt, March 1916)*

'If I am Jesse's son,' said he,
'Where must that tall Goliath be?'
For once an earlier David took
Smooth pebbles from the brook:
Out between the lines he went
To that one-sided tournament,
A shepherd boy who stood out fine
And young to fight a Philistine
Clad all in brazen mail. He swears
That he's killed lions, he's killed bears,
And those that scorn the God of Zion
Shall perish so like bear or lion.
But . . . the historian of that fight
Had not the heart to tell it right.

Striding within javelin range,
Goliath marvels at this strange
Goodly-faced boy so proud of strength.
David's clear eye measures the length;
With hand thrust back, he cramps one knee,
Poises a moment thoughtfully,
And hurls with a long vengeful swing.
The pebble, humming from the sling
Like a wild bee, flies a sure line
For the forehead of the Philistine;
Then . . . but there comes a brazen clink,
And quicker than a man can think
Goliath's shield parries each cast,

Clang! clang! And clang! was David's last.
Scorn blazes in the Giant's eye,
Towering unhurt six cubits high.
Says foolish David, 'Curse your shield!
And curse my sling! But I'll not yield.'
He takes his staff of Mamre oak,
A knotted shepherd-staff that's broke
The skull of many a wolf and fox
Come filching lambs from Jesse's flocks.
Loud laughs Goliath, and that laugh
Can scatter chariots like blown chaff
To rout; but David, calm and brave,
Holds his ground, for God will save.
Steel crosses wood, a flash, and oh!
Shame for beauty's overthrow!
(God's eyes are dim, His ears are shut),
One cruel backhand sabre-cut –
'I'm hit! I'm killed!' young David cries,
Throws blindly forward, chokes . . . and dies.
Steel-helmeted and grey and grim
Goliath straddles over him.

1916

2

Goliath & David.

(For D.C.T. Killed at Fricourt. March.1916)

Once an earlier David took
Smooth pebbles from the brook:
Out between the lines he went
To that one-sided tournament,
A shepherd boy who stood out fine
And young to fight a Philistine
Clad all in brazen mail. He sweers
That he's killed lions, he's killed bears,
And those that scorn the God of Zion
Shall perish so like bear or lion..
But the historian of that fight
Had not the heart to tell it right.
Striding within javelin range
Goliath marvels at this strange
Goodly faced boy so proud of strength.
David's clear eye measures the length,
With hand thrust back, he cramps one knee,
Poises a moment thoughtfully,
And hurls with a long vengeful swing.
The pebble, humming from the sling
Like a wild bee, flies a sure line
For the forehead of the Philistine,
Then ... but there comes a brazen clink
And quicker than a man can think
Goliath's shield parries each cast
Clang's clang! & clang! was David's last.

Recalling War

Entrance and exit wounds are silvered clean,
The track aches only when the rain reminds.
The one-legged man forgets his leg of wood,
The one-armed man his jointed wooden arm.
The blinded man sees with his ears and hands
As much or more than once with both his eyes.
Their war was fought these twenty years ago
And now assumes the nature-look of time,
As when the morning traveller turns and views
His wild night-stumbling carved into a hill.

What, then, was war? No mere discord of flags
But an infection of the common sky
That sagged ominously upon the earth
Even when the season was the airiest May.
Down pressed the sky, and we, oppressed, thrust out
Boastful tongue, clenched fist and valiant yard.
Natural infirmities were out of mode,
For Death was young again: patron alone
Of healthy dying, premature fate-spasm.

Fear made fine bed-fellows. Sick with delight
At life's discovered transitoriness,
Our youth became all-flesh and waived the mind.
Never was such antiqueness of romance,
Such tasty honey oozing from the heart.

And old importances came swimming back –
Wine, meat, log-fires, a roof over the head,
A weapon at the thigh, surgeons at call.
Even there was a use again for God –
A word of rage in lack of meat, wine, fire,
In ache of wounds beyond all surgeoning.

War was return of earth to ugly earth,
War was foundering of sublimities,
Extinction of each happy art and faith
By which the world had still kept head in air,
Protesting logic or protesting love,
Until the unendurable moment struck –
The inward scream, the duty to run mad.

And we recall the merry ways of guns –
Nibbling the walls of factory and church
Like a child, piecrust; felling groves of trees
Like a child, dandelions with a switch.
Machine-guns rattle toy-like from a hill,
Down in a row the brave tin-soldiers fall:
A sight to be recalled in elder days
When learnedly the future we devote
To yet more boastful visions of despair.

1938

The Second-Fated

My stutter, my cough, my unfinished sentences,
Denote an inveterate physical reluctance
To use the metaphysical idiom.
Forgive me: what I am saying is, perhaps this:-

Your accepted universe, by Jove's naked hand
Or Esmun's, or Odomankoma's, or Marduk's –
Choose which name jibes – formed scientifically
From whatever there was before Time was,
And begging the question of perfect consequence,
May satisfy the general run of men
(If 'run' be an apt term for patent paralytics)
That blueprints destine all they suffer here,
But does not satisfy certain few else.

Fortune enrolled me among the second-fated
Who have read their own obituaries in The Times,
Have heard 'Where, death, thy sting? Where, grave, thy victory?'
Intoned with unction over their still clay,
Have seen two parallel red-ink lines drawn
Under their manic-depressive bank accounts,
And are therefore strictly forbidden to walk in grave-yards
Lest they scandalize the sexton and his bride.

We, to be plain with you, taking advantage
Of a brief demise, visited first the Pit,
A library of shades, completed characters;
And next the silver-bright Hyperborean queendom,
Basking under the sceptre of Guess Whom?
Where pure souls matrilineally foregather.
We were then shot through by merciful lunar shafts
Until hearts tingled, heads sang, and praises flowed;
And learned to scorn your factitious universe
Ruled by the death which we had flouted;
Acknowledging only that from the Dove's egg hatched
Before aught was, but wind – unpredictable
As our second birth would be, or our second love:
A moon-warmed world of discontinuance.

1958

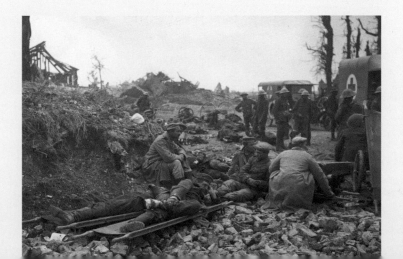

Wilfred Edward Salter Owen

Wilfred Owen was born in Oswestry on 18 March 1893. His parents were then living in a spacious and comfortable house owned by his grandfather, Edward Shaw. At his death two years later, this former Mayor of the city was found to be almost bankrupt, and Tom Owen was obliged to move with his wife and son to lodgings in the backstreets of Birkenhead. They carried with them vivid memories of their vanished prosperity, and Susan Owen resolved that her adored son Wilfred should in time restore the family to its rightful gentility. She was a devout lady and under her strong influence Wilfred grew into a serious and slightly priggish boy. At school in Birkenhead and later in Shrewsbury – where Tom Owen was appointed Assistant Superintendent of the Joint Railways (GWR and LNWR) in 1906 – he worked hard and successfully, especially at literature and botany. He had begun writing poems when he was ten or eleven, and soon fell under the spell of Keats, who was to remain the principal influence on his work.

Leaving school in 1911, Owen took up a post as lay assistant to the Vicar of Dunsden in Oxfordshire. He was to help the Vicar with his parish work and receive in return coaching for the university entrance examination that he hoped in due course to sit. Removed from his mother's influence, he became less enamoured of evangelical religion and more critical of the role of the Church – as represented by the Vicar of Dunsden – in society. His letters and poems of this period show an increasing awareness of the sufferings of the poor and the first stirrings of the compassion that was to characterize his later poems about the Western Front. At Dunsden in October 1912, there took place the double funeral of a mother and her four-year-old daughter. Owen responded to that village tragedy with a poem beginning

> Deep under turfy grass and heavy clay
> They laid her bruisèd body, and the child.

In this his compassion for victims made itself heard for the first time.

The Vicar had been praying for a religious revival in the parish and, early in 1913, it arrived like a spring tide, sweeping converts into church – but leaving Owen stranded with the recognition that literature meant more to him than evangelical religion. He had to explain this to the Vicar, and painful scenes followed. In February 1913, on the verge of a nervous breakdown, Owen left Dunsden and, while recovering that summer, made several visits to the archaeological site of the Roman city of Uriconium. Contemplating the excavated ruins of the city which, with its inhabitants (his guidebook told him) 'perished by fire and sword', the twenty-year-old poet warms to the subject of his first 'war poem', 'Uriconium, an Ode':

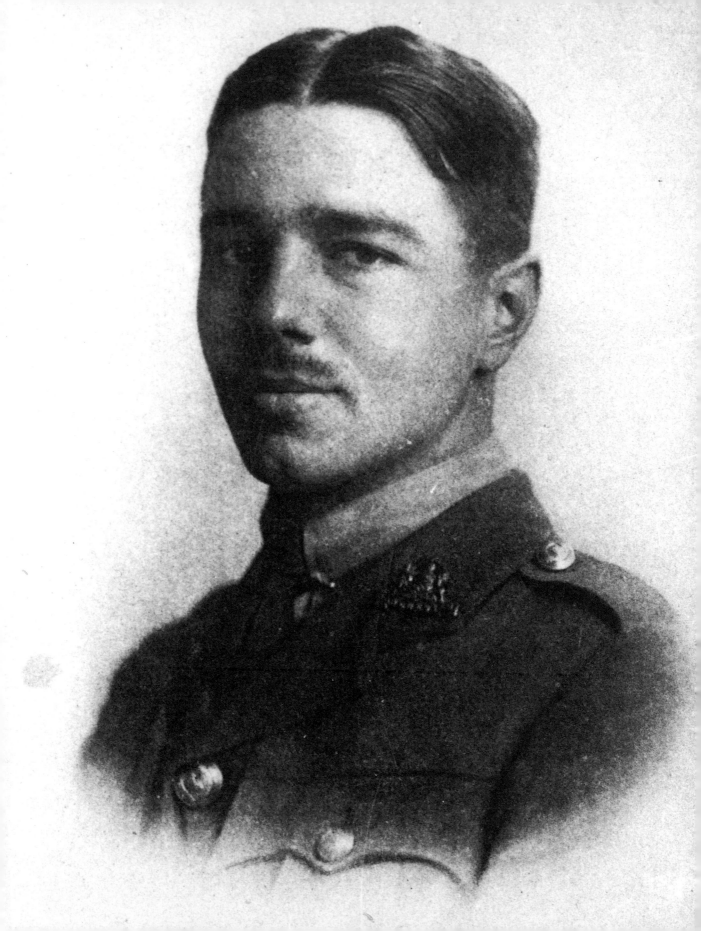

> For here lie remnants from a banquet-table –
> Oysters and marrow-bones, and seeds of grape –
> The statement of whose age must sound a fable;
> And Samian jars, whose sheen and flawless shape
> > Look fresh from potter's mould
> Plasters with Roman finger-marks impressed;
> Bracelets, that from the warm Italian arm
> > Might seem to be scarce cold
> And spears – the same that pushed the Cymry west –
> Unblunted yet.

Owen's compassionate awareness of the victims' bodies – so prominent a feature of his later and greater poems – enable him to see those

> Plasters with Roman *finger-marks* impressed;
> Bracelets, that from the *warm Italian arm*
> > Might seem to be *scarce cold*

and it sharpens his perceptions of the weapons that killed them – 'spears …*unblunted* yet'. 'Uriconium, an Ode' anticipates the later and greater poems in a more mysteriously prophetic way. As the twenty-year-old poet descends in imagination into the grave of the city and its slaughtered inhabitants, he says:

Owen with the French poet, Laurent Tailhade, in September 1914

> Ruins! On England's heart press heavily!
> For Rome hath left us more than walls and words
> And better yet shall leave, and more than herds
> Or land or gold gave the Celts to us in fee;
> E'en Blood, which makes poets sing and prophets see.

The earth is seen, metaphorically, as a threatened human body. Many of the poems he wrote later – when blood was making 'poets sing and prophets see' – involved a descent into wounded earth, trench, grave, hell.

Within weeks of writing 'Uriconium', Owen heard he had failed to win a scholarship to university, and left England to teach English in France. He was in the Pyrenees, acting as tutor in a cultivated French household, when war was declared. A visit to a hospital for the wounded soon opened his eyes to the true nature of war, but it was not until September 1915 that he finally decided to return to England and enlist. For several months he and Edward Thomas (see pp. 130–45) were privates, both training at Hare Hall Camp in Essex, although there is no evidence that they ever met.

Commissioned into the Manchester Regiment, Owen crossed the Channel on 30 December 1916 and in the first days of January 1917 joined the 2nd Manchesters on the Somme near Beaumont Hamel. His letters to his mother tell their own story:

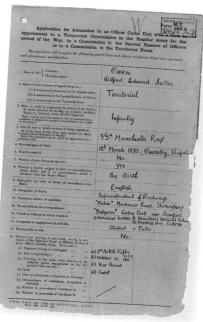

I have not been at the front.

I have been in front of it.

I held an advanced post, that is, a 'dug-out' in the middle of No Man's Land.

We had a march of 3 miles over shelled road then nearly 3 along a flooded trench. After that we came to where the trenches had been blown flat out and had to go over the top. It was of course dark, too dark, and the ground was not mud, not sloppy mud, but an octopus of sucking clay, 3, 4, and 5 feet deep, relieved only by craters full of water. Men have been known to drown in them. Many stuck in the mud and only got on by leaving their waders, equipment, and in some cases their clothes.

High explosives were dropping all around us, and machine guns spluttered every few minutes. But it was so dark that even the German flares did not reveal us.

Three quarters dead, I mean each of us ¾ dead, we reached the dug-out, and relieved the wretches therein. I then had to go forth and find another dug-out for a still more advanced post where I left 18 bombers. I was responsible for other posts on the left but there was a junior officer in charge.

My dug-out held 25 men tight packed. Water filled it to a depth of 1 or 2 feet, leaving say 4 feet of air.

One entrance had been blown in and blocked. So far, the other remained.

The Germans knew we were staying there and decided we shouldn't.

Those fifty hours were the agony of my happy life.

Every ten minutes on Sunday afternoon seemed an hour.

I nearly broke down and let myself drown in the water that was now slowly rising over my knees.

Towards 6 o'clock, when, I suppose, you would be going to church, the shelling grew less intense and less accurate: so that I was mercifully helped to do my duty and crawl, wade, climb and flounder over No Man's Land to visit my other post. It took me half an hour to move about 150 yards.

I was chiefly annoyed by our own machine guns from behind. The seeng-seeng-seeng of the bullets reminded me of Mary's canary. On the whole I can support the canary better.

In the Platoon on my left the sentries over the dug-out were blown to nothing. One of these poor fellows was my first servant whom I rejected. If I had kept him he would have lived, for servants don't do Sentry Duty. I kept my own sentries half way down the stairs during the more terrific bombardment. In spite of this one lad was blown down, and, I am afraid, blinded.

Owen's application for admission to a Temporary Commission in the Regular Army

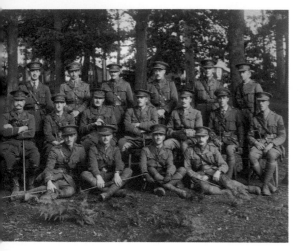

Owen (front row, second from right) and officers of the 5th (reserve) Manchester Regiment, 1916

In March 1917 Owen fell into a cellar and suffered concussion, and some weeks later, after fierce fighting near St Quentin, was invalided home with shell-shock. At Craiglockhart War Hospital on the outskirts of Edinburgh he met Siegfried Sassoon (see p. 70), whose first 'war poems' had just appeared in *The Old Huntsman and Other Poems*. Inspired by this book, and encouraged by Sassoon's constructive criticism, Owen found a language for his own experience. It was probably in August that he read the anonymous Prefatory Note to the anthology, *Poems of Today* (1916), which began:

> *This book has been compiled in order that **boys** and **girls**, already perhaps familiar with the great classics of the English speech, may also know something of the newer poetry of their own day. Most of the writers are living, and the rest are still vivid memories among us, while one of the youngest, almost as these words are written, has gone singing to lay down his life for his country's cause [. . .] there is no arbitrary isolation of one theme from another; they mingle and interpenetrate throughout, to the music of Pan's flute, and of Love's viol, and the **bugle-call** of Endeavour, and the **passing bell** of Death. [my emphasis]*

It is not difficult to imagine him, stung by those sentiments, sitting down to write his 'Anthem for Doomed Youth':

> What passing-bells for these who die as cattle?
> – Only the monstrous anger of the guns.
> Only the stuttering rifles' rapid rattle
> Can patter out their hasty orisons.
> No mockeries now for them; no prayers nor bells;
> Nor any voice of mourning save the choirs, –
> The shrill, demented choirs of wailing shells;
> And bugles calling for them from sad shires.
>
> What candles may be held to speed them all?
> Not in the hands of boys but in their eyes
> Shall shine the holy glimmers of goodbyes.
> The pallor of girls' brows shall be their pall;
> Their flowers the tenderness of patient minds,
> And each slow dusk a drawing-down of blinds.

Those who die as cattle in a slaughterhouse die in such numbers that there is no time to give them the trappings of a Christian funeral that Owen remembers from his Dunsden days. Instead, they receive a brutal parody of such a service: 'the stuttering rifles' praying (presumably) that they will kill them; the 'choirs . . . of shells' wailing as

they hunt them down. The bugles may sound the Last Post for them, but they had previously called them to the colours in those same sad shires. So, bitterly but obliquely, Owen assigns to Church and State responsibility for their deaths.

The 'turn' at the end of the octave (line 8) brings the reader home, across the Channel, and the sestet opens with a question paralleling the first: 'What candles may be held to speed them all?' A gentler question than 'What passing bells for these who die as cattle?' it prepares for the gentler answer that, instead of the parodic rituals offered by rifle, shell and bugle, those who love the soldiers will mark their death with observances more heart-felt, more permanent, than those prescribed by convention:

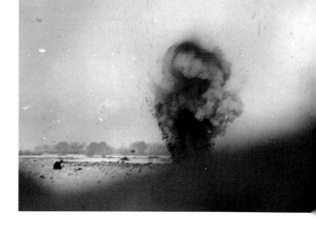

German shell bursting near British trenches, Beaumont Hamel, December 1916

> The pallor of girls' brows shall be their pall;
> Their flowers the tenderness of patient minds,
> And each slow dusk a drawing-down of blinds.

Memories of the dead will lie behind the foreheads of the girls who loved them, not just for the fortnight of formal mourning, but for the rest of their lives.

Some indication of the nature of Sassoon's contribution to Owen's poetic development can be gained from the fact that the final manuscript draft of this poem (see p. 107) contains nine words and several cancellations in the handwriting of the older poet, whose own work would never equal the rich density of meaning and music in these lines. Owen's poem 'Dulce et Decorum Est', begun at about the same time, again owes much to Sassoon – in its graphic depiction of the battlefield and in its explosive use of direct speech – and again was triggered by Owen's angry response to another text: in this case, a poem or poems by Jessie Pope (to whom manuscript versions of 'Dulce et Decorum Est' are dedicated). She was the author of another sort of 'war poem' – one, for example, beginning:

Army orders sent to Owen

> Who's for the trench –
> Are you, my laddie?
> Who'll follow the French –
> Will you, my laddie?
> Who's fretting to begin,
> Who's going to win?
> And who wants to save his skin –
> Do you, my laddie?

Discharged from Craiglockhart in November 1917, Owen spent Christmas with his regiment in Scarborough, and there read *Under Fire*, the English translation of Henri Barbusse's book, *Le Feu*. One of the most brilliant and searing accounts of life on the Western Front, it made an immediate impact on him, and its influence can be detected in his poems of this period. One such debt appears in the transformation of a sentence from Barbusse's chapter nine:

> *The soldier held his peace. In the distance he saw the night as they would pass it — cramped up, trembling with vigilance in the deep darkness, at the bottom of the listening-hole whose ragged jaws showed in black outline all around whenever a gun hurled its dawn into the sky.*

Owen expanded this into a vision of 'one of the many mouths of Hell':

> Cramped in that funnelled hole, they watched the dawn
> Open a jagged rim around; a yawn
> Of death's jaws, which had all but swallowed them
> Stuck in the bottom of his throat of phlegm.
>
> They were in one of many mouths of Hell
> Not seen of seers in visions; only felt
> As teeth of traps; when bones and the dead are smelt
> Under the mud where long ago they fell
> Mixed with the sour sharp odour of the shell.

Once again, he is reacting against the vision of another poet: here it is Tennyson and 'The Charge of the Light Brigade':

> Into the jaws of Death
> Into the mouth of Hell
> Rode the six hundred.

Panoramic view of the ruined village of Beaumont Hamel, November 1916

Owen's vision of the mouth of hell became more fully elaborated in 'Miners' and 'Strange Meeting' and can be traced back, by way of 'Uriconium', to the hell of which he heard at his mother's knee. These descents into the underworld have a

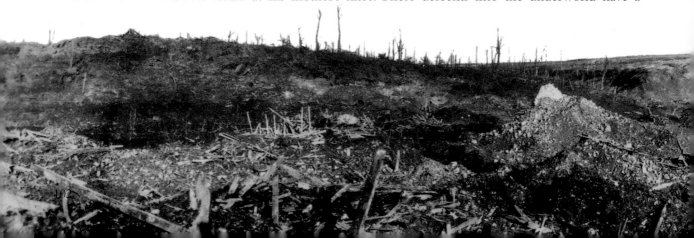

curious common denominator. The Dunsden elegy for a mother and child speaks of 'Chaos murky womb'; the landscape of 'The Show' is said to be 'pitted with great pocks and scabs of plagues'; the soldiers 'Cramped in that funnelled hole' watched the yawn 'Of death's jaws, which had all but swallowed them/Stuck in the bottom of his throat of phlegm'; and in 'Strange Meeting', the speaker escapes down a tunnel 'through granites which titanic wars had groined'. In each case, the earth is described in terms of the human body, and in three out of four instances there is a marked sense of physical loathing. This comes strangely, tragically, from a poet whose early poems are full of lyrical descriptions of beautiful bodies and celebrations of the natural world.

Part of the power of many of Owen's mature poems derives from his pioneering use of pararhymes: escaped/scooped, groined/groaned. In 'Strange Meeting', from which these examples are taken, the second rhyme is lower in pitch than the first, giving the couplet 'a dying fall' that musically reinforces the poem's meaning; the tragedy of the German poet (one manuscript reads 'I was a German conscript, and your friend'), his life cut short by the British poet whom he meets in Hell. In the poem 'Miners', the pitch of the pararhymes rises and falls as the sense moves from grief to happiness and back to grief again:

Owen's Military Cross (worn on a chain by his mother)

> The centuries will burn rich loads
> With which we groaned,
> Whose warmth shall lull their dreaming lids,
> While songs are crooned;
> But they will not dream of us poor lads,
> Left in the ground.

In December 1917, Sassoon was again posted overseas – first to Palestine, then to France – and in March 1918, Owen was transferred to 'an awful camp' at Ripon. There he rented an attic room in a nearby cottage to which he could escape when not on duty. In this, over the next three months, he either wrote or revised and

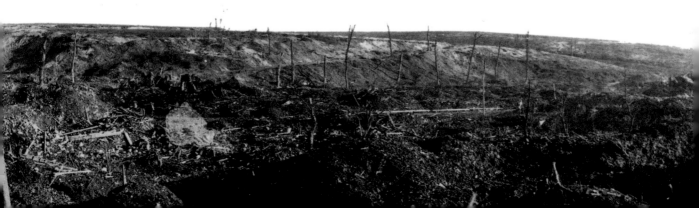

Owen's last letter to his mother

completed many of his most powerful poems, including 'Insensibility', 'Strange Meeting', 'Exposure' and 'Futility'. In early June, he was graded 'G. S.' (fit for General Service) and rejoined the 5th Manchesters at Scarborough. A friend in the War Office recommended him for a home posting, as instructor to a cadet battalion, but the recommendation was rejected. By then, however, Sassoon had been shot in the head and invalided home, and Owen seems to have accepted that it was his duty as a poet to take his place. 'Now must I throw my little candle on his torch,' he told his mother, 'and go out again.'

The great German offensives of March and April 1918 had exhausted the attackers and in mid-July they launched what was to prove their last offensive. This had been contained and their armies were retreating when, at the end of August, Owen returned to France, under no illusions about what awaited him. Before going into the trenches he wrote to Sassoon: 'Serenity Shelley never dreamed of crowns me. Will it last when I shall have gone into Caverns & Abysmals such as he never reserved for his worst daemons?' Once again, his image is of hell. Later that month, remembering his sentry blinded in January 1917, he wrote 'The Sentry':

Troops returning from the line through a wilderness of mud, 1918

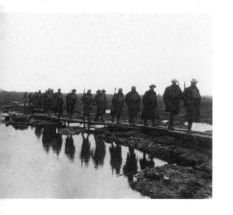

> We'd found an old Boche dug-out, and he knew,
> And gave us hell; for shell on frantic shell
> Lit full on top, but never quite burst through.
> Rain, guttering down in waterfalls of slime,
> Kept slush waist-high and rising hour by hour,
> And choked the steps too thick with clay to climb.
> What murk of air remained stank old, and sour
> With fumes from whizz-bangs, and the smell of men
> Who'd lived there years, and left their curse in the den,
> If not their corpses . . .
> There we herded from the blast
> Of whizz-bangs; but one found our door at last, –
> Buffeting eyes and breath, snuffing the candles,
> And thud! flump! thud! down the steep steps came thumping
> And sploshing in the flood, deluging muck,
> The sentry's body; then his rifle, handles
> Of old Boche bombs, and mud in ruck on ruck.
> We dredged it up, for dead, until he whined,
> 'O sir – my eyes, – I'm blind, – I'm blind, – I'm blind.'
> Coaxing, I held a flame against his lids
> And said if he could see the least blurred light
> He was not blind; in time they'd get all right.

'I can't', he sobbed. Eyeballs, huge-bulged like squids',
Watch my dreams still, – yet I forgot him there
In posting Next for duty, and sending a scout
To beg a stretcher somewhere, and flound'ring about
To other posts under the shrieking air.

Those other wretches, how they bled and spewed,
And one who would have drowned himself for good, –
I try not to remember these things now.
Let Dread hark back for one word only: how,
Half-listening to that sentry's moans and jumps,
And the wild chattering of his shivered teeth,
Renewed most horribly whenever crumps
Pummelled the roof and slogged the air beneath, –
Through the dense din, I say, we heard him shout
'I see your lights!' – But ours had long gone out.

*Wilfred Owen
in 1916*

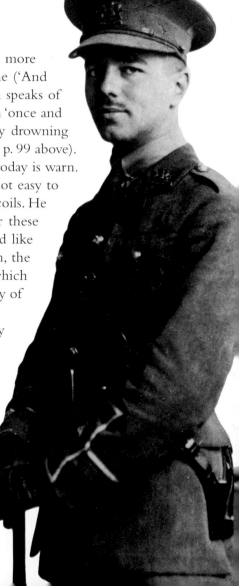

The torrential movement of this poem makes it seem simpler, more
straightforward than it is. The slang figure of speech in the second line ('And
gave us hell') conceals the recurrent metaphor. Similarly, when Owen speaks of
'one who would have drowned himself for good', he means more than 'once and
for all', and may well have had in mind the moment when death by drowning
seemed, to him, good and preferable to living (see the letter quoted on p. 99 above).

In his celebrated draft Preface, Owen wrote: 'All a poet can do today is warn.
That is why the true Poets must be truthful.' It sounds easy, but it is not easy to
tell the truth in a poem, especially a truth from which the memory recoils. He
tells the truth in 'The Sentry' when he says 'I try not to remember these
things now.' But, when he tries to forget them, 'Eyeballs, huge-bulged like
squids',/Watch my dreams still.' In those dreams the horror is reborn, the
reality of battle reshaped to the dimensions of the poem; poems to which
we, his readers, owe – more than to any other – our vision of the reality of
the Western Front, of hell on earth.

At the start of October 1918, Owen was awarded the Military
Cross for his part in a successful attack on the Beaurevoir-Fonsomme
Line and, before sunrise on the morning of 4 November, led his
platoon to the west bank of the Sambre and Oise Canal. They came
under murderous fire from German machine-guns behind the
parapet of the east bank, and at the height of the ensuing battle
Owen was hit and killed while helping his men bring up duck-
boards at the water's edge.

In Shrewsbury, the Armistice bells were ringing when his
parents' front-door bell sounded its small chime, heralding the
telegram they had dreaded for two years.

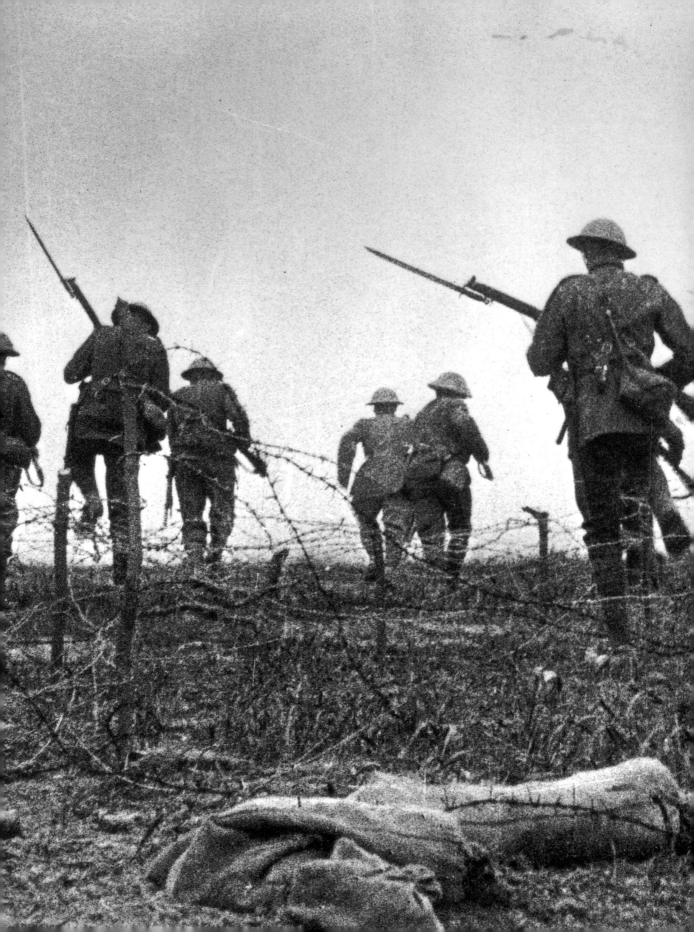

Anthem for ~~Dead~~ Doomed Youth. <u>Nation</u> 17

What passing-bells for these who die as cattle?
 — Only the monstrous anger of the guns.
 Only the stuttering rifles' rapid rattle
Can patter out their hasty orisons.
No { ~~music for all them~~ / mockeries } for them; { ~~from~~ / nor no } prayers ~~or~~ nor bells,
 Nor any voice of mourning save the choirs,
The shrill ~~demented~~ / discomfortate choirs of wailing shells;
 And bugles calling ~~sad~~ for them from sad ~~across the~~ shires.

What candles may be held to speed them all?
 Not in the hands of boys, but in their eyes
Shall shine the holy glimmers of goodbyes.
~~And~~ The pallor of girls' brows shall be their pall;
 Their flowers the tenderness of { ~~sweet white~~ / silent patient } minds,
And each slow dusk a drawing-down of blinds.

(Pencil words were written by
S.S. when W. showed him the
sonnet at Craiglockhart in
Sept. 1917.)

Miners

There was a whispering in my hearth,
 A sigh of the coal,
Grown wistful of a former earth
 It might recall.

I listened for a tale of leaves
 And smothered ferns;
Frond-forests; and the low, sly lives
 Before the fawns.

My fire might show steam-phantoms simmer
 From Time's old cauldron,
Before the birds made nests in summer,
 Or men had children.

But the coals were murmuring of their mine,
 And moans down there
Of boys that slept wry sleep, and men
 Writhing for air.

And I saw white bones in the cinder-shard,
 Bones without number.
Many the muscled bodies charred,
 And few remember.

I thought of all that worked dark pits
 Of war, and died
Digging the rock where Death reputes
 Peace lies indeed.

Comforted years will sit soft-chaired
 In rooms of amber:
The years will stretch their hands, well-cheered
 By our lives' ember;

The centuries will burn rich loads
 With which we groaned,
Whose warmth shall lull their dreaming lids,
 While songs are crooned;
But they will not dream of us poor lads,
 Left in the ground.

1918

Dulce et Decorum Est

Bent double, like old beggars under sacks,
Knock-kneed, coughing like hags, we cursed through sludge,
Till on the haunting flares we turned our backs
And towards our distant rest began to trudge.
Men marched asleep. Many had lost their boots
But limped on, blood-shod. All went lame; all blind;
Drunk with fatigue; deaf even to the hoots
Of tired, outstripped Five-Nines that dropped behind.

Gas! GAS! Quick, boys!- An ecstasy of fumbling,
Fitting the clumsy helmets just in time;
But someone still was yelling out and stumbling,
And flound'ring like a man in fire or lime . . .
Dim, through the misty panes and thick green light,
As under a green sea, I saw him drowning.

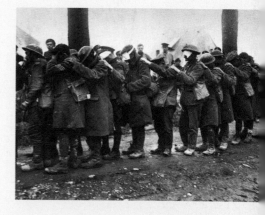

In all my dreams, before my helpless sight,
He plunges at me, guttering, choking, drowning.

If in some smothering dreams you too could pace
Behind the wagon that we flung him in,
And watch the white eyes writhing in his face,
His hanging face, like a devil's sick of sin;
If you could hear, at every jolt, the blood
Come gargling from the froth-corrupted lungs,
Obscene as cancer, bitter as the cud
Of vile, incurable sores on innocent tongues, –
My friend, you would not tell with such high zest
To children ardent for some desperate glory,
The old Lie: Dulce et decorum est
Pro patria mori.

1917–18

Insensibility

1

Happy are men who yet before they are killed
Can let their veins run cold.
Whom no compassion fleers
Or makes their feet
Sore on the alleys cobbled with their brothers.
The front line withers.
But they are troops who fade, not flowers,
For poets' tearful fooling:
Men, gaps for filling:
Losses, who might have fought
Longer; but no one bothers.

2

And some cease feeling
Even themselves or for themselves.
Dullness best solves
The tease and doubt of shelling,
And Chance's strange arithmetic
Comes simpler than the reckoning of their shilling.
They keep no check on armies' decimation.

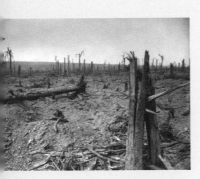

3

Happy are these who lose imagination:
They have enough to carry with ammunition.
Their spirit drags no pack.
Their old wounds, save with cold, can not more ache.
Having seen all things red,
Their eyes are rid
Of the hurt of the colour of blood for ever.
And terror's first constriction over,
Their hearts remain small-drawn.
Their senses in some scorching cautery of battle
Now long since ironed,
Can laugh among the dying, unconcerned.

4

Happy the soldier home, with not a notion
How somewhere, every dawn, some men attack,
And many sighs are drained.
Happy the lad whose mind was never trained:
His days are worth forgetting more than not.
He sings along the march
Which we march taciturn, because of dusk,
The long, forlorn, relentless trend
From larger day to huger night.

5

We wise, who with a thought besmirch
Blood over all our soul,
How should we see our task
But through his blunt and lashless eyes?
Alive, he is not vital overmuch;
Dying, not mortal overmuch;
Nor sad, nor proud,
Nor curious at all.
He cannot tell
Old men's placidity from his.

6

But cursed are dullards whom no cannon stuns,
That they should be as stones.
Wretched are they, and mean
With paucity that never was simplicity.
By choice they made themselves immune
To pity and whatever moans in man
Before the last sea and the hapless stars;
Whatever mourns when many leave these shores;
Whatever shares
The eternal reciprocity of tears.

1917–18

Strange Meeting

It seemed that out of battle I escaped
Down some profound dull tunnel, long since scooped
Through granites which titanic wars had groined.

Yet also there encumbered sleepers groaned,
Too fast in thought or death to be bestirred.
Then, as I probed them, one sprang up, and stared
With piteous recognition in fixed eyes,
Lifting distressful hands, as if to bless.
And by his smile, I knew that sullen hall, –
By his dead smile I knew we stood in Hell.

With a thousand pains that vision's face was grained;
Yet no blood reached there from the upper ground,
And no guns thumped, or down the flues made moan.
'Strange friend,' I said, 'here is no cause to mourn.'
'None,' said that other, 'save the undone years,
The hopelessness. Whatever hope is yours,
Was my life also; I went hunting wild
After the wildest beauty in the world,
Which lies not calm in eyes, or braided hair,
But mocks the steady running of the hour,
And if it grieves, grieves richlier than here.

For by my glee might many men have laughed,
And of my weeping something had been left,
Which must die now. I mean the truth untold,
The pity of war, the pity war distilled.
Now men will go content with what we spoiled,
Or, discontent, boil bloody, and be spilled.
They will be swift with swiftness of the tigress.
None will break ranks, though nations trek from progress.
Courage was mine, and I had mystery,
Wisdom was mine, and I had mastery:
To miss the march of this retreating world
Into vain citadels that are not walled.
Then, when much blood had clogged their chariot-wheels,
I would go up and wash them from sweet wells,
Even with truths that lie too deep for taint.
I would have poured my spirit without stint
But not through wounds; not on the cess of war.
Foreheads of men have bled where no wounds were.

'I am the enemy you killed, my friend.
I knew you in this dark: for so you frowned
Yesterday through me as you jabbed and killed.
I parried; but my hands were loath and cold.
Let us sleep now . . .'

1918

Futility

Move him into the sun –
Gently its touch awoke him once,
At home, whispering of fields half-sown.
Always it woke him, even in France,
Until this morning and this snow.
If anything might rouse him now
The kind old sun will know.

Think how it wakes the seeds –
Woke once the clays of a cold star.
Are limbs so dear-achieved, are sides
Full-nerved, still warm, too hard to stir?
Was it for this the clay grew tall?
– O what made fatuous sunbeams toil
To break earth's sleep at all?

1918

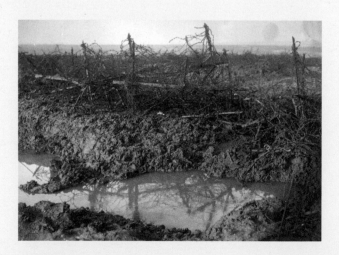

The Send-Off

Down the close darkening lanes they sang their way
To the siding-shed,
And lined the train with faces grimly gay.

Their breasts were stuck all white with wreath and spray
As men's are, dead.

Dull porters watched them, and a casual tramp
Stood staring hard,
Sorry to miss them from the upland camp.

Then, unmoved, signals nodded, and a lamp
Winked to the guard.

So secretly, like wrongs hushed-up, they went.
They were not ours:
We never heard to which front these were sent;

Nor there if they yet mock what women meant
Who gave them flowers.

Shall they return to beating of great bells
In wild train-loads?
A few, a few, too few for drums and yells,

May creep back, silent, to still village wells
Up half-known roads.

1918

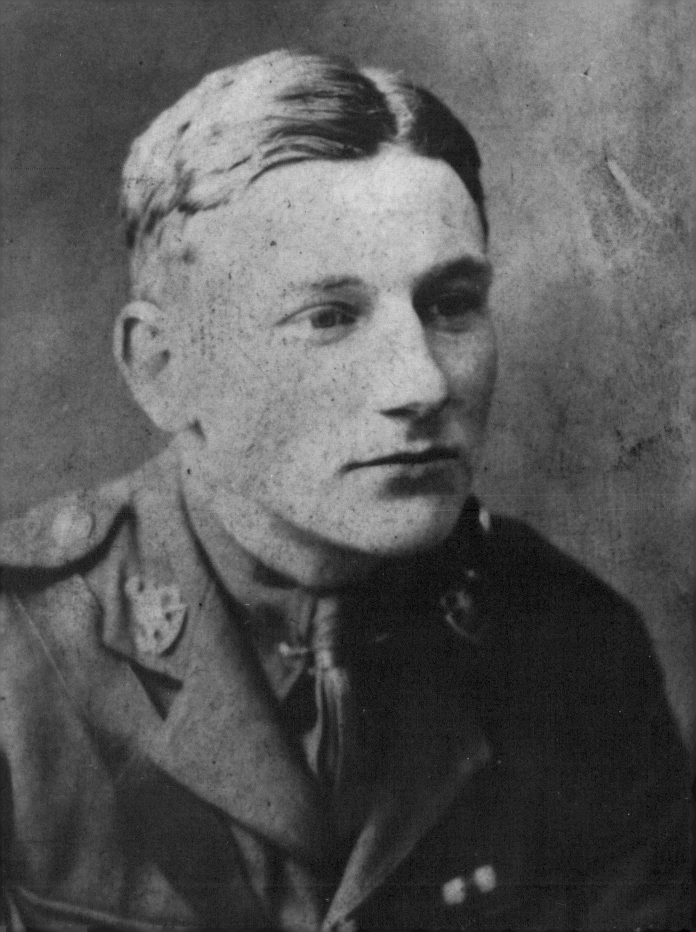

Edmund Charles Blunden

Edmund Charles Blunden was born in London on 1 November 1896 and two years later moved with his family to a village in Kent where his father was a schoolmaster. From the local grammar school he won a scholarship to Christ's Hospital, Horsham, where in due course he became senior 'Grecian' (classical scholar). He was happy at this school and was to remain devoted to it all his life. Coleridge, Leigh Hunt and Lamb had walked the same corridors and sat at the same benches, and the writings of these 'Old Blues' were a major influence on the young poet. In 1914 he gained the senior Classics scholarship at The Queen's College, Oxford, and privately printed two pamphlets of verse: *Poems* and *Poems Translated from the French.*

The outbreak of war changed his life as it did the lives of so many others. Within months he was training as a volunteer with the Royal Sussex Regiment and in 1916, a temporary 2nd lieutenant, he crossed to France. He took part in some of the worst fighting of the war (carrying in his pack a copy of Julius Caesar's *De Bello Gallico*), and, as soon as it was over, sat down to write his own personal history of the preceding three years. This work, entitled *De Bello Germanico*, he soon abandoned, but ten years later returned to the subject in a book to be called *Undertones of War.* The change of title – from magniloquent Latin to the modesty of *Undertones* – is typical of the man who was to present himself (in the last sentence of the later work) as 'a harmless young shepherd in a soldier's coat'. *De Bello Germanico* is not so much revised as shaken like a kaleidoscope, its bright fragments being incorporated into a larger and richer pattern. One comparison will illustrate the principal difference between the first and final version. In *De Bello Germanico*, the 'harmless young shepherd' had noticed how

small lizards slid from their sunbath into their dugouts as we passed; the self-sown wheat was swarming with small birds, hares, and wild-flowers; and not a ditch but was in a flurry with tiny fish such as Walton called skipjacks.

In *Undertones of War* this becomes:

Acres of self-sown wheat glistened and sighed as we wound our way between, where rough scattered pits recorded a hurried firing-line of long ago. Life, life abundant sang here and smiled; the lizard ran warless in the warm dust; and the ditches were trembling with odd tiny fish, in worlds as remote as Saturn.

The difference is almost that between prose and poetry. G. S. Fraser, indeed, once called *Undertones* 'the best war poem'.

Its *undertones* – under 'the monstrous anger of the guns' – are predominantly literary. Blunden takes his epigraph from Bunyan:

Reinforcements moving up for the attack on Mametz Wood, July 1916

Yea, how they set themselves in battle-array
I shall remember to my dying day

and in his Preliminary (or Foreword) he speaks of approaching 'such mysteries as Mr Hardy forthshadowed in *The Dynasts*'. Hardy's poem, of course, is another *De Bello Gallico*, and the influence of Hardy (Blunden's favourite contemporary poet, as he was Sassoon's, and a major figure in the pastoral tradition) is everywhere discernible in the archaisms ('warless', for example), the syntactic inversions and compound adjectives of *Undertones of War*. There are also specific references or allusions to Shakespeare, Milton, Herbert, Clare, Wordsworth; and the 'harmless young shepherd in a soldier's coat' is properly steeped in pastoral literature. His 'Trench Education' (as he calls it) begins in the Old British Line at Festubert:

The morning when I emerged was high and blue and inspiriting, but the landscape somewhat tattered and dingy. I washed ungrudgingly in a biscuit-tin, and [a brother officer] took me for a walk along the reserve line, explaining as we went the system of sentries and trench duty. At some points in the trench, bones pierced through their shallow burial, and skulls appeared like mushrooms [. . . .]

We were well off in this reserve trench, though my blood ran high in the excitement of novelty. In the evenings, while some of the men were amusing themselves in digging out a colony of rats, for which sport they had enlisted a stray terrier, there would suddenly begin a tremendous upheaval two or three miles to the south. The officers not on definite duty would leave their dinner to stand and terrify their eyes with this violence. On the blue and lulling mist of evening, proper to the nightingale, the sheep-bell, and falling waters, the strangest phenomena of fire inflicted themselves. The red sparks of German trench mortars described their seeming-slow arcs, shrapnel shells clanged in crimson, burning, momentary cloudlets, smoke billowed into a tidal wave, and the powdery glare of many a signal-light showed the rolling folds.

He sees the battlefield with a true countryman's eye, and he makes us share his sense of outrage at the violence done to man and nature by showing us skulls as plentiful as mushrooms, and the 'crimson, burning, momentary cloudlets' of shrapnel shells intruding 'on the blue and lulling mist of evening, proper to the nightingale, the sheep-bell, and falling waters'.

Blunden is always on the look-out for the consoling beauties of nature, including human nature. 'I began to love these [. . .] soldiers', he says on the first page of *Undertones*, and goes on to stress time and again that his regiment is a family. One of its commanders was 'Paternal Northcote', and its 'Colonel Draffen [. . .] was fatherly'. One chapter is entitled 'Domesticities', another, 'Home from Home'. Home – one of Blunden's favourite words – more often means an officer's mess or a trench

than England, where, he noted, 'the German air raids had almost persuaded my London friends that London was the sole battle front'. *Undertones of War* is less grimly realistic than, say, Graves's *Goodbye to All That*, but when the family is violated Blunden can set his reticence aside with shattering effect, as here:

a young and cheerful lance-corporal of ours was making some tea as I passed one warm afternoon. Wishing him a good tea, I went along three firebays; one shell dropped without warning behind me; I saw its smoke faint out, and I thought all was lucky as it should be. Soon a cry from that place recalled me; the shell had burst all wrong. Its butting impression was black and stinking in the parados where three minutes ago the lance-corporal's mess-tin was bubbling over a little flame. For him, how could the gobbets of blackening flesh, the earth-wall sotted with blood, with flesh, the eye under the duckboard, the pulpy bone be the only answer? At this moment, while we looked with dreadful fixity at so isolated a horror, the lance-corporal's brother came round the traverse.

Such moments derive much of their impact from the archaic and literary quality of the framing narrative. Paul Fussell puts it well, in *The Great War and Modern Memory*, when he says that

archaism is more than an over-educated tic in Blunden. It is directly implicated in his meaning. With language as with landscape, his attention is constantly on pre-industrial England, the only repository of criteria for measuring fully the otherwise unspeakable grossness of the war. In a world where literary quality of Blunden's sort is conspicuously an antique, every word of *Undertones of War*, every rhythm, allusion, and droll personification, can be recognized as an assault on the war and on the world which chose to conduct and continue it. Blunden's style is his critique.

Blunden (seated right) with four Christ's Hospital contemporaries, St Omer, June 1917

The same can be said of his poems. 'Festubert: The Old German Line' opens with the inextricably associated violence endured by man and nature:

> Sparse mists of moonlight hurt our eyes
> With gorged and scourged uncertainties
> Of soul and soil in agonies.

The moon – emblematic of love in numberless poems – looks down on the evidence of hatred and, far from consoling the wakeful lover, hurts the eyes that strain to interpret movements in No Man's Land where, in a grim parody of leaves, 'The grey rags fluttered on the dead'.

The traditional associations of flowers are similarly invoked and subverted in another of Blunden's many poems set in a specific landscape, 'Vlamertinghe: Passing the Château, July 1917':

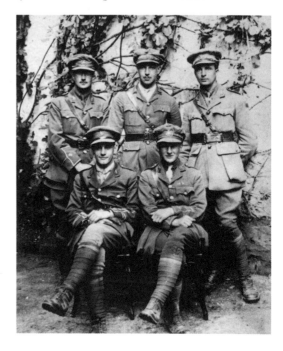

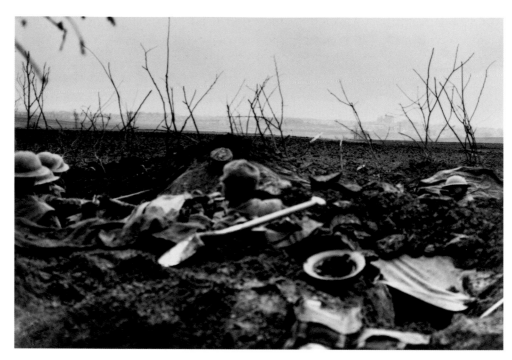

Distant view of St Quentin from the British front line, April 1917

'And all her silken flanks with garlands drest' –
But we are coming to the sacrifice.
Must those have flowers who are not yet gone West?
May those have flowers who live with death and lice?
This must be the floweriest place
That earth allows; the queenly face
Of the proud mansion borrows grace for grace
Spite of those brute guns lowing at the skies.

Bold great daisies, golden lights,
Bubbling roses' pinks and whites –
Such a gay carpet! poppies by the million;
Such damask! such vermilion!
But if you ask me, mate, the choice of colour
Is scarcely right: this red should have been much duller.

Has the speaker been quoting Keats's 'Ode on a Grecian Urn' comfortingly to himself, or has the start of its fourth stanza swum unbidden into his mind?

Who are these coming to the sacrifice?
 To what green altar, O mysterious priest,
Lead'st thou that heifer lowing at the skies,
 And all her silken flanks with garlands drest?

The speaker realizes that he and his companions (rather than the heifer) 'are coming to the sacrifice'; and that the flowers of the château are all too likely to deck their graves. Even so, nature and the past offer their consolations:

> This must be the floweriest place
> That earth allows; the queenly face
> Of the proud mansion borrows grace for grace
> Spite of those brute guns lowing at the skies.

By making the guns that will deliver the sacrificial stroke low like Keats's sacrificial heifer, Blunden initiates a movement of ironic anti-pastoral. He returns, in the sestet of his sonnet, to the delighted contemplation of the flowers,

> Such a gay carpet! poppies by the million;
> Such damask! such vermilion!

before initiating another movement of ironic anti-pastoral; undercutting his high-flown literary exclamations with a soldierly colloquialism:

> But if you ask me, mate, the choice of colour
> Is scarcely right: this red should have been much duller.

A page from one of Blunden's post-war letters about the war

The grim humour of this return to the sacrificial theme ambushes the reader who has lost sight of the silken flanks behind the garlands.

With his Regiment, to which he was ever afterwards to remain deeply attached, Blunden went through the horrors of Cuinchy Brickstacks and Thiepval Wood, and in 1917 was awarded the Military Cross. Miraculously, he survived unscathed and, after demobilization in 1919, took up his scholarship at Oxford, and was subsequently at different times a journalist, Professor of English in the University of Tokyo, Fellow and Tutor at Merton College, Oxford, cultural Liaison Officer to the British Mission in Japan, and Professor of Poetry at Oxford. He wrote several volumes of poems and critical or biographical studies of a wide range of English authors: among them, Hardy, Coleridge, Shelley and Keats. Wherever he went he was loved and respected for his learning, his wisdom, his modesty, his humour and his generosity. The last

121

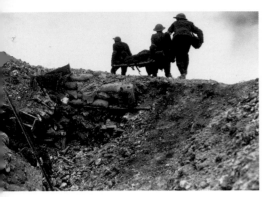

Carrying a
wounded man
in the battle of
Thiepval Ridge,
September 1916

was legendary and extended not only to the living but to the dead, such as John Clare and Wilfred Owen, whose poems he edited with rare devotion.

Unlike Owen, Blunden may have survived the Western Front, but the echoed prophecy with which *Undertones of War* began –

Yea, how they set themselves in battle-array
I shall remember to my dying day –

was to be painfully fulfilled. For him – as for Sassoon and many other survivors – the aftermath of the war brought him nearer to despair than the trenches had ever done. None of his poems is based on a more bitter irony than the one called '1916 seen from 1921' (see p. 127):

Tired with dull grief, grown old before my day,
I sit in solitude and only hear
Long silent laughters, murmurings of dismay,
The lost intensities of hope and fear;
In those old marshes yet the rifles lie,
On the thin breastwork flutter the grey rags,
The very books I read are there – and I
Dead as the men I loved, wait while life drags

Ration party
resting in a
communication
trench, July
1916

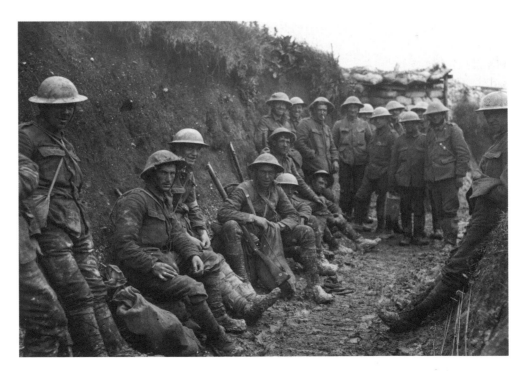

Its wounded length from those sad streets of war
Into green places here, that were my own;
But now what once was mine is mine no more,
I seek such neighbours here and I find none.
With such strong gentleness and tireless will
Those ruined houses seared themselves in me,
Passionate I look for their dumb story still,
And the charred stub outspeaks the living tree.

I rise up at the singing of a bird
And scarcely knowing slink along the lane,
I dare not give a soul a look or word
Where all have homes and none's at home in vain:
Deep red the rose burned in the grim redoubt,
The self-sown wheat around was like a flood,
In the hot path the lizard lolled time out,
The saints in broken shrines were bright as blood.

Sweet Mary's shrine between the sycamores!
There we would go, my friend of friends and I,
And snatch long moments from the grudging wars,
Whose dark made light intense to see them by.
Shrewd bit the morning fog, the whining shots
Spun from the wrangling wire; then in warm swoon
The sun hushed all but the cool orchard plots,
We crept in the tall grass and slept till noon.

*Ruined church
at Zonnebeke,
1917*

His life 'drags/Its wounded length' (like Alexander Pope's wounded snake) 'from those sad streets of war/Into green places here'. This should be a source of happiness for the 'harmless young shepherd' who has now shed his soldier's coat but, ironically, it is not. The first three stanzas present the dichotomy: *here* and *there, now* and *then*, and everything of value is *there* and *then*. 'The very books I read are *there*' (my italics). Home and family ('the men I loved') are *there*, and with them the earlier self he echoes:

> The self-sown wheat around was like a flood,
> In the hot path the lizard lolled time out [. . . .]

In the last stanza he escapes from 'green places *here*' into the happier pastoral of *there* and *then* (my italics):

> *There* would we go, my friend of friends and I [. . . .]
> *then* in warm swoon
> The sun hushed all but the cool orchard plots,
> We crept in the tall grass and slept till noon.

As buried shell splinters will work themselves, after many years, to the surface of the flesh, memories of war continually resurface in Blunden's imagination. Perhaps the most famous of his later poems, 'The Midnight Skaters', opens with a scene as peaceful, at first sight, as the similar one in Wordsworth's *Prelude*:

> The hop-poles stand in cones,
> The icy pond lurks under,
> The pole-tops steeple to the thrones
> Of stars, sound gulfs of wonder;
> But not the tallest there, 'tis said,
> Could fathom to this pond's black bed.
>
> Then is not death at watch
> Within those secret waters?
> What wants he but to catch
> Earth's heedless sons and daughters?
> With but a crystal parapet
> Between, he has his engines set.
>
> Then on, blood shouts, on, on,
> Twirl, wheel and whip above him,
> Dance on this ball-floor thin and wan,
> Use him as though you love him;
> Court him, elude him, reel and pass,
> And let him hate you through the glass.

Blunden's inscription in a copy of Undertones of War *given to a friend*

The haunted watcher senses another, waiting like a sniper behind his 'parapet'. The 'green places' of the present are once again no refuge from memories of the past, but not all such watchers are deathly. In his Preliminary (or Foreword) to *Undertones of War*, Blunden had said:

> *I must go over the ground again.*
>
> *A voice, perhaps not my own, answers within me. You will be going over the ground again, it says, until that hour when agony's clawed face softens into the smilingness of a young spring day; when you, like Hamlet, your prince of peaceful war-makers, give the ghost a 'Hic et ubique? then we'll change our ground,' and not that time in vain; when it shall be the simplest thing to take in your hands and hands of companions like E.W.T., and W.J.C., and A.G.V, in whose recaptured gentleness no sign of death's astonishment or time's separation shall be imaginable.*

In his poem 'The Watchers', it is midnight again, but behind the parapet there lies in wait not an enemy sniper but a friendly sentry:

Edmund Blunden in old age

I heard the challenge 'Who goes there?'
Close-kept but mine through midnight air;
I answered and was recognised,
And passed, and kindly thus advised:
'There's someone crawling through the grass
By the red ruin, or there was,
And them machine-guns been a firin'
All the time the chaps was wirin',
So sir if you're goin' out
You'll keep your 'ead well down no doubt.'

When will the stern fine 'Who goes there?'
Meet me again in midnight air?
And the gruff sentry's kindness, when
Will kindness have such power again?
It seems, as now I wake and brood,
And know my hour's decrepitude,
That on some dewy parapet
The sentry's spirit gazes yet,
Who will not speak with altered tone
When I at last am seen and known.

Blunden faced that final challenge in 1974, at the age of seventy-seven, and went to his grave with Flanders poppies on his coffin.

Two Voices

"There's something in the air," he said
 In the large parlour cool and bare;
The plain words in his hearers bred
 A tumult, yet in silence there
All waited; wryly gay, he left the phrase,
Ordered the march and bade us go our ways.

"We're going South, man"; as he spoke
 The howitzer with huge ping-bang
Racked the light hut; as thus he broke
 The death-news, bright the skylarks sang;
He took his riding-crop and humming went
Among the apple-trees all bloom and scent.

Now far withdraws the roaring night
 Which wrecked our flower after the first
Of those two voices; misty light
 Shrouds Thiepval Wood and all its worst:
But still "There's something in the air" I hear,
And still "We're going South, man," deadly near.

FESTUBERT, 1916

10 g

Tired with dull grief, grown old before my day,
I sit in solitude and only hear
Long silent laughters, murmurings of dismay,
The lost intensities of hope and fear;
In those old marshes yet the rifles lie,
On the thin breastwork flutter the gray rags,
The very books I read are there — and I,
Dead as the men I loved, wait while life drags

Its wounded length from those sad streets of war
Into green places here, that were my own;
But now my home is no home any more,
I look for such friends here and I find none.
With such strong *gentleness* and tireless will
Those ruined houses seared themselves in me,
Passionate I look for their dumb story still;
And the charred stub outspeaks the living tree.

I rise up at the singing of a bird
And scarcely knowing slink along the lane,
I dare not give a soul a look or word,
For all have homes and none's at home in vain:
Deep red the rose burned in the grim redoubt,
The self-sown wheat around was like a flood,
In the hot path the lizard lolled time out,
The saints in broken shrines were bright as blood.

Each waking moment won new melody
Out of my soul that was a harp new strung;
The past was like dropt fetters, I was free:
Death came so swift and seldom, and all seemed young.
Shrewd bit the morning fog, the whining shots
Spun from the tangling wire; then in warm swoon
The sun hushed all but the cool orchard plots,
We crept in the tall grass and slept till noon.

Sweet Mary's shrine between the sycamores:
There we would go, my friend of friends and I,
And snatch rich moments from the grudging wars,
Whose dark made light intense to see them by.

st.

Keepsake

127

The Zonnebeke Road

Morning, if this late withered light can claim
Some kindred with that merry flame
Which the young day was wont to fling through space!
Agony stares from each gray face.
And yet the day is come; stand down! stand down!
Your hands unclasp from rifles while you can,
The frost has pierced them to the bended bone?
Why, see old Stevens there, that iron man,
Melting the ice to shave his grotesque chin:
Go ask him, shall we win?
I never liked this bay, some foolish fear
Caught me the first time that I came in here;
That dugout fallen in awakes, perhaps,
Some formless haunting of some corpse's chaps.
True, and wherever we have held the line,
There were such corners, seeming-saturnine
For no good cause.
 Now where Haymarket starts,
That is no place for soldiers with weak hearts;
The minenwerfers have it to the inch.
Look, how the snow-dust whisks along the road,
Piteous and silly; the stones themselves must flinch
In this east wind; the low sky like a load
Hangs over – a dead-weight. But what a pain
Must gnaw where its clay cheek
Crushes the shell-chopped trees that fang the plain –
The ice-bound throat gulps out a gargoyle shriek.
The wretched wire before the village line
Rattles like rusty brambles or dead bine,
And then the daylight oozes into dun;
Black pillars, those are trees where roadways run.
Even Ypres now would warm our souls; fond fool,
Our tour's but one night old, seven more to cool!
O screaming dumbness, O dull clashing death,
Shreds of dead glass and willows, homes and men,
Watch as you will, men clench their chattering teeth
And freeze you back with that one hope, disdain.

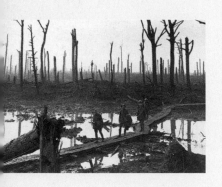

Concert Party: Busseboom

The stage was set, the house was packed,
 The famous troop began;
Our laughter thundered, act by act;
 Time light as sunbeams ran.

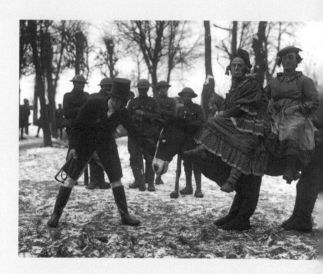

Dance sprang and spun and neared and fled,
 Jest chirped at gayest pitch,
Rhythm dazzled, action sped
 Most comically rich.

With generals and lame privates both
 Such charms worked wonders, till
The show was over – lagging loth
 We faced the sunset chill;

And standing on the sandy way,
 With the cracked church peering past,
We heard another matinee,
 We heard the maniac blast

Of barrage south by Saint Eloi,
 And the red lights flaming there
Called madness: Come, my bonny boy,
 And dance to the latest air.

To this new concert, white we stood;
 Cold certainty held our breath;
While men in the tunnels below Larch Wood
 Were kicking men to death.

Philip Edward Thomas

Philip Thomas was born at Lambeth on 3 March 1878 and spent most of his childhood in London where his father was a staff clerk at the Board of Trade. A stern man, who had worked his way up in the world, he had temperamentally little in common with Edward, the eldest of his six sons. 'Almost as soon as I could babble,' the poet was later to write, 'I "babbled of green fields"', and he was never happier than in his school holidays spent with his aunt or grandmother in Swindon. There he discovered his lifelong passion for the countryside and its creatures, for country people and country pursuits.

His father introduced him to literature, first of all to the prose writers who celebrated the country and its ways, Isaac Walton and Richard Jefferies, and when he was fifteen he began to read poetry for pleasure. By then he was at St Paul's School, Hammersmith, where his natural shyness was increased by the greater confidence of the other boys, who for the most part came from more prosperous middle-class homes. He had recently begun writing seriously – in the manner of Richard Jefferies – and found an ally and encourager in James Ashcroft Noble, a fifty-year-old journalist and author. Thomas left St Paul's in 1895 and went up to Oxford, after two years ostensibly reading for the Civil Service examination, but in fact extending his knowledge of literature and writing a book of his own, *The Woodland Life* (1897). This was dedicated to Noble, who had died the previous year, and to whose daughter Helen he was secretly engaged. In 1899, following a courtship movingly described in her book *As it Was*, they were married – secretly because of the disapproval of their parents. A year later, with a second-class degree, a baby son, and high literary ambitions, Edward Thomas left Oxford for slum lodgings in Earlsfield, south London.

Reviewing work and literary journalism were hard to come by and, when found, exhausting and poorly paid. 'I now live – if living it may be called – by my writing,' he told a friend, ' "literature" we call it in Fleet Street (derived from 'litter') It's a painful business, and living in this labyrinth of red brick makes it worse.' Unable to resist the lure of the country, the Thomases moved to Kent in 1901. Their spirits rose only to be dashed by the discovery that Helen was again pregnant. She wrote: 'it means more anxiety for Edward and more work for him. Home will become unendurable to him. Even now poverty, anxiety, physical weakness, disappointments and discouragements are making him bitter, hard and impatient, quick to violent anger, and subject to long fits of depression.'

A melancholy inherited from his much-loved mother became more marked over the difficult years that followed. He was reviewing up to fifteen books a week and, though he hated the drudgery, reviewing them conscientiously and with discernment. The meagre income that brought him he supplemented by selling his review copies and writing one book after another. Thirty volumes were published between 1897 and 1917, and during those twenty years he also edited sixteen anthologies and editions of poetry and prose. Everything was done hurriedly, but

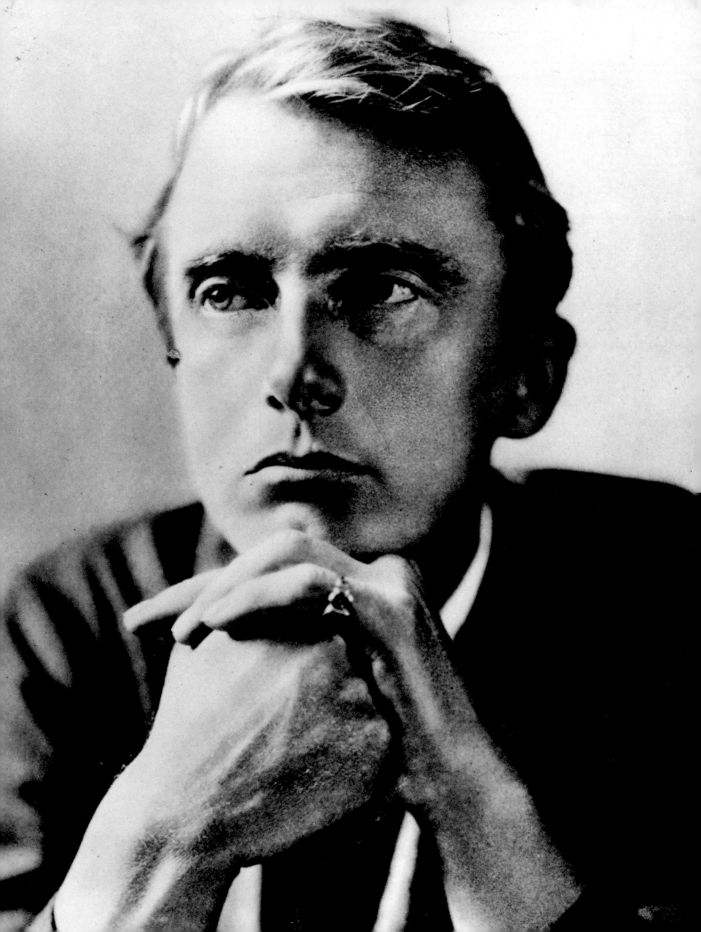

nothing was slovenly, and he was able to find delight – and communicate it with freshness and charm – in even the most unpromising 'hack' assignment.

Thomas's great gift as a literary critic appeared to best advantage in his reviewing of poetry, and he was the first to salute such new stars in the literary firmament as W. H. Davies, the 'Super-Tramp', and the American poets Ezra Pound and Robert Frost. Frost and Thomas met in October 1913 and began a friendship that became of central importance to them both. It was Frost who first urged Thomas to try his hand at writing poems, on the grounds that some of his prose was essentially poetry. Thomas was full of self-doubt, though, and made no serious attempt to turn from the prose that was earning him the money he so desperately needed until November or December 1914. Then, under the stress of deciding whether or not to enlist, poems suddenly began to pour out of him: five between 3 and 7 December, and at least five more before the end of the month. After he had written a number, he wrote to a friend:

By the way, what I have done so far have been like quintessences of the best parts of my prose books – not much sharper or more intense, but I hope a little: since the first take off they haven't been Frosty very much, or so I imagine, and I have tried as often as possible to avoid the facilities offered by blank verse, and I try not to be too long – I have an ambition to keep under 12 lines (but rarely succeed).

On New Year's Day 1915 he sprained his ankle so badly that he was lame for nearly three months, during which time the stream of poetry flowed more swiftly and more richly than ever. From 7 to 9 January, for example, he wrote 'A Private', 'Snow', 'Adlestrop', 'Tears', and 'Over the Hills'.

While his ankle was recovering he considered emigrating to America, where Robert Frost had offered to find him work, but decided against it and in July 1915 enlisted in the Artists' Rifles. A responsible family man of thirty-seven, he was much older than most of his fellow recruits, and his greater maturity was soon recognized by the award of a lance-corporal's stripe. In the intervals between drilling, weapon training, cleaning his equipment, and instructing a squad in map-reading, he was still writing poems. One of the best of them, 'Rain', illustrates a common and curious feature of his work:

Thomas, Bronwen and a neighbour

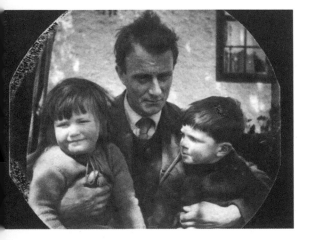

Rain, midnight rain, nothing but the wild rain
On this bleak hut, and solitude, and me
Remembering again that I shall die
And neither hear the rain nor give it thanks
For washing me cleaner than I have been
Since I was born into this solitude.
Blessed are the dead that the rain rains upon:
But here I pray that none whom once I loved
Is dying tonight or lying still awake
Solitary, listening to the rain,

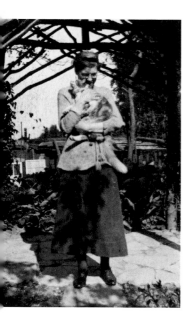

Either in pain or thus in sympathy
Helpless among the living and the dead,
Like a cold water among broken reeds,
Myriads of broken reeds all still and stiff,
Like me who have no love which this wild rain
Has not dissolved except the love of death,
If love it be for what is perfect and
Cannot, the tempest tells me, disappoint.

Three years before, in his prose book *The Icknield Way*, he had written a four-page meditation on the rain falling round him as he lay, half asleep, at an inn:

I lay awake listening to the rain, and at first it was as pleasant to my ear and my mind as it had long been desired; but before I fell asleep it had become a majestic and finally terrible thing, instead of a sweet sound and symbol. It was accusing and trying me and passing judgment. Long I lay still under the sentence, listening to the rain, and then at last listening to words which seemed to be spoken by a ghostly double beside me. He was muttering: the all-night rain puts out summer like a torch. In the heavy, black rain falling straight from invisible, dark sky to invisible, dark earth the heat of summer is annihilated, the splendour is dead, the summer is gone. The midnight rain buries it away where it has buried all sound but its own. I am alone in the dark still night, and my ear listens to the rain piping in the gutters and roaring softly in the trees of the world. Even so will the rain fall darkly upon the grass over the grave when my ears can hear it no more. I have been glad of the sound of rain, and wildly sad of it in the past; but that is all over as if it had never been; my eye is dull and my heart beating evenly and quietly; I stir neither foot nor hand; I shall not be quieter when I lie under the wet grass and the rain falls, and I of less account than the grass [. . . .] Black and monotonously sounding is the midnight and solitude of the rain. In a little while or in an age – for it is all one – I shall know the full truth of the words I used to love, I knew not why, in my days of nature, in the days before the rain: 'Blessed are the dead that the rain rains on.'

Helen Thomas and cat

The manuscript of 'Rain' dated 7.1.16

The most important difference between these texts is that four pages of prose has been distilled into eighteen lines of poetry; or, to be more precise, the essence of those four pages has been distilled into less than eighteen lines, for there is much in the poem that is not in the prose. The inn and the ghostly double have gone. The poet is now in a hut – presumably an army hut – and speaks in his own voice. He moves quickly from a perception of his own death to the quotation with which the prose extract had ended: 'Blessed are the dead that the rain rains on'. That conclusion to the earlier self-absorbed meditation becomes the beginning of a prayer, not for himself, but for others. But – the poem turns on that hinge conjunction –

[. . .] I pray that none whom once I loved
Is dying tonight or lying still awake
Solitary, listening to the rain,
Either in pain or thus in sympathy
Helpless among the living and the dead,
Like a cold water among broken reeds,
Myriads of broken reeds all still and stiff,
Like me [. . . .]

Love may have gone, but sympathy has taken its place; sympathy for the sufferings of the living and the dead in France, their bodies imagined as 'Myriads of broken reeds all still and stiff,/Like me'. With this the poem changes direction again, circling back to the speaker's perception of, and longing for, his own death. Now he has

[. . .] no love which this wild rain
Has not dissolved except the love of death,
If love it be for what is perfect and
Cannot, the tempest tells me, disappoint.

John Donne said that 'particulars do ever touch more than generals' (particularities more than generalities), and Thomas focuses on the dead more sharply in another poem, 'A Private':

Letter to Thomas from Robert Frost, September 1916

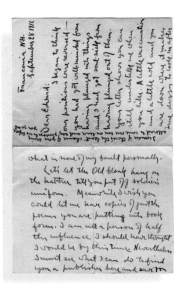

This ploughman dead in battle slept out of doors
Many a frosty night, and merrily
Answered staid drinkers, good bedmen, and all bores:
'At Mrs. Greenland's Hawthorn Bush,' said he,
'I slept.' None knew which bush. Above the town,
Beyond 'The Drover', a hundred spot the down
In Wiltshire. And where now at last he sleeps
More sound in France – that, too, he secret keeps.

By juxtaposing the Private with the love of privacy, and ironically implying a natural resemblance between peace and war, Thomas forces us to perceive the *un*natural disjunction, the break in the natural order. This is the theme, too, of his beautiful little quatrain, 'The Cherry Trees':

The cherry trees bend over and are shedding,
On the old road where all that passed are dead,
Their petals, strewing the grass as for a wedding
This early May morn when there is none to wed.

Behind those tolling rhymes lurks an echo of Gertrude's words in *Hamlet*, spoken over Ophelia's grave:

> I thought thy bride-bed to have deck'd,
> sweet maid,
> And not have strewed thy grave.

It was because he was a married man, no doubt, that Thomas saw sooner than most other poets that the victims of the war would be women as well as men.

He saw other things clearly too, in particular a distinction between different kinds of patriotism, beginning a poem

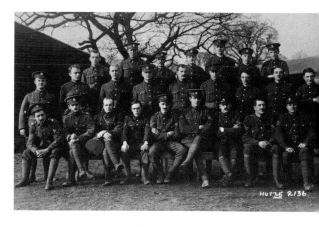

Edward Thomas (middle row, second from left) in a group of NCOs

> This is no case of petty right or wrong
> That politicians or philosophers
> Can judge. I hate not Germans, nor grow hot
> With love of Englishmen, to please newspapers.

In an essay called 'England', Thomas wrote that Isaac Walton's *The Compleat Angler* was for him the most patriotic of books:

Since the war began I have not met so English a book, a book that filled me so with a sense of England, as this, though I have handled scores of deliberately patriotic works. There, in that sort of work, you get, as it were, the shouting without the crowd, which is ghastly. In Walton's book I touched the antiquity and sweetness of England – English fields, English people, English poetry, all together.

It was this pastoral patriotism that, in July 1915, led him to enlist rather than emigrate to America where Frost had offered to find him work. When, later, another friend asked him if he knew what he would be fighting for, he bent down, picked up a pinch of earth, and crumbling it between his fingers, said: 'Literally, for this.'

Thomas's best poems are (again literally) grounded in this, and I would like to look at one of them in the light of John H. Johnston's criticism that Thomas 'refused to let the conflict interfere with his nostalgic rural vision'; and Bernard Bergonzi's, that 'in his loving concentration on the unchanging order of nature and rural society, the war exists only as a brooding but deliberately excluded presence.' The poem (see p. 144 for its manuscript) takes its title from its opening words:

> As the team's head-brass flashed out on the turn
> The lovers disappeared into the wood.
> I sat among the boughs of the fallen elm
> That strewed the angle of the fallow, and
> Watched the plough narrowing a yellow square

Of charlock. Every time the horses turned
Instead of treading me down, the ploughman leaned
Upon the handles to say or ask a word,
About the weather, next about war.
Scraping the share he faced towards the wood,
And screwed along the furrow till the brass flashed
Once more.

 The blizzard felled the elm whose crest
I sat in, by a woodpecker's round hole,
The ploughman said. 'When will they take it away?'
'When the war's over.' So the talk began –
One minute and an interval of ten,
A minute more and the same interval.
'Have you been out?' 'No.' 'And don't want to, perhaps?'
'If I could only come back again, I should.
I could spare an arm. I shouldn't want to lose
A leg. If I should lose my head, why, so,
I should want nothing more Have many gone
From here?' 'Yes.' 'Many lost?' 'Yes, a good few.
Only two teams work on the farm this year.
One of my mates is dead. The second day
In France they killed him. It was back in March,
The very night of the blizzard, too. Now if
He had stayed here we should have moved the tree.'
'And I should not have sat here. Everything
Would have been different. For it would have been

Another world.' 'Ay, and a better, though
If we could see all all might seem good.' Then
The lovers came out of the wood again:
The horses started and for the last time
I watched the clods crumble and topple over
After the ploughshare and the stumbling team.

The poem opens with images of light and darkness –
flashing brass and wood; love and death. The ominous note is
dominant. It is a *fallen* elm (fallen, as in Laurence Binyon's elegy,
'For the Fallen', was then a current euphemism for dead soldiers).
Thomas's speaker seems to feel threatened:

> [. . .] Every time the horses turned
> Instead of treading me down, the ploughman leaned
> Upon the handles to say or ask a word,
> About the weather, next about the war.

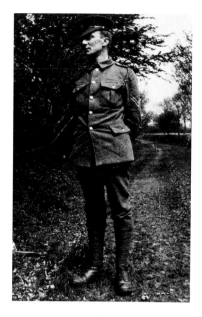

*Corporal
Thomas in
1916*

Natural weather, unnatural war: the antithesis is reinforced by a repetition of the
images of light and darkness, life and death:

> [. . .] he faced towards the wood,
> And screwed along the furrow till the brass flashed
> Once more.

Their talk about the tree –

> [. . .] 'When will they take it away?'
> 'When the war's over.' –

leads naturally to the casual revelation of a fact crucial to the structure of the poem.
The ploughman says:

> 'One of my mates is dead. The second day
> In France they killed him. It was back in March,
> The very night of the blizzard, too.'

Fallen man and fallen tree are linked by something more than coincidence.
The reader is invited to believe in the truth of the pathetic fallacy. And if the fallen
tree stands/lies as a symbol of the fallen *man*, the reader fears for the speaker who now
stands/sits in his place. Such connections, however, are made obliquely as the
conversation runs its unruffled course:

> [. . .] 'Now if
> He had stayed here we should have moved the tree.'
> 'And I should not have sat here. Everything
> Would have been different. For it would have been
> Another world.' 'Ay, and a better, though
> If we could see all all might seem good.' Then
> The lovers came out of the wood again [. . . .]

As if in confirmation of the ploughman's optimism, the lovers 'came out of the wood' (and notice the rhyming link of 'good' and 'wood'). Life goes on, but so does death, surely foreshadowed in the speaker's closing lines:

> The horses started and for the last time
> I watched the clods crumble and topple over
> After the ploughshare and the stumbling team.

Why does he say 'for the last time'? Death is in the air. To quote the words of the burial service: 'Earth to earth, ashes to ashes, dust to dust'. Our intimations of the poem's impending closure – reinforced by the internal rhyme ('crumble'/'stumbling') and the final pararhyme ('time'/'team') – suggest an impending closure of another kind.

That Thomas himself felt this is made clear in poem after poem. None more so than one of the very last he wrote – 'Lights Out', the military command with its ghostly echo of Othello's command: 'Put out the light, and then put out the light'. The contention of light and darkness, with which 'As the Team's Head-brass' had opened, takes much the same form as before:

Men of the Machine Gun Corps firing at a German plane, April 1917

> I have come to the borders of sleep,
> The unfathomable deep
> Forest where all must lose
> Their way, however straight,
> Or winding, soon or late;
> They cannot choose.

As in the poem 'Rain', all but one of his loves have dissolved:

> There is not any book
> Or face of dearest look
> That I would not turn from now . . .

He turns from them towards his last and truest love – 'the love of death':

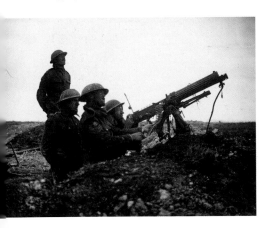

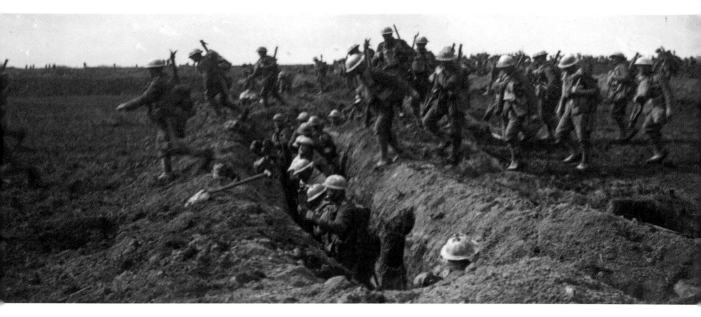

The tall forest towers:
Its cloudy foliage lowers
Ahead, shelf above shelf:
Its silence I hear and obey
That I may lose my way
And myself.

Infantry moving up in the Battle of Arras, 9 April 1917 (the day that Thomas was killed)

This, like all Thomas's poems – except the one found in his diary at his death – was written in England before he was exposed to the violence and destruction of the trenches. His love of England and its seasons, celebrated so long in prose, rise again, distilled to a purer form in these poems. His awareness of the natural world, its richness and beauty, is now intensified by a sense of impending loss and the certainty of death – his own and others. His 'war poems' are those of a countryman perceiving the violence done by a distant conflict to the natural order of things.

The grave of Edward Thomas

Two months after 'Lights Out' was written, Thomas crossed to France and on 9 February 1917 reached Arras, where a massive build-up for the Easter offensive was in progress. There he heard that three of his poems had been accepted by the magazine *Poetry* and, on 4 April, was heartened to read an enthusiastic review in *The Times Literary Supplement* of his contribution to *An Annual of New Poetry*. Five days later, on Easter Monday, the Battle of Arras began with a deafening artillery barrage, and in the opening minutes, in a forward observation post, Edward Thomas was killed by the blast of a shell.

In Memoriam [*Easter 1915*]

The flowers left thick at nightfall in the wood
This Eastertide call into mind the men,
Now far from home, who, with their sweethearts, should
Have gathered them and will do never again.

1915

The Owl

Downhill I came, hungry, and yet not starved;
Cold, yet had heat within me that was proof
Against the North wind; tired, yet so that rest
Had seemed the sweetest thing under a roof.

Then at the inn I had food, fire, and rest,
Knowing how hungry, cold, and tired was I.
All of the night was quite barred out except
An owl's cry, a most melancholy cry.

Shaken out long and clear upon the hill,
No merry note, nor cause of merriment,
But one telling me plain what I escaped
And others could not, that night, as in I went.

And salted was my food, and my repose,
Salted and sobered, too, by the bird's voice
Speaking for all who lay under the stars,
Soldiers and poor, unable to rejoice.

1915

[*This is no case of petty right or wrong*]

This is no case of petty right or wrong
That politicians or philosophers
Can judge. I hate not Germans, nor grow hot
With love of Englishmen, to please newspapers.
Beside my hate for one fat patriot
My hatred of the Kaiser is love true: –
A kind of god he is, banging a gong.
But I have not to choose between the two,
Or between justice and injustice. Dinned
With war and argument I read no more
Than in the storm smoking along the wind
Athwart the wood. Two witches' cauldrons roar.
From one the weather shall rise clear and gay;
Out of the other an England beautiful
And like her mother that died yesterday.
Little I know or care if, being dull,
I shall miss something that historians
Can rake out of the ashes when perchance
The phoenix broods serene above their ken.
But with the best and meanest Englishmen
I am one in crying, God save England, lest
We lose what never slaves and cattle blessed.
The ages made her that made us from the dust:
She is all we know and live by, and we trust
She is good and must endure, loving her so:
And as we love ourselves we hate her foe.

1915

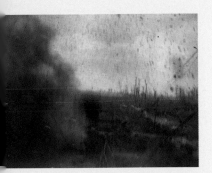

Bugle Call

'No one cares less than I,
Nobody knows but God
Whether I am destined to lie
Under a foreign clod'
Were the words I made to the bugle call in the morning.

But laughing, storming, scorning,
Only the bugles know
What the bugles say in the morning,
And they do not care, when they blow
The call that I heard and made words to early this morning.

1916

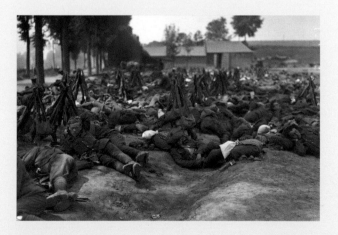

As the team's head brass flashed out on the turn
The lovers disappeared into the wood.
I sat among the boughs of the fallen elm
That strewed the angle of the fallow, and
Watched the plough narrowing the yellow square
Of charlock. Everytime the horses turned
Instead of treading me down, the ploughman leaned
Upon the handles to say or ask a word,
About the weather, next about the war.
Scraping the share he faced ~~towards the wood~~ towards the wood,
And screwed along the furrow till the brass flashed
Once more. The blizzard felled the elm whose crest
I sat in, by a woodpecker's round hole,
The ploughman said. "When will they take it away?"
"When the war's over." So the talk began —
One minute & an interval of ten,
A minute more & the same interval.
"Have you been out?" "No." "And don't want to, perhaps?"
"If I could only come back again, I should.
I could spare an arm. I shouldn't want to lose
A leg. If I should lose my head, why, so,
I should want nothing more.... Have many gone
From here?" "Yes." "Many lost?" "Yes: a good few.
Only 2 teams work on the farm this year.
One of my mates is dead. The second day
In France they killed him. It was back in March,
The very night of the blizzard, too. Now if
He had stayed here we should have moved the tree."
"And I should not have sat here. Everything
Would have been different. For it would have been
Another world." "Ay, and a better, though
If we could see all all might seem good." Then
The lovers came out of the wood again:
The horses started & for the last time
I watched the clods crumble & topple over
After the ploughshare & the stumbling team.

Lights Out

I have come to the borders of sleep,
The unfathomable deep
Forest, where all must lose
Their way, however straight
Or winding, soon or late;
They can not choose.

Many a road and track
That since the dawn's first crack,
Up to the forest brink
Deceived the travellers,
Suddenly now blurs,
And in they sink.

Here love ends –
Despair, ambition ends;
All pleasure and all trouble,
Although most sweet or bitter,
Here ends, in sleep that is sweeter
Than tasks most noble.

There is not any book
Or face of dearest look
That I would not turn from now
To go into the unknown
I must enter, and leave, alone
I know not how.

The tall forest towers:
Its cloudy foliage lowers
Ahead, shelf above shelf:
Its silence I hear and obey
That I may lose my way
And myself.

1916

Ivor Bertie Gurney

Ivor Gurney was born in Gloucester on 28 August 1890, the elder son and second of four children of David Gurney, proprietor of a small tailoring business, and his wife Florence. He was educated at the King's School as a chorister of Gloucester Cathedral, then as an articled pupil of the cathedral organist and, finally, at the Royal College of Music, to which he won a scholarship on the strength of prodigious gifts as a composer. His teacher there, Sir Charles Stanford, used to say that of all his pupils – Vaughan Williams, John Ireland, Arthur Bliss, and dozens more – Gurney was, potentially, 'the biggest of them all, but the least teachable.'

In 1912 Gurney began setting poems to music, including five Elizabethan lyrics. His biographer, Michael Hurd (himself a musician) said of these: 'Gurney jumped in one bound from mere competence to mastery and genuine originality.' He added that, in his view, the inspiration did not seem to be a musical one at all, but in direct response to the innocence and freedom of the poetry. So it is not surprising that about this time Gurney began writing poetry himself. He also began to manifest signs of instability, which suggests that, while the intermittent madness of his last fifteen years was clearly triggered by the war, it was not the sole cause.

He was rejected by the army in 1914 on grounds of defective eyesight, but managed to enlist in February 1915 while still a student and, in May 1916, crossed to France with the 2nd/5th Gloucesters. There, he continued to write poems and, by 1917, had enough for a first book. This he called *Severn and Somme*, juxtaposing the much-loved river of his childhood with the one that had given its name to the battle in which he had been fighting. Many of these poems have the word 'song' in their titles and/or are song-like. One of the best takes its title, 'Ballad of the Three Spectres', from another, related musical form:

> As I went up by Ovillers
> In mud and water cold to the knee,
> There went three jeering, fleering spectres,
> That walked abreast and talked of me.
>
> The first said, 'Here's a right brave soldier
> That walks the dark unfearingly;
> Soon he'll come back on a fine stretcher,
> And laughing for a nice Blighty.'
>
> The second, 'Read his face, old comrade,
> No kind of lucky chance I see;
> One day he'll freeze in mud to the marrow,
> Then look his last on Picardie.'

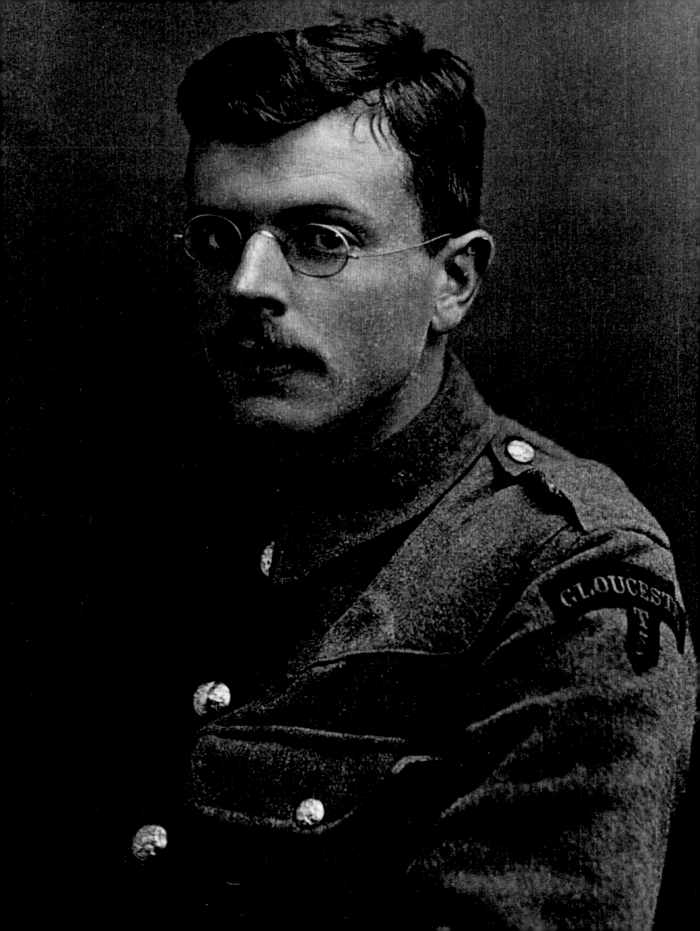

Though bitter the word of these first twain
 Curses the third spat venomously;
'He'll stay untouched till the war's last dawning
 Then live one hour of agony.'

Liars the first two were. Behold me
 At sloping arms by one – two – three;
Waiting the time I shall discover
 Whether the third spake verity.

Ivor Gurney
with Matilda
and Marjorie
Chapman,
1919

On Good Friday 1917, Gurney was first wounded (though not seriously enough to be sent home), then gassed, and only then sent home. Two years later he produced a second book, *War's Embers*, that contained what many consider his masterpiece, the song-like elegy 'To His Love' (see p.157 for its manuscript):

He's gone, and all our plans
 Are useless indeed.
We'll walk no more on Cotswold
 Where the sheep feed
 Quietly and take no heed.

His body that was so quick
 Is not as you
Knew it, on Severn river
 Under the blue
 Driving our small boat through.

Manuscript of
Gurney's song,
'In Flanders'

You would not know him now . . .
 But still he died
Nobly, so cover him over
 With violets of pride
 Purple from Severn side.

Cover him, cover him soon!
 And with thick-set
Masses of memoried flowers –
 Hide that red wet
 Thing I must somehow forget.

Both the title and the opening euphemism, 'He's gone', conceal the fact that the subject of the poem is dead (or mistakenly believed to be dead: he, F. W. Harvey, was in fact a prisoner of war). Grief is held in check by the pastoral forms, the pastoral convention. The truth begins to emerge in the second stanza – 'His body that was so quick' – but first euphemism, and then memory draw the veil:

> Is not as you
> Knew it, on Severn river
> Under the blue
> Driving our small boat through.

Memory makes that body, momentarily, as *quick* as ever. But reality will not be denied. The pastoral elegy, however, can propose its traditional consolation. As the dead man had lived under the blue canopy of Gloucestershire sky, the speaker wishes him now concealed under a purple canopy of Gloucestershire flowers:

> [. . .] cover him over
> With violets of pride
> Purple from Severn side.

A tin box sent to Gurney at the front by the Chapmans, 1915

The voice is elegiac but as controlled as ever. Only with the final stanza does the control begin to crack, at first with a near-hysterical repetition: 'Cover him, cover him soon!' That is followed by a sentence which again tries to veil truth with tradition, before finally admitting the horror:

> And with thick-set
> Masses of memoried flowers –
> Hide that red wet
> Thing I must somehow forget.

After so much pastoral formality, the colloquial *in*formality of 'that red wet/*Thing*' comes with shattering force. Humanity floods into the poem with the imprecision of that noun and with the irreconcilable demands of memory and forgetfulness.

The same word, 'thing', is used repeatedly in a very different context, in the poem 'First Time In', that begins:

View of earthworks from the bridge over the Omignon, April, 1917

> After the dread tales and red yarns of the Line
> Anything might have come to us; but the divine
> Afterglow brought us up to a Welsh colony
> Hiding in sandbag ditches, whispering consolatory
> Soft foreign things. Then we were taken in
> To low huts candle-lit, shaded close by slitten
> Oilsheets, and there the boys gave us kind welcome,
> So that we looked out as from the edge of home,
> Sang us Welsh things, and changed all former notions
> To human hopeful things. And the next day's guns
> Nor any line-pangs ever quite could blot out
> That strangely beautiful entry to war's rout.

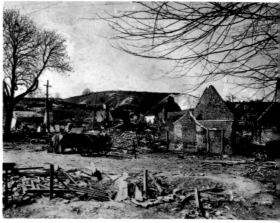

There is a touching honesty about those 'soft foreign things', those 'Welsh things', that cannot be identified more specifically because they are in a foreign language. This is not to suggest that Gurney's poetry lacks specificity. Far from it. In this poem, he goes on to catalogue the gifts that the Welshmen give the Englishmen:

> Candles they gave us, precious and shared over-rations –
> Ulysses found little more in his wanderings without doubt.
> 'David of the White Rock', the 'Slumber Song' so soft, and that
> Beautiful tune to which roguish words by Welsh pit boys
> Are sung – but never more beautiful than here under the guns' noise.

Gurney never acquired the technical control of an Owen or a Sassoon – neither of whom would have admitted the filler 'without doubt' (to rhyme with 'that') – but, as with Hardy, his clumsiness can be a source of strength. He is an honest, humane and touching poet, never more so than in 'The Silent One':

> Who died on the wires, and hung there, one of two –
> Who for his hours of life had chattered through
> Infinite lovely chatter of Bucks accent:
> Yet faced unbroken wires; stepped over, and went
> A noble fool, faithful to his stripes – and ended.
> But I weak, hungry, and willing only for the chance
> Of line – to fight in the line, lay down under unbroken
> Wires, and saw the flashes and kept unshaken,
> Till the politest voice – a finicking accent, said:
> 'Do you think you might crawl through, there; there's a hole.' In the afraid
> Darkness, shot at; I smiled, as politely replied –
> 'I'm afraid not, Sir.' There was no hole no way to be seen
> Nothing but chance of death, after tearing of clothes.
> Kept flat, and watched the darkness, hearing bullets whizzing –
> And thought of music – and swore deep heart's deep oaths
> (Polite to God) and retreated and came on again,
> Again retreated – and a second time faced the screen.

Field postcard from Ivor Gurney

There is no Sassoon-like indignation here – not even against the officer who invites him to crawl to his death. Instead, there is a delight in the varieties of human voice – the 'lovely chatter of Bucks accent', the 'finicking accent' of the officer – and the grief in the poem (as its title suggests) stems from the silencing of the Bucks accent. Gurney's own Gloucestershire voice was not silenced by the war, but after it he had to face a darker 'screen': the madness that, in 1922, led his family to commit him, first to Barnwood House Asylum and then to the City of London Mental Hospital in

Dartford, Kent. There, like that earlier countryman poet, John Clare, he went on writing poems; among them some of his best.

There is a last heart-rending glimpse of him in an essay by Edward Thomas's widow, Helen, who visited him in the Dartford asylum:

We arrived at the asylum which looked like – as indeed it was – a prison. A warder let us in after unlocking the door, and doors were opened and locked behind us as we were ushered into the building. We were walking along a bare corridor when we were met by a tall gaunt dishevelled man clad in pyjamas and dressing gown, to whom Miss Scott introduced me. He gazed with an intense stare into my face and took me silently by the hand. Then I gave him the flowers which he took with the same deeply moving intensity and silence. He then said: 'You are Helen, Edward's wife and Edward is dead.' I said, 'Yes, let us talk of him' [. . . .]

We spoke of country that he knew and which Edward knew too and he evidently identified Edward with the English countryside, especially that of Gloucestershire. I learned from the warder that Ivor Gurney refused to go into the grounds of the asylum. It was not his idea at all of countryside – the fields and woods and footpaths he loved so well – and he would have nothing to do with this travesty of something that was sacred to him [. . . .]

The next time I went I took with me one of Edward's own well-used Ordnance maps of Gloucester where he had often walked. This proved to have been a sort of inspiration, for Ivor Gurney at once spread it out on his bed and he and I spent the whole time I was there tracing with our fingers the lanes and byeways and villages of which he knew every step and over which Edward had walked. He spent that hour in re-visiting his beloved home, in spotting a village or a track, a hill or a wood and seeing it all in his mind's eye, a mental vision sharper and more actual for his heightened intensity. He trod, in a way we who were sane could not emulate, the lanes and fields he knew and loved so well, his guide being his finger tracing the way on the map. It was most deeply moving, and I knew that I had hit on an idea that gave him more pleasure than anything else I could have thought of. For he had Edward as his companion in this strange perambulation [. . . .]

Ivor Gurney died in 1937, after fifteen years in that asylum.

One of Gurney's letters from the Dartford asylum

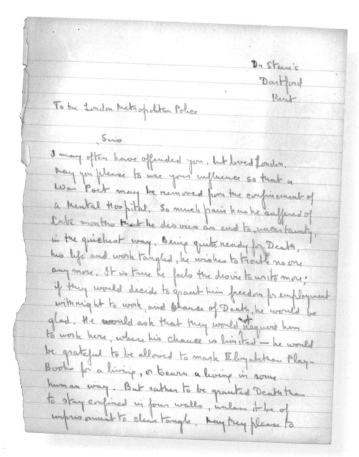

Bach and the Sentry

Watching the dark my spirit rose in flood
 On that most dearest Prelude of my delight.
The low-lying mist lifted its hood,
 The October stars showed nobly in clear night.

When I return, and to real music-making,
 And play that Prelude, how will it happen then?
Shall I feel as I felt, a sentry hardly waking,
 With a dull sense of No Man's Land again?

1917

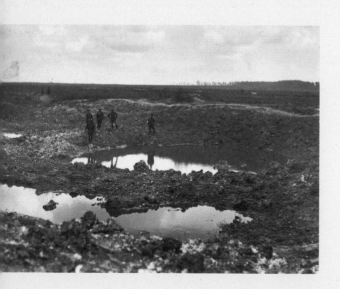

Servitude

If it were not for England, who would bear
This heavy servitude one moment more?
To keep a brothel, sweep and wash the floor
Of filthiest hovels were noble to compare
With this brass-cleaning life. Now here, now there
Harried in foolishness, scanned curiously o'er
By fools made brazen by conceit, and store
Of antique witticisms thin and bare.

Only the love of comrades sweetens all,
Whose laughing spirit will not be outdone.
As night-watching men wait for the sun
To hearten them, so wait I on such boys
As neither brass nor Hell-fire may appal,
Nor guns, nor sergeant-major's bluster and noise.

1917

Laventie

One would remember still
Meadows and low hill
Laventie was, as to the line and elm row
Growing through green strength wounded, as home elms grow.
Shimmer of summer there and blue autumn mists
Seen from trench-ditch winding in mazy twists.
The Australian gunners in close flowery hiding
Cunning found out at last, and smashed in the unspeakable lists.
And the guns in the smashed wood thumping and griding.

The letters written there, and received there,
Books, cakes, cigarettes in a parish of famine,
And leaks in rainy times with general all-damning.
The crater, and carrying of gas cylinders on two sticks
(Pain past comparison and far past right agony gone),
Strained hopelessly of heart and frame at first fix.

Café-au-lait in dug-outs on Tommies' cookers,
Cursed minniewerfs, thirst in eighteen-hour summer.
The Australian miners clayed, and the being afraid
Before strafes, sultry August dusk time than Death dumber –
And the cooler hush after the strafe, and the long night wait –

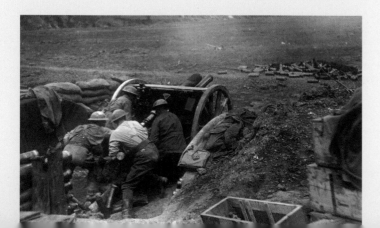

The relief of first dawn, the crawling out to look at it,
Wonder divine of dawn, man hesitating before Heaven gate.
(Though not on Cooper's where music fire took at it.
Though not as at Framilode beauty where body did shake at it)
Yet the dawn with aeroplanes crawling high at Heaven's gate
Lovely aerial beetles of wonderful scintillate
Strangest interest, and puffs of soft purest white –
Seeking light, dispersing colouring for fancy's delight.

Of Machonachie, Paxton, Tickler and Gloucester's Stephens;
Fray Bentos, Spiller and Baker, odds and evens
Of trench food, but the everlasting clean craving
For bread, the pure thing, blessèd beyond saving.
Canteen disappointments, and the keen boy braving
Bullets or such for grouse roused surprisingly through
(Halfway) Stand-to.
And the shell nearly blunted my razor at shaving;
Tilleloy, Fauquissart, Neuve Chapelle, and mud like glue.

But Laventie, most of all, I think is to soldiers
The town itself with plane trees, and small-spa air;
And vin, rouge-blanc, chocolat, citron, grenadine:
One might buy in small delectable cafés there.
The broken church, and vegetable fields bare;
Neat French market-town look so clean,
And the clarity, amiability of North French air.

Like water flowing beneath the dark plough and high Heaven,
Music's delight to please the poet pack-marching there.

1919–22

Ypres – Minsterworth

(*To F.W.H.*)

Thick lie in Gloucester orchards now
 Apples the Severn wind
With rough play tore from the tossing
 Branches, and left behind
Leaves strewn on pastures, blown in hedges,
 And by the roadway lined.

And I lie leagues on leagues afar
 To think how that wind made
Great shoutings in the wide chimney,
 A noise of cannonade –
Of how the proud elms by the signpost
 The tempest's will obeyed –

To think how in some German prison
 A boy lies with whom
I might have taken joy full-hearted
 Hearing the great boom
Of autumn, watching the fire, talking
 Of books in the half gloom.

O wind of Ypres and of Severn
 Riot there also, and tell
Of comrades safe returned, home-keeping
 Music and autumn smell.
Comfort blow him and friendly greeting,
 Hearten him, wish him well!

1919

To His Love

~~An undead~~ Soldier,

~~War Embers~~

He's gone, and all our plans
are useless indeed.
Will walk no more on Cotswold
Where the sheep feed
Quietly and take no heed

His body, that was so quick
Is not as you
Knew it. ~~and I am sick~~
Still, ~~at the~~ ~~Sailing Seven~~ on Seven rivers
~~Sailing the blue~~
Under the blue
Driving our small boat through.

You would not know him now. ~~- -~~
But still he died
~~Well~~ Nobly. So cover him over ~~in your tears~~ ~~musings~~
~~With a great pride~~
~~of violets.~~
With violets of pride
Purple from Seven side ~~bright tranq~~ Triumphant ~~grace~~
Blue bells of truth, ~~bright tranced~~
~~of~~ daffodillies, grace
On grace from most tender musings

1919

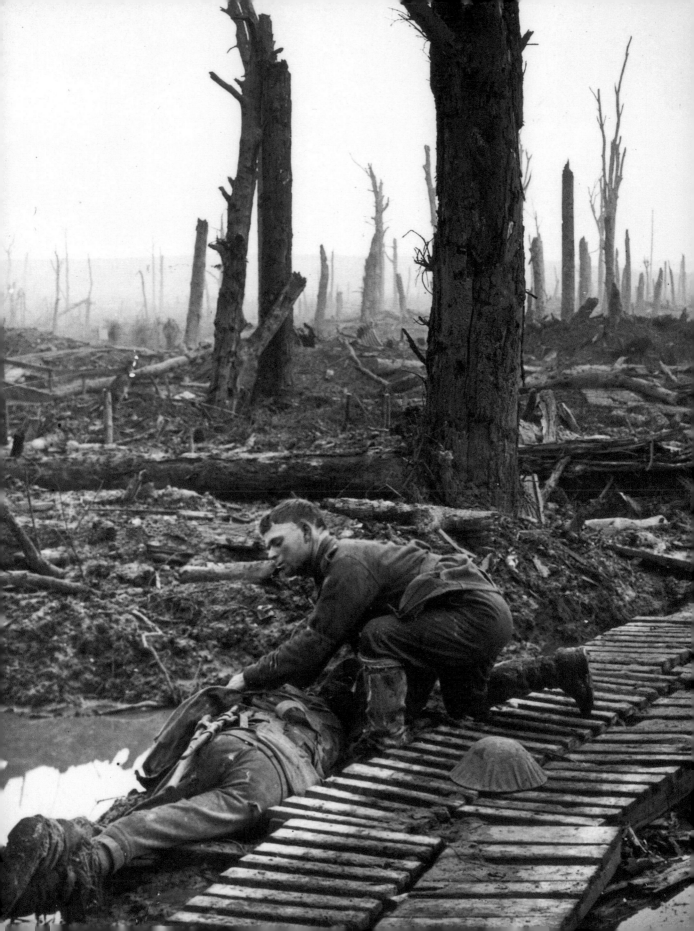

Towards Lillers

In October marching, taking the sweet air,
Packs riding lightly, and homethoughts soft coming,
'This is right marching, we are even glad to be here,
Or very glad?' But looking upward to dark smoke foaming,
Chimneys on the clear crest, no more shades for roaming,
Smoke covering sooty what man's heart holds dear,
Lillers we approached, a quench for thirsty frames,
And looked once more between houses and at queer names
Of estaminets, longed for cool wine or cold beer.
This was war; we understood; moving and shifting about;
To stand or be withstood in the mixèd rout
Of fight to come after this. But that was a good dream
Of justice or strength-test with steel tool a gleam
Made to the hand. But barb-wire lay to the front,
Tiny aeroplanes circled as ever their wont
High over the two ditches of heart-sick men;
The times scientific, as evil as ever again.
October lovely bathing with sweet air the plain.

1919–22

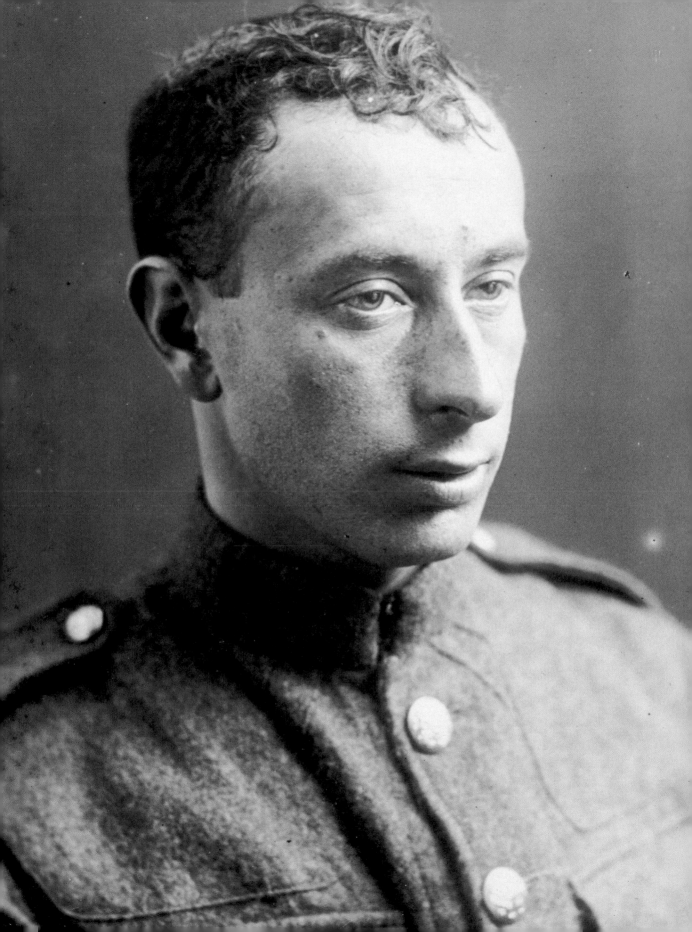

Isaac Rosenberg

Isaac Rosenberg was born in Bristol on 25 November 1890. His parents had emigrated from Russia some years before. When he was seven, the family moved to the East End of London in search of better-paid work, but they were not successful and the boy, whose health had never been good, developed a lung ailment. From the Board School of St George's in the East he went on to Stepney Board School, where his natural gift for drawing and writing so impressed the headmaster that he allowed him to spend most of his time on them. Out of school, he read poetry and drew with chalks on the pavements of the East End.

Obliged to leave school at fourteen, he was apprenticed to the firm of Carl Hertschel, engravers, in Fleet Street. His parents hoped that this might prove a stepping-stone to an artist's career, but Isaac hated the work, writing in a letter: 'It is horrible to think that all these hours, when my days are full of vigour and my hands craving for self-expression, I am bound, chained to this fiendish mangling machine, without hope and almost desire of deliverance.' Such phrasing shows the stamp of an earlier London poet and artist, William Blake, who was to remain the most potent influence on Rosenberg's writings. The earliest of his poems that survive, his 'Ode to David's Harp', was written when he was fifteen and included this stanza:

> The harp that faster caused to beat
> The heart that throbbed for war,
> The harp that melancholy calmed,
> Lies mute on Judah's shore.
> One chord awake – one strain prolong
> To wake the zeal in Israel's breast;
> Oh sacred lyre, once more, how long?
> 'Tis vain, alas! in silence rest.

The influence here is one of Byron's *Hebrew Melodies*: the lines beginning 'The harp the monarch minstrel swept'. Robert Graves said that Rosenberg, as a poet, was 'a born revolutionary', and certainly he stands in the line of such earlier revolutionaries as Blake, Byron, and Shelley. The subject of the 'Ode to David's Harp', and its relation to Byron's *Hebrew Melodies*, are also significant. Rosenberg was a Jew, steeped in Hebrew mythology and legend, but he had little Hebrew and less Yiddish, and the vision of his mature work was cosmic rather than sectarian, personal rather than specifically Jewish. Siegfried Sassoon – a fellow Jew – put it well:

I have recognized in Rosenberg a fruitful fusion between English and Hebrew culture. Behind all his poetry there is a racial quality – biblical and prophetic. Scriptural and sculptural are the epithets I would apply to him.

*Rosenberg shop,
Steward Street,
East End of
London*

Rosenberg wrote poems during his lunch-hours in Fleet Street, and in the evenings attended classes at the Art School of Birkbeck College. At last, his apprenticeship completed, he was free and in 1911 three generous Jewish women undertook to pay his tuition fees at the Slade School of Fine Art. There he came to know the artists Mark Gertler, David Bomberg, Jacob Kramer, William Roberts, Christopher Nevinson and Stanley Spencer, but increasingly found art and poetry incompatible and was drawn more towards poetry. 'Art is not a plaything,' he wrote, 'it is blood and tears, it must grow up with one; and I believe I have begun too late.' Even so, he was a capable draughtsman and painted some impressive landscapes, portraits and allegorical scenes, a few of which were shown at the Whitechapel Gallery's exhibition of twentieth-century art in 1914.

On leaving the Slade, he considered going to Russia, but it was difficult for a Jew to get a passport and he abandoned the idea. He had hoped to earn a living from his portraits, but in 1914 was told that his lungs were weak and was advised to seek a warmer climate. Having a married sister in Cape Town, he sailed for South Africa in June. There he painted some pictures, gave a series of lectures on modern art, and published a few articles and poems, but he was far from happy, as he made clear in a letter to Eddie Marsh (see p.12):

I am in an infernal city by the sea. This city has men in it – and these men have souls in them – or at least have the passages to souls. Though they are millions of years behind time, they have yet reached the stage of evolution that knows ears and eyes. But these passages are dreadfully clogged up: gold dust, diamond dust, stocks and shares, and Heaven knows what other flinty muck.

His reactions to the outbreak of The First World War were complex and found their way into a poem:

On Receiving News of the War
(*Cape Town, 1914*)

Snow is a strange white word;
No ice or frost
Has asked of bud or bird
For Winter's cost.

Yet ice and frost and snow
From earth to sky
This Summer land doth know.
No man knows why.

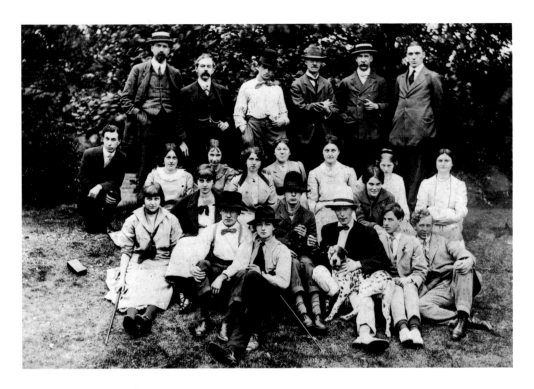

Rosenberg (kneeling far left) at the annual Slade School of Art picnic, 1912

In all men's hearts it is.
Some spirit old
Hath turned with malign kiss
Our lives to mould.

Red fangs have torn His face.
God's blood is shed.
He mourns from His lone place
His children dead.

O! ancient crimson curse!
Corrode, consume.
Give back this universe
Its pristine bloom.

Title page of Rosenberg's play Moses, *published in 1916*

His letter speaks of 'an infernal city', but so strong was the shaping influence of the pastoral tradition that, when he came to write his poem, the ominous snow – the 'strange white word' – was inscribed not in a cityscape but a *landscape*. He perceives the approaching violence more distinctly than many other poets; it is an 'ancient

crimson curse', but he hopes it may have a purging effect and restore the universe to its original prelapsarian innocence and beauty.

Although Rosenberg was later to express a dislike of Brooke's 'begloried sonnets' (as he called them), one of his own 1914 poems, 'The Dead Heroes', reveals a patriotism which, if less personal, is hardly less ardent:

> Flame out, you glorious skies,
> Welcome our brave,
> Kiss their exultant eyes;
> Give what they gave.
>
> Flash, mailèd seraphim,
> Your burning spears;
> New days to outflame their dim
> Heroic years.
>
> Thrills their baptismal tread
> The bright proud air;
> The embattled plumes outspread
> Burn upwards there.
>
> Flame out, flame out, O Song!
> Star ring to star,
> Strong as our hurt is strong
> Our children are.
>
> Their blood is England's heart;
> By their dead hands
> It is their noble part
> That England stands.
>
> England – Time gave them thee;
> They gave back this
> To win Eternity
> And claim God's kiss.

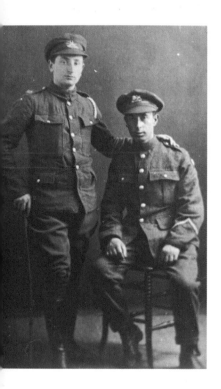

Isaac Rosenberg (seated) with his brother, Elkon, September 1917

Rosenberg's three-fold repetition of 'England' calls to mind its four-fold repetition in Brooke's 'The Soldier' (see p. 20), and his patriotic sentiments are more commonplace than those expressed in Brooke's sonnet. What Rosenberg really seems to be celebrating here is the English language: the language of Blake with its fire, spears, seraphim and stars. At much the same time, Wilfred Owen was writing: 'Do you know what would hold me together on a battlefield? The sense that I was perpetuating the language in which Keats and the rest of them wrote.'

In 1915 Rosenberg returned to England, where he published a small pamphlet of poems, *Youth*, and then enlisted in what was called the Bantam Regiment, being, as he said, 'too short for any other'. He enlisted purely to help his family, having been told that half his pay could be paid to his mother as a separation allowance. From the first, he hated the army, and the army, in the person of his 'impudent schoolboy pup' of an officer, disliked him. The Rosenbergs were 'Tolstoyans' and Isaac, himself the most vulnerable of men, hated the idea of killing. However, after a period of training at Bury St Edmunds and at Farnborough, he crossed the Channel early in 1916 with the King's Own Lancaster Regiment. He had not been at the Front long when he sent Eddie Marsh 'a poem I wrote in the trenches, which is surely as simple as ordinary talk'. This was 'Break of Day in the Trenches' (see p. 173 for a corrected typescript):

Letter from Rosenberg to Sonia Rodker

The darkness crumbles away.
It is the same old druid Time as ever,
Only a live thing leaps my hand,
A queer sardonic rat,
As I pull the parapet's poppy
To stick behind my ear.
Droll rat, they would shoot you if they knew
Your cosmopolitan sympathies.
Now you have touched this English hand
You will do the same to a German
Soon, no doubt, if it be your pleasure
To cross the sleeping green between.
It seems you inwardly grin as you pass
Strong eyes, fine limbs, haughty athletes,
Less chanced than you for life,
Bonds to the whims of murder,
Sprawled in the bowels of the earth,
The torn fields of France.
What do you see in our eyes
At the shrieking iron and flame
Hurled through still heavens?
What quaver – what heart aghast?
Poppies whose roots are in man's veins
Drop, and are ever dropping;
But mine in my ear is safe –
Just a little white with the dust.

Letter from Rosenberg to R.C. Trevelyan

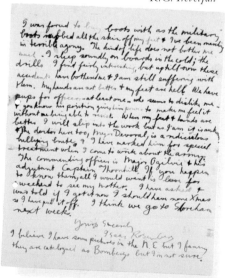

Rosenberg has absorbed – and in 'Break of Day in the Trenches' looks back on – the great tradition of pastoral poetry: his poppy nods to the rose of George Herbert's poem 'Virtue':

> Sweet rose, whose hue, angry and brave,
> Bids the rash gazer wipe his eye;
> Thy root is ever in its grave,
> And thou must die.

Curiously, though, given the battlefield context of Rosenberg's 'Break of Day', his tone is lighter, more informal and ironic than that of his peacetime predecessors. As his day breaks, 'The darkness crumbles away' like the dusty edge of the trench parapet that is the speaker's horizon. In the strange sentence that follows – 'It is the same old druid Time as ever' – we can see the figure of Old Father Time personified as a druid (standing perhaps before a druidic sacrificial altar), and can *hear* an alternative and complementary meaning: it is a customary time for druidic sacrifice – dawn. The colloquial setting of this image saves it from portentousness, and there is a wry good humour (altogether foreign to the great pastoral elegies) in the entrance on stage of the poem's protagonists:

> Only a live thing leaps my hand,
> A queer sardonic rat,
> As I pull the parapet's poppy
> To stick behind my ear

Sketch by Rosenberg

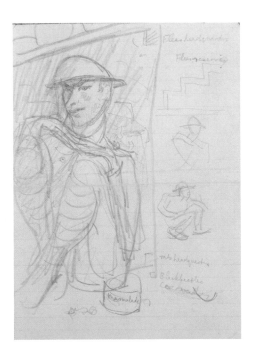

– just where a bullet might be expected to open another red flower if he were to lift his head above the parapet. But he keeps his head down because in this world of anti-pastoral the roles of man and rat are reversed: the man hiding as the rat commutes between the British and German lines. The creature is imagined to be inwardly grinning – in vengeful mockery, perhaps – as it passes the bodies of its former hunters, now

> Sprawled in the bowels of the earth,
> The torn fields of France.

The prophecy of 'On Receiving News of the War' – 'Red fangs have torn His face' – has been fulfilled. Man and Nature personified have both been torn. The poppy, too, has been torn from its root 'in man's veins' and, when we are told that the flower

[. . .] in my ear is safe
Just a little white with the dust

we know that, far from being safe, poppy and
man are ever dropping towards the charnel dust.

 This poem represents an advance on
'The Dead Heroes' as astonishing as that of
Owen's 'Anthem for Doomed Youth' on *his*
poems of 1914. And not the least astonishing
thing about 'Break of Day' is its impersonality,
the total absence of the bitterness and
indignation characteristic of Owen's poems.
Rosenberg is even capable of expressing active

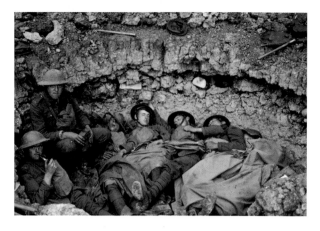

happiness, the 'lurid glee', as he calls it, of the demonic pantomime described in the
poem 'Louse Hunting', or the purer joy of 'Returning, We Hear the Larks':

Men resting in a
shell hole, 1918

 Sombre the night is.
And though we have our lives, we know
What sinister threat lurks there.

Dragging these anguished limbs, we only know
This poison-blasted track opens on our camp –
On a little safe sleep.

But hark! joy – joy – strange joy.
Lo! heights of night ringing with unseen larks.
Music showering our upturned list'ning faces.

Death could drop from the dark
As easily as song –
But song only dropped,
Like a blind man's dreams on the sand
By dangerous tides,
Like a girl's dark hair for she dreams
 no ruin lies there,
Or her kisses where a serpent hides.

Corrected
typescript of
Rosenberg's poem
'Daughters of
War'

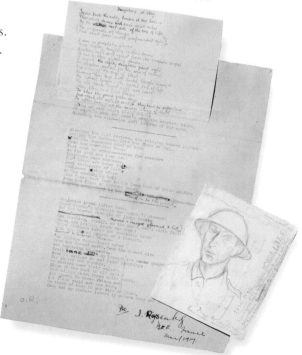

 This, Rosenberg's most complex version of
pastoral, evokes – even, obliquely, invokes – Shelley's
poem 'To a Skylark', whose 'unbodied joy . . .
Showers a rain of melody'. The Romanic poet had
supposed his sky-lark possessed of higher knowledge
than himself:

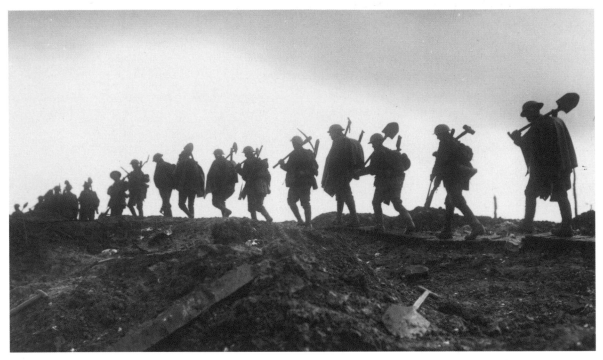

Working party,
January 1917

> Waking or asleep,
> Thou of death must deem
> Things more true or deep
> Than we mortals dream

By contrast, Rosenberg frames the lyrical centre of his poem with darker perceptions of destruction, but they are significantly different. Whereas the first six lines are grimly realistic, the bird's song diminishes the horror:

> Death could drop from the dark
> As easily as song –
> But song only dropped,
> Like a blind man's dreams on the sand
> By dangerous tides,
> Like a girl's dark hair for she dreams
> no ruin lies there,
> Or her kisses where a serpent hides.

Those closing similes reflect, like the similes in Shelley's poem, the poet's search for the precise quality of his inner experience: their happy dreams (in the shadow of perils imperceived) at once fulfilling and complicating the earlier promise of 'a little safe sleep'.

168

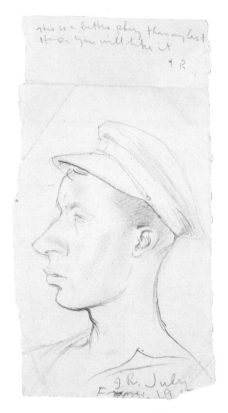

In poems like this and his masterpiece, 'Dead Man's Dump' (a title inviting comparison with 'The Dead Heroes'), Rosenberg succeeded in his intention of writing what he called 'Simple poetry, – that is where an interesting complexity of thought is kept in tone and right value to the dominating idea so that it is understandable and still ungraspable.'

On 28 March 1918 he ended a letter to Eddie Marsh:

I think I wrote you I was about to go up the line again after our little rest. We are now in the trenches again, and though I feel very sleepy, I just have a chance to answer your letter, so I will while I may. It's really my being lucky enough to bag an inch of candle that incites me to this pitch of punctual epistolary. I must measure my letter by the light [. . . .]

Before this letter was postmarked 2 April 1918, Isaac Rosenberg was dead.

Self-portrait sketch in a letter, 1917

Self-portrait in a pink tie, 1914

169

August 1914

What in our lives is burnt
In the fire of this?
The heart's dear granary?
The much we shall miss?

Three lives hath one life –
Iron, honey, gold.
The gold, the honey gone –
Left is the hard and cold.

Iron are our lives
Molten right through our youth.
A burnt space through ripe fields,
A fair mouth's broken tooth.

1916

[A Worm Fed on the Heart of Corinth]

A worm fed on the heart of Corinth,
Babylon and Rome:
Not Paris raped tall Helen,
But this incestuous worm,
Who lured her vivid beauty
To his amorphous sleep.
England! Famous as Helen
Is thy betrothal sung
To him the shadowless,
More amorous than Solomon

1916

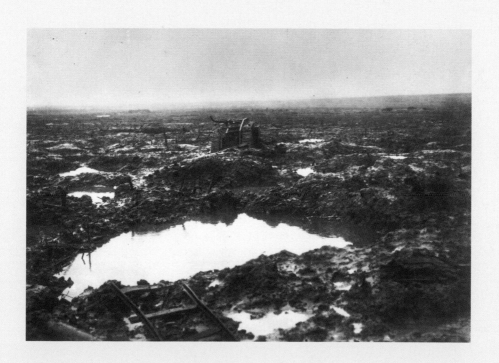

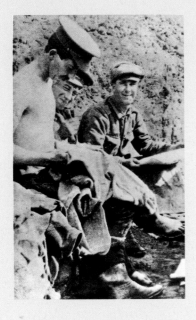

Louse Hunting

Nudes – stark and glistening,
Yelling in lurid glee. Grinning faces
And raging limbs
Whirl over the floor one fire.
For a shirt verminously busy
Yon soldier tore from his throat, with oaths
Godhead might shrink at, but not the lice.
And soon the shirt was aflare
Over the candle he'd lit while we lay.

Then we all sprang up and stript
To hunt the verminous brood.
Soon like a demons' pantomime
The place was raging.
See the silhouettes agape,
See the gibbering shadows
Mixed with the battled arms on the wall.
See gargantuan hooked fingers
Pluck in supreme flesh
To smutch supreme littleness.
See the merry limbs in hot Highland fling
Because some wizard vermin
Charmed from the quiet this revel
When our ears were half lulled
By the dark music
Blown from Sleep's trumpet.

1917

Break of day in the trenches.

The darkness crumbles away.

It is the same old Druid Time as ever,

Only a live think leaps my hand,

A queer sardonic rat,

As I pull the parapets poppy

To stick behind my ear.

Droll rat, they would shoot you if they knew

Your cosmopolitan sympathies,

~~(And God knows what antipathies).~~

Now you have touched this English hand

You will do the same to a German

Soon, no doubt, if it be your pleasure

To cross the sleeping green between,

It seems odd thing, you grin as you pass

Strong eyes, fine limbs, haughty athletes,

Less chanced than you for life,

Bonds to the whims of Murder,

Sprawled in the bowels of the earth

The torn fields of France.

What do you see in our eyes

~~At the boom, the hiss, the swiftness,~~

~~The irrevocable earth--buffet....~~

~~What rockets ~~~~~~~~~ drooping~~

But mine in my ear is safe---

Just a little white with the dust.

At the shrieking iron & flame
Hurl'd through still heavens?
What quaver — what heart aghast?
Poppies whose roots are in mans veins
Drop, & are ever dropping.

Isaac Rosenberg.
June. 1916.

a.R.

Dead mans dump.

The plunging limbers over the shattered track
Racketted with their rusty freight,
Stuck out like many crowns of thorns,
And the rusty stakes like sceptres old
To stay the flood of brutish men
Upon our brothers dear.

The wheels lurched over sprawled dead
But pained them not, though their bones crunched,
Their ~~clenched~~ mouths made no moan,.
They lie there huddled, friend and forman;
Man born of man, and born of woman,
And shells go crying over them
From night till night and now.

shut.

Earth has waited for them
All the time of their growth
Fretting for their decay:
Now she has them at last!
In the strength of their strength
Suspended-- stopped and held.

Now let the seasons know
There are some less to feed of them,
That Winter need not hoard her snow,
Nor Autumn her fruits and grain.

What fierce imaginings their dark souls lit
Earth! have they gone into you!
Somewhere they must have gone,
And flung on your hard back
Is their souls sack
~~Emptied of all that made it more than the world~~ *Emptied of God ancestralled essences.*
~~In its small fleshly compass.~~
Who hurled them out? Who hurled?

None saw their spirits shadow shake the grass,
Or stood aside for the half used life to pass
Out of those doomed nostrils and the doomed mouth,
When the swift iron burning bee
Drained the wild honey of their youth.

What of us, who flung on the shrieking pyre,
Walk, our usual thoughts untouched,
Our lucky limbs as on ichor fed,
Immortal seeming ever!
Perhaps when the flames beat loud on us,
A fear may choke in our veins
And the startled blood may stop.

174

2

The air is loud with death,
The dark air spurts with fire
The explosions ceaseless are,
Timelessly now, some minutes past,
These dead strode time with vigorous life,
Till the shrapnel called 'an end!'
But not to all. In bleeding pangs,
Some born on stretchers, dreamed of home,
Dear things, war-blotted from their hearts.

A man's brains splattered on
A stretcher bearer's face;
His shook shoulders slipped its load,
But when they bent to look again,
The drowning souldwas sunk too deep
For human tenderness.

They left this dead with the older dead,
Stretched at the cross roads.

Burnt black by strange decay,
Their sinister faces lie
The lid over each eye,
The grass and coloured clay
More motion have than they,
Joined to the great sunk silences.

Here is one not long dead;
His dark hearing caught our far wheels,
And the choked soul stretched weak hands
To reach the living word the far wheels said,
The blood dazed intelligence beating for light,
Crying through the suspence of the far torturing wheels,
Swift for the end to break,
Or the wheels to break,
Cried as the tide of the world broke over his sight.

Will they come? Will they ever come?
Even as the mixed hoofs of the mules,
The quivering bellied mules,
And the rushing wheels all mixed
With his tortured upturned sight,
So we crashed round the bend,
We heard his weak scream,
We heard his very last sound,
And our wheels grazed his dead face.

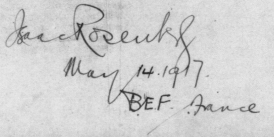

Isaac Rosenberg
May 14.1917.
B.E.F. France

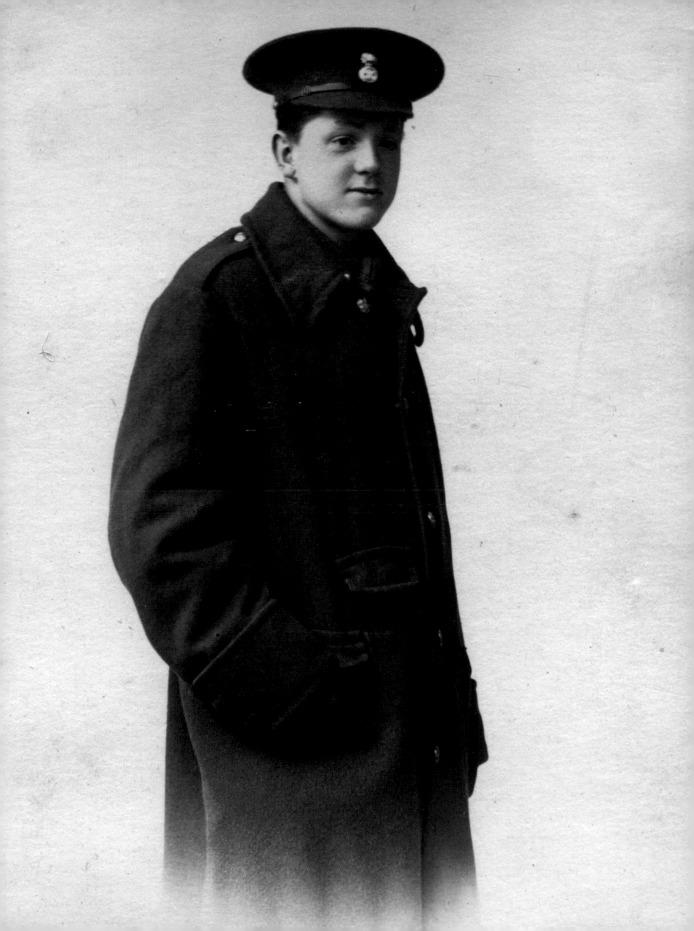

David Jones

David Jones was born on 1 November 1895 in Brockley, Kent, the youngest of three children of a Welsh father, James Jones, printer, and an English mother, Alice. From 1910 to 1914, he studied at Camberwell School of Art. At the outbreak of war, he tried, unsuccessfully, to join the Artists' Rifles and some new Welsh cavalry, before enlisting in the Royal Welch Fusiliers. Unlike Graves and Sassoon (see pp. 83 and 63), he served in that regiment as a private soldier, surviving the opening of the Battle of the Somme but being wounded in the leg on 11 July 1916 in the attack on Mametz Wood. He was back in action that October, but left France with severe trench fever in February 1918.

On demobilization, he at first wished to rejoin, but in 1919 accepted a grant to work at Westminster School of Art. He perceived connections between Post-Impressionist theory and Catholic sacramental theology and in 1921 became a Roman Catholic, working with Eric Gill, the engraver and stone-carver, whose own Roman Catholic and artistic beliefs strongly influenced Jones's. His life was his work. He lived alone, frequently in poverty, but with the support of many friends, who loved him for his great learning, his generosity, gaiety and good humour; qualities that survived increasing eye trouble, chronic insomnia, and breakdowns in 1932 and 1947. His later writings include the obscure but powerful long religious poem, *The Anathemata* (1952), and the *The Sleeping Lord and Other Fragments* (1973). There were major retrospective exhibitions of his drawings and paintings at the National Museum of Wales and the Tate Gallery in 1954-5 and (posthumously) in 1981. The recipient of numerous awards, honours, and prizes, he died in 1974.

Jones began *In Parenthesis,* his first literary work, in 1927 (as Blunden, Graves and Sassoon were at work on *their* memoirs of the war), but it was not published until 1937. T. S. Eliot 'was proud to share the responsibility for that first publication'. He thought it 'a work of genius' and wrote 'A Note of Introduction' to its 1961 reissue. Long before, reviewing James Joyce's novel, *Ulysses,* he had written:

In using the myth, in manipulating a continuous parallel between contemporaneity and antiquity, Mr. Joyce is pursuing a method which others must pursue after him [. . . .] It is simply a way of controlling, of ordering, of giving a shape and a significance to the immense panorama of futility and anarchy which is contemporary history.

When Eliot wrote that, in 1932, he had already fulfilled his own prophecy with *The Waste Land.* That poem and Joyce's novel showed David Jones 'a way of controlling, of ordering, of giving shape and a significance to' his own bitter experience of 'the futility and anarchy which is contemporary history', namely, his experience as a private soldier in the First World War.

The underlying narrative of *In Parenthesis*, like those underlying *Ulysses* and *The Waste Land*, is a journey: in Jones's case, that of an infantry platoon from a parade-

Jones's wartime sketchbook

ground in England to a killing-ground in France. An old Welsh poem, *The Gododdin* (attributed to the sixth-century poet, Aneirin), provides the mythic sub-structure for Jones's narrative. It commemorates the raid of 300 Celtic warriors of the tribe of Gododdin into the Saxon kingdom of Deira, and describes the ensuing battle at Catraeth (Catterick in Yorkshire). From this, 'but a single man returned' – perhaps an echo of the messenger's refrain in the Old Testament Book of Job: 'I only am escaped to tell thee.'

In Parenthesis is a difficult work. Jones called it a 'writing', at once acknowledging and dodging his reader's first question: 'Is it poetry or prose?' The answer is 'both'. It has the narrative structure we associate with the novel, but its language at many points takes on the allusiveness, density and momentum of poetry. This blending of categories, like its blending of matter ancient and modern, unsettles the reader – as, clearly, Jones meant us to be unsettled – and leaves us with the problem of how 'this writing' is to be read. Some of its most attentive readers have come to different conclusions. Herbert Read found it 'as near a great epic of the war as ever the war generation will reach.' Paul Fussell, however, holding that the Great War 'will not be understood in traditional terms,' thinks *In Parenthesis* 'curiously ambiguous and indecisive [....] a deeply conservative work which uses the past not, as it often pretends to do, to shame the present, but really to ennoble it.' In his view, it is an 'honourable miscarriage' by a 'turgid allusionist'. His criticisms raise crucial questions, which bear on how 'this writing' is to be read, a problem I should like to consider.

Jones's map, drawn to illustrate the sector described in Parts 3 and 4 of In Parenthesis

Setting aside for a moment Jones's Preface, in which he speaks frankly and informally, as author to reader, we are introduced in the dedication to the more hieratic intonation of the poet. Its

opening words proclaim it part of the work – 'THIS WRITING IS FOR MY FRIENDS'. Printed in capital letters and without punctuation, it looks like a war memorial and sounds like a poem. The dedication states the theme, which is the commemoration of the dead – friends and enemies who shared the same pains. The dedication is followed by a quotation from another old Welsh text, *The Mabinogion*, and the title of Part I, 'THE MANY MEN SO BEAUTIFUL,' which invites the reader to remember a stanza from Coleridge's 'Rime of the Ancient Mariner':

> The many men so beautiful
> And they all dead did lie:
> And a thousand thousand slimy things
> Lived on; and so did I.

The title of Part I is followed by a epigraph, in which another lone survivor speaks:

> Men marched, they kept equal step . . .
> Men marched, they had been nurtured together.

Soldier attending to a grave near Mametz Wood, August 1916

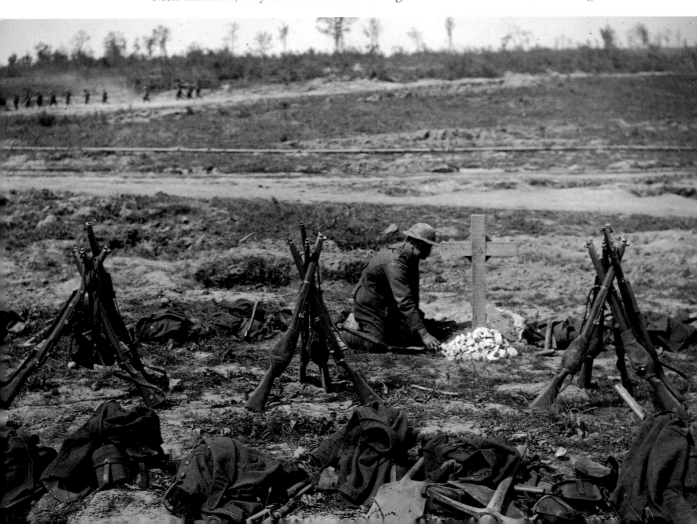

Even a Welsh reader might not recognize the source of these lines as *The Gododdin*, but neither will an Irish reader recognize the source of every quotation in Joyce's *Ulysses*. Modernist writers, however, have taught their readers how to respond to this strategy and, if the author of *In Parenthesis* is a 'turgid allusionist', as Fussell charges, the authors of *Ulysses* and *The Waste Land* must stand indicted of the same offence – and to a greater degree, in that their allusions are culled from wider fields of reference.

Jones, unlike Joyce, assists his reader with notes, so there can be no mistaking the one message of his three preliminary quotations. They introduce the action like the voice of the Chorus in Greek tragedy, and the descendants of those who died at Catraeth once again keep 'equal step':

> '49 Wyatt, 01549 Wyatt.
> Coming sergeant.
> Pick 'em up, pick 'em up – I'll stalk within yer chamber.
> Private Leg . . . sick.
> Private Ball . . . absent.

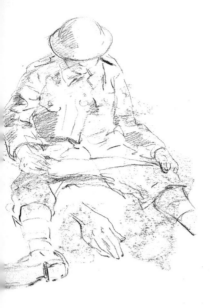

Two sketches from Jones's notebook

The shift of tone – from tragic poetry to comic prose – is bold and brilliantly successful. One must not overlook the jokes: that at the expense of Sir Thomas Wyatt's poem beginning:

> They flee from me that sometime did me seek
> With naked foot stalking in my chamber

which appeared in his book, *Certayne Psalms*, published in 1549 – '01549 Wyatt' – and, more important, Jones's pun on his hero's name. Fussell misses two-thirds of the point when he says that John Ball is 'named after the priest who led the Peasant's Revolt in 1381.' The Private Ball, who follows Private Leg in the sergeant's roster, is sacerdotal, surely, but also ballistic and – it must be said – anatomical.

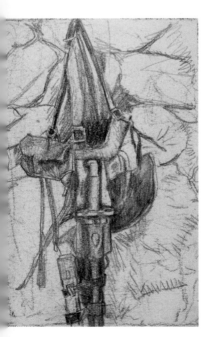

Jones's bardic predecessor, Aneirin, had celebrated the high-ranking heroes of *The Gododdin* in a high style. The low-ranking celebrant of a more democratic age suits his style to his lower ranking heroes, though his ear is marvellously attuned to social distinctions. As befits a poet whose earliest memory 'was of a thing of great marvel – a troop of horses moving a column to the *tarantara* of bugles,' and who thereupon resolved 'some day I shall ride on horseback,' his mounted officers are generally presented in chivalric terms. The platoon commander, Mr Jenkins, in keeping with his lower station, is presented in gentlemanly terms: 'The Squire from the Rout of San Romano

smokes Melachino No. 9.' Jones, the painter, is alluding to the young man in the foreground of Paolo Uccello's great painting, 'Rout of San Romano', who sits erect in the saddle, as we first see Mr Jenkins: 'flax head held front . . . unhelmeted.' Jones presents him affectionately:

Mr. Jenkins got his full lieutenancy on his twenty-first birthday, and a parcel from Fortnum and Mason; he grieved for his friend, Talbot Rhys [killed and left hanging on the wire], and felt an indifference to the spring offensive – and why was non-conforming Captain Gwyn so stuffy about the trebled whisky chits.

With two exceptions, all the characters in *In Parenthesis* are presented sympathetically, including 'the enemy front-fighters' and those who pray for them behind the lines:

But all the old women in Bavaria are busy with their novenas, you bet your life, and don't sleep lest the watch should fail, nor weave for the wire might trip his darling feet and the dead Karl might not come home.

Jones's sketch of platoon commander

Jones has his indignation, but it is reserved for a certain category of non-combatants first referred to in Part 2. Entitled 'CHAMBERS GO OFF, CORPORALS STAY', this opens with the troops being lectured 'in the barn, with its great roof, sprung, upreaching, humane, and redolent of a vanished order.' There are lectures on hygiene by the medical officer, 'who glossed his technical discourses with every lewdness, whose heroism and humanity reached towards sanctity.' Like the great roof of the barn, upreaching, humane, he speaks of a vanished order, but 'The old order changeth, yielding place to new,' and Jones portrays the representative of the new order less kindly:

the Bombing Officer [. . .] told them lightly of the efficacy of his trade; he predicted an important future for the new Mills Mk. IV grenade, just on the market; he discussed the improvised jam-tins of the veterans, of the bombs of after the Marne, grenades of Loos and Laventie – he compared these elementary, amateurish, inefficiencies with the compact and supremely satisfactory invention of this Mr. Mills, to whom his country was so greatly indebted.

Long before the Bombing Officer takes his leave 'like a departing commercial traveller', Jones's scornful irony has told us that he is no gentleman and has no understanding of history, heroism or humanity. This theme is developed further at the end of Part 2, when his hero is introduced to the supremely satisfactory invention of someone in Mr Mills's line of trade: a shell that narrowly misses him, 'a stinking physicist's destroying toy.'

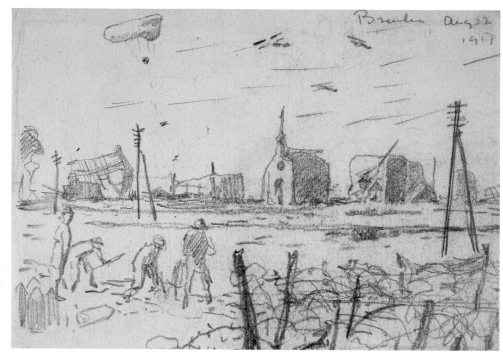

Jones's 1917 sketch of a parachute, barbed wire and a ruined church

The indictment of the scientist is delivered more coolly and searchingly in the Preface:

We feel a rubicon has been passed between striking with a hand weapon as men used to do and loosing poison from the sky as we do ourselves. We doubt the decency of our inventions [. . . .]

Not everyone would feel the same about the decency of 'striking with a hand weapon', but Jones's use of the word is revealing. Decency is the distinguishing characteristic of the gentlemen, that nineteenth-century mutation of the medieval knight. The traditions of the gentleman were chivalric, humanistic and tended to produce a deep distrust of science. The subject of *In Parenthesis* is the destruction of an old order – still recognizably chivalric – by a new disorder, here represented by the 'physicist's destroying toy'.

The imminence of that destruction reinforces the tragic dignity with which Mr Jenkins's platoon prepares for what the reader knows will be its last battle. Two moments of preparation, in particular, evoke the rituals of the old order, and at both the narrator adopts the shorter line, the higher style, of poetry. As Cibno, in *The Gododdin*, took communion and his comrades drank together before setting off for Catraeth, so the men of No. 1 section receive the sacrament – 'one-third part of a loaf' and a share of the 'half mess-tin of rum':

Opposite below: *British raiding party under fire, March 1917*

> Come off it Moses – dole out the issue.
> Dispense salvation,
> strictly apportion it,

let us taste and see,
let us be renewed,
for christ's sake let us be warm.
O have a care – don't spill the precious
O don't jog his hand – ministering;
do take care.
O please – give the poor bugger elbow room.

The sacrament of the Last Supper is followed – as the mead-drinking of Aneirin's warriors was followed – by the boast. Dai Great-coat articulates his English with an

alien care.
 My fathers were with the Black Prinse of Wales
at the passion of
the blind Bohemian king.
They served in these fields [. . . .]

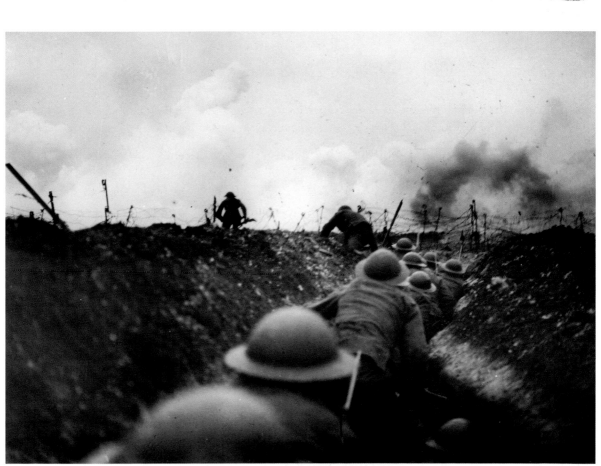

Dai's boast, modelled on Taliesin's boast in *The Mabinogion*, asserts that he was present at all the major moments in the history of the 'hand weapon', from the primal war in Heaven to the Crucifixion and after.

That history begins its last chapter with Part 7 of *In Parenthesis*, entitled 'THE FIVE UNMISTAKEABLE MARKS'. The allusion to the five wounds of the crucified Christ is balanced by the secular epigraph:

> Gododdin I demand thy support.
> It is our duty to sing: a meeting
> place has been found.

Invoking Aneirin's aid, in Aneirin's words, Jones proceeds to discharge his duty as a poet: he *sings* – there is more poetry in Part 7 than in any other – of the meeting at Mametz Wood in July 1916. As the platoon waits to go over the top at 'the place of a skull', the first of the comrades is killed:

> No one to care there for Aneirin Lewis spilled there
> Who worshipped his ancestors like a chink
> Who sleeps in Arthur's lap [. . . .]

At zero hour, their platoon commander takes them over the top:

> Mr. Jenkins half inclined his head to them – he walked just
> barely in advance of his platoon and immediately to the left of
> Private Ball.
> He makes the conventional sign
> and there is the deeply inward effort of spent men who would
> make response for him,
> and take it at the double.
> He sinks on one knee
> and now on the other,
> his upper body tilts in rigid inclination
> this way and back;
> weighted lanyard runs out to full tether,
> swings like a pendulum
> and the clock run down.
> Lurched over, jerked iron saucer over tilted brow,
> clampt unkindly over lip and chin
> nor no ventaille to this darkening
> and masked face lifts to grope the air
> and so disconsolate;
> enfeebled fingering at a paltry strap –
> buckle holds,
> holds him blind against the morning.

That *ventaille* – the old French word for a helmet's movable visor – reminds us that it is the Squire from the Rout of San Romano who has fallen. One by one, the 'family' – Jones's word, as it was Blunden's – is cut down until Private Ball finds himself first 'alone in a denseness of hazel-brush', and then shot in the legs. He crawls away, encumbered by his rifle:

Background image: *British and German wounded on stretchers outside a dressing station, August 1916*

> Slung so, it swings its full weight. With you going
> blindly on all paws, it slews its whole length, to hang
> at your bowed neck like the Mariner's white oblation [. . . .]
> Hung so about, you make [. . .] your close escape.

Once again we hear the voice of the survivor: 'I only am escaped to tell thee.' But his elegy for his friends is not yet finished, and we share the wounded man's pastoral hallucination of the Queen of the Woods dispensing garlands to the dead:

> Some she gives white berries
> some she gives brown
> Emil has a curious crown it's
> made of golden saxifrage.
> Fatty wears sweet-briar,
> he will reign with her for a thousand years.
> For Balder she reaches high to fetch his.
> Ulrich smiles for his myrtle wand.
> That swine Lillywhite has daisies to his chain – you'd hard-
> ly credit it.
> She plaits torques of equal splendour for Mr. Jenkins and
> Billy Crower.
> Hansel with Gronwy share dog-violets for a palm, where
> they lie in serious embrace beneath the twisted tripod.

The modern poet makes no distinction between officer and private soldier; they receive 'torques [gold collars] of equal splendour', and German and Welshman, friend and so-called enemy, embrace. At the last, the survivor disengages himself from his rifle, as the Ancient Mariner (see p.179) had disengaged himself from his albatross. We infer that Private Ball, too, has expiated his guilt as a killer and, having escaped, must tell. His message, however, is not that of Aneirin: the celebration of the heroic dead, that their names may live and their example be followed. David Jones bears witness to the death of friends, many of whom never saw the men who killed them.

In *The Great War and Modern Memory*, Paul Fussell gives a brilliant account of the extent to which British soldiers of all ranks were steeped in English literature, and of the extent to which this shaped their responses to the experience of the trenches. His understandable revulsion from the horrors of that experience leads him,

however, to deny the inescapable conclusion of his own evidence and seriously mis-read *In Parenthesis*. Jones, he says,

has attempted [. . .] to elevate the new Matter of Flanders and Picardy to the status of the old Matter of Britain. That it refuses to be so elevated, that it resists being subsumed into the heroic myth is less Jones's fault than the war's. The war will not be understood in traditional terms [. . . .]

But Fussell's own evidence shows that Jones – and Blunden and many others – *did* see the war (at least up to July 1916, the time-span of *In Parenthesis*) in traditional terms. It comforted them to feel that they were sharing their parapet with Shakespeare's Fluellen and Malory's knights. Jones's battlefield is one on which past and future clash in unequal combat. The poet celebrates the traditional humanity his heroes show to one another, their courage in the face of almost certain death, as he execrates the inhumanity of the mechanistic forces brought against them.

He dedicated *In Parenthesis* to

> [. . .] MY FRIENDS [. . .]
> AND TO THE ENEMY
> FRONT-FIGHTERS WHO SHARED OUR
> PAINS AGAINST WHOM WE FOUND
> OURSELVES BY MISADVENTURE

The crucial conclusion to that long dedication calls to mind a poem by another poet of Welsh descent, Wilfred Owen's 'Strange Meeting':

> It seemed that out of battle I escaped
> Down some profound dull tunnel, long since scooped
> Through granites which titanic wars had groined.

And again the Book of Job: 'I only am escaped to tell thee.' Owen's speaker too, tells of friendship, that of a 'strange friend' who tells *him*:

> 'I am the enemy you killed, my friend.
> I knew you in this dark: for so you frowned
> Yesterday through me as you jabbed and killed.
> I parried; but my hands were loath and cold.
> Let us sleep now . . .'

A ghostly whisper from beyond the grave is perhaps a fitting note on which to end an account of the soldier poets' witness to the First World War.

THIS WRITING IS FOR MY FRIENDS
IN MIND OF ALL COMMON & HIDDEN
MEN AND OF THE SECRET PRINCES
AND TO THE MEMORY OF THOSE
WITH ME IN THE COVERT AND IN
THE OPEN FROM THE BLACKWALL
THE BROADWAY THE CAUSEWAY
THE CUT THE FLATS THE LEVEL THE
ENVIRONS AND THOSE OTHERS
FROM TREATH VAWR AND LONG
MOUNTAIN THE HENDREF AND Y
HAFOD THE PENTRE PANDY AND Y
TAREN THE MAELORS THE BOUNDARY
WALLS AND NO. 4 WORKING
ESPECIALLY PTE. R.A. LEWIS-GUNNER
FROM NEWPORT MONMOUTHSHIRE
KILLED IN ACTION IN THE BOE-
SINGHE SECTOR N.W. OF YPRES
SOME TIME IN THE WINTER 1916-17
AND TO THE BEARDED INFANTRY
WHO EXCHANGED THEIR LONG
LOAVES WITH US AT A SECTOR'S
BARRIER AND TO THE ENEMY
FRONT-FIGHTERS WHO SHARED OUR
PAINS AGAINST WHOM WE FOUND
OURSELVES BY MISADVENTURE

published 1937

Further Reading

General texts

Anthologies:

Up the Line to Death: The War Poets, 1914-1918, ed. Brian Gardner (London: Methuen, 1964, rev. ed. 1986)

Men Who March Away: Poems of the First World War, ed. I. M. Parsons (London: Chatto & Windus, 1965)

The Penguin Book of First World War Poetry, ed. Jon Silkin (London: Penguin, 2nd ed. rev., 1996)

The Penguin Book of First World War Prose, ed. Jan Glover and Jon Silkin (London: Penguin, 1990)

English Poetry of the First World War: A Bibliography, Catherine W. Reilly (London: G. Prior, 1978)

The Lost Voices of World War I, ed. Tim Cross (London: Bloomsbury, 1988)

Experience of War: An Anthology of Articles from MHQ, The Quarterly Journal of Military History, ed. Robert Cowley (New York & London: Norton, 1992)

Critical studies and histories

Drummer Hodge: The Poetry of the Anglo-Boer War, 1899-1902, Malvern Van Wyk Smith (Oxford: The Clarendon Press, 1978)

The Great War and Modern Memory, Paul Fussell (Oxford: Oxford University Press, 1975)

A War Imagined: The First World War and British Culture, Samuel Hynes (London: Pimlico, 1990)

Heroes' Twilight: A Study of the Literature of the Great War, Bernard Bergonzi (Manchester: Carcanet, 3rd ed., 1996)

English Poetry of the First World War: A Study in the Evolution of Lyric and Narrative Form, John H. Johnston (Princeton and London: Princeton University Press and Oxford University Press, 1964)

Out of Battle: The Poetry of the Great War, Jon Silkin (Basingstoke: Macmillan, 2nd ed., 1998)

The Truth of War: Owen, Blunden and Rosenberg, Desmond Graham (Manchester: Carcanet, 1984)

The Flower of Battle: British Fiction Writers of the First World War, Hugh Cecil (London: Secker & Warburg, 1998)

The German Poets of the First World War, Patrick Bridgwater (London: Croom Helm, 1985)

British and French Writers of the First World War, Frank Field (Cambridge: Cambridge University Press, 1991)

The Experience of World War I, J. M. Winter (London: Macmillan, 1988)

The First World War, John Keegan (London: Hutchinson, 1999)

The Oxford Illustrated History of the First World War, ed. Hew Strachan (Oxford: Oxford University Press, 1999)

The First World War, vol. I: To Arms, Hew Strachan (Oxford: Oxford University Press, 2001)

Battlefields

Before Endeavours Fade, Rose E. Coombs (London: Battle of Britain Prints, Ltd., 7th ed., 1994)

The Routledge Atlas of the First World War, Martin Gilbert (London: Routledge, 1994)

A Military Atlas of the First World War, Arthur Banks (London: Leo Cooper, 1997)

The Poets

RUPERT BROOKE
Primary texts

The Poetical Works of Rupert Brooke, ed. Geoffrey Keynes (London: Faber, 1970)

The Letters of Rupert Brooke, ed. Geoffrey Keynes (London: Faber, 1968)

Rupert Brooke / Four Poems, Drafts and fair copies in the author's hand with a Foreword and Introduction by Geoffrey Keynes (London: Folio Society, 1974)

Song of Love: The Letters of Rupert Brooke and Noel Oliver, ed. Pippa Harris (London: Bloomsbury, 1991)

Friends and Apostles: The Correspondence of Rupert Brooke and James Strachey, ed. Keith Hale (New Haven and London: Yale University Press, 1998)

Biography and critical works

Rupert Brooke / A Biography, Christopher Hassell (London: Faber, 1972)

The Neopagans: Friendship and Love in the Rupert Brooke Circle, Paul Delany (London: Macmillan, 1987)

Rupert Brooke: Life, Death and Myth, Nigel H. Jones (London: R. Cohen, 1999)

JULIAN GRENFELL
Biography and critical works

Julian Grenfell: His Life and the Times of His Death, 1888-1915, Nicholas Mosley (London: Persephone [1976] revised 2000 with a new preface by the author)

CHARLES SORLEY
Primary texts

The Collected Letters of Charles Hamilton Sorley, ed. Jean Moorcroft Wilson (London: Cecil Woolf, 1990)

Collected Poems, ed. Jean Moorcroft Wilson (London: Cecil Woolf, 1995)

Poems and Selected Letters, ed. Hilda D. Spear (Dundee: Blackness Press, 1978)

Biography and critical works

Charles Hamilton Sorley: a Biography, Jean Moorcroft Wilson (London: Cecil Woolf, 1985)

The Ungirt Runner: Charles Hamilton Sorley, Poet of World War I, Thomas Burnett Swann (Hamden, Conn.: Archon Books, 1965)

FRANCIS LEDWIDGE
Primary texts

The Complete Poems of Francis Ledwidge, ed. Alice Curtayne (Dublin: Poolbeg Press, new ed. 1998)

Selected Poems, ed. Dermot Bolger, introduced by Seamus Heaney (Dublin: New Island Books, 1992)

Biography and critical works

Francis Ledwidge: A Life of the Poet, 1887-1917, Alice Curtayne (Dublin: New Island Books, 1998)

Francis Ledwidge: Song of the Blackbird, Elizabeth Cassidy Olson (Lincoln, NE: Writers Club Press, 2000)

SIEGFRIED SASSOON
Primary texts
War Poems, ed. Rupert Hart-Davis (London: Faber, 1983)
Collected Poems, 1908-56 (London: Faber, 1961)
Memoirs of an Infantry Officer (London: Faber, 1930)
Sherston's Progress (London: Faber, 1936)
Siegfried's Journey (London: Faber, 1945)
Diaries, 1915-18, ed. Rupert Hart-Davis (London: Faber, 1983)
Diaries, 1920-21, ed. Rupert Hart-Davis (London: Faber, 1981)
Diaries, 1923-25, ed. Rupert Hart-Davis (London: Faber, 1985)

Biography and critical works
Siegfried Sassoon: A Critical Study, Michael Thorpe (Leiden and London: Leiden University Press and Oxford University Press, 1966)
Siegfried Sassoon: The Making of a War Poet, 1896-1918, Jean Moorcroft Wilson (London: Duckworth, 1998)
Siegfried Sassoon: A Study of the War Poetry, Patrick Campbell (Jefferson, NC: McFarland, 1999)
Not About Heroes: The Friendship of Siegfried Sassoon and Wilfred Owen, Stephen MacDonald (London: Faber, 1983)

ROBERT GRAVES
Primary texts
Robert Graves: The Complete Poems, ed. Beryl Graves and Dunstan Ward (Manchester: Carcanet, 1995, 1997, 1999)
Collected Poems 1975 (London: Cassell, 1975)
Good-bye to All That (London: Penguin, 2000)
The Common Asphodel: Collected Essays on Poetry (London: Hamish Hamilton, 1949)
On Poetry: Talks and Essays (Garden City, NY: Doubleday, 1969)
The White Goddess (London: Faber, 1948, amended and enlarged ed., 1997)
In Broken Images: Selected Letters of Robert Graves, 1914-1946, ed. Paul O'Prey (London: Hutchinson, 1982)
Between Moon and Moon: Selected Letters of Robert Graves, 1946-1972), ed. Paul O'Prey (London: Hutchinson, 1984)

Biography and critical works
Robert Graves: His Life and Works, ed. Martin Seymour-Smith (London: Blooomsbury, 2nd ed., 1995)
Robert Graves: The Assault Heroic, 1895-1926, Richard Perceval Graves (London: Weidenfeld & Nicolson, 1986)
Robert Graves - The Years with Laura, 1926-1940 Richard Perceval Graves (London: Weidenfeld & Nicolson, 1990)
Robert Graves and the White Goddess 1940-1985 Richard Perceval Graves (London: Weidenfeld & Nicolson, 1995)
Robert Graves: Life on the Edge, Miranda Seymour (London: Doubleday, 1995)
Swifter than Reason, The Poetry and Criticism of Robert Graves, Michael Kirkham (Chapel Hill: University of North Carolina Press, 1963)
The Poetry of Robert Graves, Michael Kirkham (London: Athlone Press, 1969)
Robert Graves, ed. Harold Bloom (New York: Chelsea House, 1987)
Robert Graves: The Lasting Poetic Achievement, D. N. G. Carter (Basingstoke: Macmillan, 1989)
The Great War and the Missing Muse: The Early Writings of Robert Graves and Siegfried Sassoon, Patrick J. Quinn (Selinsgrove and London: Susquehanna University Press and Associated University Press, 1994)

WILFRED OWEN
Primary texts
The Complete Poems & Fragments, 2 vols, ed. Jon Stallworthy (London: Chatto & Windus, 1983)
The Poems of Wilfred Owen, ed. Jon Stallworthy (London: Chatto & Windus, 1990)
War Poems, ed. Jon Stallworthy (London: Chatto & Windus, 1994)
Wilfred Owen: Collected Letters, ed. Harold Owen and John Bell (London and Oxford: Oxford University Press, 1967)
Wilfred Owen: Selected Letters, ed. John Bell (Oxford: Oxford University Press, 2nd ed., 1998)

Biography and critical works
Journey from Obscurity, Harold Owen, 3 vols (Oxford: Oxford University Press, 1963-5)
Wilfred Owen, Jon Stallworthy (London: Chatto & Windus, 1974; Oxford: Oxford University Press, 1980)
Wilfred Owen: A Critical Study, D. S. R. Welland (London: Chatto & Windus, rev. and enlarged ed., 1978)
Wilfred Owen: The Last Year, Dominic Hibberd (London: Constable, 1992)
Owen the Poet, Dominic Hibberd (London: Macmillan, 1988)
Tradition Transformed: Studies in the Poetry of Wilfred Owen, Sven Backman (Lund: LiberLäronmedel/ Gleerup, 1979)
An Adequate Response: The War Poetry of Wilfred Owen, Arthur E. Lane (Detroit: Wayne State University Press, 1972)
Wilfred Owen's Voices: Language and Community, Douglas Kerr (Oxford: The Clarendon Press, 1993)
Wilfred Owen: Poet and Soldier, Helen McPhail (London: Gliddon Books in association with the Wilfred Owen Association, 1993)
Wilfred Owen, Merryn Williams (Bridgend: Seren, 1993)
My Dear Old Wolf: an undelivered letter to Wilfred Owen from his brother Harold Owen (Wooton-by-Woodstock, The Backwater Press, 1996)

EDMUND BLUNDEN
Primary texts
Poems, 1914-30 (London: Cobden-Sanderson, 1930)
Undertones of War (1928; Penguin edition, 2000)
Selected Poems (London: Fyfield Books, 1982)

Biography and critical works

War Poets: 1914-1918 (London: Longmans, Green, 1958)

Edmund Blunden: A Biography, Barry Webb (New Haven and London: Yale University Press, 1990)

More Than a Brother: Correspondence Between Edmund Blunden and Hector Buck, 1917-1967, ed. Carol Z. Rothkopf and Barry Webb (London: Sexton, 1996)

Edmund Blunden, Helen McPhail and Philip Guest (London: Pen & Sword Books/Leo Cooper, 1999)

EDWARD THOMAS
Primary texts

Collected Poems, with a foreword by Walter de la Mare (London: Faber, 1949)

Collected Poems of Edward Thomas, ed. R. G. Thomas (Oxford: Oxford University Press, 1981)

Selected Poems, ed. R. G. Thomas (London: Faber, 1964)

Letters from Edward Thomas to Gordon Bottomley, ed. R. G. Thomas (London: Oxford University Press, 1968)

Edward Thomas: Selected Letters, ed. R. George Thomas (Oxford: Oxford University Press, 1996)

The Diary of Edward Thomas: 1 Jan-8 Apr 1917, with an Introduction by Roland Gant (Andoversford: Whittington Press, 1977)

Biography and critical works

Edward Thomas: A Critical Biography, William Cooke (London: Faber, 1970)

As it Was and World Without End, Helen Thomas (London: Faber, 1956)

A Language Not to Be Betrayed: Selected Prose of Edward Thomas, ed. Edna Longley (Manchester: Carcanet, in association with Mid-Northumberland Arts Group, 1981)

Edward Thomas: the Last Four Years, Eleanor Farjeon, with a Foreword by P. J. Kavanagh and an Introduction by Anne Harvey (Stroud: Sutton, 1997)

Edward Thomas, R. George Thomas (Cardiff: University of Wales Press, rev. ed., 1993)

The Poetry of Edward Thomas, Andrew Motion (London: Hogarth, 1980)

The Imagination of Edward Thomas, Michael Kirkham (Cambridge: Cambridge University Press, 1986)

IVOR GURNEY
Primary texts

Collected Poems of Ivor Gurney, ed. P. J. Kavanagh (Oxford: Oxford University Press, 1983)

War Letters, ed. R. K. R. Thornton (Ashington and Manchester: Mid-Northumberland Arts Group/Carcanet, 1983)

Rewards of Wonder: Poems of Cotswold, France, London, ed. George Walter (Manchester: Fyfield Books, 2000)

Best Poems: The Book of Five Makings, ed. R. K. R. Thornton (Manchester: Fyfield Books, 1995)

Ivor Gurney, ed. George Walter (London: Phoenix Press, 1996)

Biography and critical works

The Ordeal of Ivor Gurney, Michael Hurd (Oxford: Oxford University Press, 1978)

Ivor Gurney, John Lucas (Tavistock: Northcote House, in association with the British Council Educational Publications, 2001)

ISAAC ROSENBERG
Primary texts

The Collected Works of Isaac Rosenberg: Poetry, Prose, Letters, Paintings, and Drawings, with a foreword by Siegfried Sassoon; edited with an introduction and notes by Ian Parsons (London: Chatto & Windus, Hogarth, 1984)

Biography and critical works

Isaac Rosenberg: The Half-Used Life, Jean Liddiard (London: Gollancz, 1975)

Isaac Rosenberg: Poet and Painter, Jean Moorcroft Wilson (London: Cecil Woolf, 1975)

Journey to the Trenches: The Life of Isaac Rosenberg, Joseph Cohen (London: Robson Books, 1975)

DAVID JONES
Primary texts

In Parenthesis (London: Faber, 1937)

The Anathémata (London: Faber, 1952)

Introducing David Jones: A Selection of His Writings, ed. John Matthias, with a preface by Stephen Spender (London and Cambridge, MA: Faber, 1980)

The Sleeping Lord and Other Fragments (London: Faber, 1974)

Dai Great-Coat: A Self-Portrait of David Jones in His Letters, ed. René Hague (London and Cambridge, MA: Faber, 1980)

Inner Necessities: The Letters of David Jones to Desmond Chute, ed. Thomas Dilworth (Toronto: Anson-Cartwright Editions, 1984)

David Jones: Letters to Vernon Watkins, ed. Ruth Pryor (Cardiff: University of Wales Press, 1976)

Epoch Artist: Selected Writings, ed. Harmon Grisewood (London: Faber, 1959)

The Dying Gaul and Other Writings, ed. Harmon Grisewood (London: Faber, 1978)

David Jones: A Fusilier at the Front, ed. Anthony Hyne (Bridgend: Seren, 1995)

Biography and critical works

David Jones: Artist and Writer, David Blamires (Manchester: Manchester University Press, 1971)

David Jones: An Exploratory Study of the Writings, Jeremy Hooker (London: Enitharmon, 1975)

The Shape of Meaning in the Poetry of David Jones, Thomas Dilworth (Toronto and London: University of Toronto Press, 1988)

David Jones: The Maker Unmade, Jonathan Miles and Derek Shiel (Bridgend: Seren, 1996)

Acknowledgements and Credits

The author wishes to thank a number of friends who helped in the preparation of this book: Carol O'Brien, who commissioned it; Jenny Houlsby, who converted manuscribble into setting-copy; Jane Robertson, who copy-edited it; Charlotte Deane, Jane Potter, and Liz Bowers, who gathered the illustrations, Pete Duncan and Les Dominey, who designed the book; Anna Williamson, who directed these operations; and others who contributed in a variety of ways: Sarita Cargas, Angela Godwin, Roy Foster, Seamus Heaney, Kate Kavanagh, Nancy Macky, and Mark Pottle.

Thanks are also due to Chatto and Windus for permission to reproduce material from my edition of *The War Poems of Wilfred Owen* (1994); and to the Folio Society for permission to reproduce the Introduction to my edition of Edmund Blunden's *Undertones of War* (1989).

Text Acknowledgements

Faber and Faber Limited and Farrar, Straus and Giroux, Inc., for lines from 'MCMXIV' by Philip Larkin from *Collected Poems*, edited by Anthony Thwaite (1988), reproduced by permission of Faber and Faber Ltd; Faber and Faber Limited and Farrar, Straus and Giroux, Inc., for lines from 'In Memoriam Francis Ledwidge' by Seamus Heaney from *New Selected Poems 1966-1987* (1990), reproduced by permission of Faber and Faber Limited; New Island Books Ltd for an extract from Seamus Heaney's Introduction to *Francis Ledwidge: Selected Poems,* edited by Dermot Bolger (1992); George Sassoon and Barbara Levy Literary Agency for an extract from Siegfried Sassoon's Declaration in *The Nation* (1917), an extract from *Sherston's Progress* (Faber & Faber, 1937), and for lines from 'Prelude: The Troops', 'To My Brother' and poems 'Absolution', 'The Redeemer', 'Christ and the Soldier', 'Glory of Women', 'Stand-to: Good Friday Morning', 'The Hero', 'They', 'Base Details', 'The General', 'Everyone Sang' and 'On Passing the Menin Gate', from *The War Poems of Siegfried Sassoon*, edited by Rupert Hart-Davis (Faber & Faber, 1983), copyright Siegfried Sassoon by kind permission of George Sassoon; Carcanet Press Limited for an extract from *Goodbye To All That* by Robert Graves (Cassell & Co., 1929), for lines from 'Escape', and for poems 'Two Fusiliers', 'Goliath and David', 'Sergeant-Major Money', 'The Persian Version', 'The Dead Fox Hunter', 'A Dead Boche', 'Recalling War' and 'The Second Fated' by Robert Graves from *Robert Graves: The Complete Poems*, edited by Beryl Graves and Dunstan Ward (Carcanet Press, 1995); © Oxford University Press 1967. Reprinted from *The Letters of Wilfred Owen*, edited by John Bell and Harold Owen (1967) by permission of Oxford University Press; The Random House Group Ltd for extracts from 'The Women and the Slain' and 'Uriconium: An Ode' by Wilfred Owen as it appears in *Wilfred Owen: The Complete Poems and Fragments*, edited by Jon Stallworthy © The Executors of Harold Owen's Estate 1963 and 1983, published by Chatto & Windus, 1983. Used by permission of The Random House Group Limited; The Peters Fraser and Dunlop Group Ltd for extracts from *Undertones of War* (Copyright Edmund Blunden 1928) and lines from 'Festubert: The Old German Line', 'Vlamertinghe: Passing the Château, July 1917' (Copyright Edmund Blunden 1928) and the poems '1916 Seen from 1921' (Copyright Edmund Blunden 1922), 'The Midnight Skaters (Copyright Edmund Blunden 1925), 'The Watchers' (Copyright Edmund Blunden 1928), 'Two Voices' (Copyright Edmund Blunden 1928), 'The Zonnebeke Road' (Copyright Edmund Blunden 1928), 'Concert Party: Busseboom' (Copyright Edmund Blunden 1928), reproduced by permission of PFD on behalf of the Estate of Mrs Claire Blunden; Carcanet Press Limited and Myfanwy Thomas for an extract from an essay about Ivor Gurney from *Under Storm's Wing* by Helen Thomas, with additions by Myfanwy Thomas (Carcanet Press, 1988); The Ivor Gurney Trust for poems 'Ballad of the Three Spectres', 'To His Love', 'First Time In', 'The Silent One', 'Bach and the Sentry', 'Servitude', 'Laventie', 'Ypres-Minsterworth' and 'Towards Lillers' from *The Collected Poems of Ivor Gurney*, edited by P. J. Kavanagh (Oxford University Press, 1982); Faber and Faber Limited and Anthony Hyne for verse and prose extracts, including the dedication, from *In Parenthesis* by David Jones (Faber & Faber, 1937), reproduced by permission of Faber and Faber Limited.

Picture Credits

Bodleian Library, Oxford: 133 bottom (Ms Don.d.28); The British Library: 107; The British Library (reproduced with the permission of PFD on behalf of the Estate of Mrs Claire Blunden): 127; Cardiff University Library Archives: 134, 144; By kind permission of Christ's Hospital (reproduced with the permission of PFD on behalf of the Estate of Mrs Claire Blunden): 120 bottom; English Faculty Library, University of Oxford: 100 bottom; Fitzwilliam Museum, Cambridge (© Siegfried Sassoon by kind permission of George Sassoon): 77, 79; Collection Viscount Gage: 24 bottom, 25; Hulton Archive/Getty Images: 47; The Ivor Gurney Trust: 147, 148 top, 148 bottom, 149 top, 150, 151, 157; Hertfordshire Archives and Local Studies: 24 top (D/ERv/C1135/495), 26 top (D/EX789/F22), 27 bottom (D/ERv/C1135/712), 30-31 (D/EX789/F23A); Imperial War Museum, London: 4 (Q82950), 6 (Q53286), 7 top (Q91867), 7 bottom (Q42033), 8 top (Q5875), 8 bottom (Q4069), 9 (Q8467), 10 (Q71073), 13, 14 (Q71074), 26 bottom (Q69527), 27 (Q57254) top, 29 (Q28938), 35 bottom (Q60741), 36 top (Q11731), 36 bottom (Q4218), 38 (Q4305), 42 (Q51150), 45 (Q50689), 49 top (Q13449), 49 bottom (Q13424), 51 (Q13820), 53 (Q751), 54 (Q13332), 55 (Q5935), 59 (Q13378), 61 (Q13429), 62 (Q101780), 66-67 (Q90), 67 top (Q97), 68 (Q3974), 70 top (Q108833), 70 bottom (Q100259), 71 bottom (Q101781), 72 (Q10681), 73 (Q5092), 74 (E573), 78 (Q4256), 81 (Q45871), 84 bottom (Q3979), 85 bottom (Q867), 86 (Q723), 89 (Q2041), 95 (Q3976), 97 (Q79045), 98 (Q101798), 100 top (Q71250), 101 top (Q1687), 102-103 (Q1546), 104 bottom (Q10660), 105 (Q101783), 106 (Q70167), 109 (Q11586), 110 (Q1259), 114 (Q1530), 116 (Q101795), 118 (Q44390), 119 (Q101807), 120 top (Q2064), 122 top (Q1332), 122 bottom (Q1), 123 (Q45461), 125 (Q101782), 128 (E1220), 129 (Q8381), 131 (Hu60473), 132 (Q101808), 133 top (Q100265), 135 (Q71060), 136 (Q101789), 137 (Q71059), 138 (Q5172), 139 top (Q5117), 139 bottom (Q101788), 142 (Q2890), 143 (Q171), 149 bottom (Q17598), 152 (Q116), 154 (E600), 158 (E4599), 167 top (Q6867), 168 (Q1792), 171 (CO2241), 172 (Hu70315), 179 (Q4095), 183 bottom (Q5100), 185 (Q906), 187 (Q70165); Imperial War Museum (reproduced with the permission of PFD on behalf of the Estate of Mrs Claire Blunden): 121; Imperial War Museum (with kind permission of Carcanet Press and the Estate of Robert Graves): 84 top, 91; Imperial War Museum (© Trustees of the David Jones Estate): 178 top, 178 bottom, 180 top, 180 bottom, 181, 182, 183 top; Imperial War Museum (reproduced with the permission of the Rosenberg family): 160, 162 (Q93491), 163 top, 163 bottom, 164 (Q93489), 165 top, 165 bottom, 166, 167 bottom, 169 left (Q6372), 169 right, 173 (Q108830), 174-175; Imperial War Museum (© Siegfried Sassoon by kind permission of George Sassoon): 66 top (Hu53735), 71 top; © Trustees of the David Jones Estate: 176; By kind permission of the Provost and Scholars, King's College, Cambridge: 12, 15 top, 15 bottom, 17, 20, 21; By courtesy of Marlborough College Archives: 35 top, 41; Courtesy of the National Library of Ireland: 48, 50; © National Museums and Galleries of Wales: 82; National Portrait Gallery: 23; Peter Owen: 103 top; Public Record Office: 34 (WO339/11501), 37 (WO339/11501), 69 (WO339/51440), 87 (WO339/23299), 99 (WO138/74), 101 bottom (WO138/74); Harry Ransom Humanities Research Center, The University of Texas at Austin: 104 top; With permission of the Trustees of the Royal Welch Fusiliers Museum: 64, 65, 85 top; Reproduced by courtesy of the Director and Librarian, The John Rylands University Library of Manchester: 52; West Sussex Record Office (reproduced with the permission of PFD on behalf of the Estate of Mrs Claire Blunden): 124

Index of Poem Titles and First Lines

1916 seen from 1921 122–3, 127

A Dead Boche 89
A hundred thousand million mites we go 39
A Private 134
A Worm Fed on the Heart of Corinth 171
A young Apollo, golden-haired 14
Absolution 63–4
After Court Martial 60
All the hills and vales along 34–5
Anthem for Doomed Youth 100–1, 107
As the team's head-brass flashed out on the turn 134–5, 144
A Soldier's Grave 51
At Evening 57
August 1914 170

Bach and the Sentry 152
Ballad of the Three Spectres 146–7
Barbury Camp 33
Base Details 77
Blighters 67
Break of Day in the Trenches 165–7, 173
Bugle Call 143

Call, The 7–8
Charge of the Light Brigade, The 102
Cherry Trees, The 134
Christ and the Soldier 65–7
Concert Party: Busseboom 129
Cramped in that funnelled hole, they watched the dawn 102

Dawn 11
Dead Boche, A 89
Dead Fox Hunter, The 88
Dead Heroes, The 164
Dead Man's Dump 174–5
Dead, The (I) 18
Dead, The (II) 19. 35
Deep under turfy grass and heavy clay 96
Dulce et Decorum Est 101, 109

Escape 84
Everyone Sang 80
Exposure 104

Festubert, 1916 127
Festubert: The Old German Line 119

First Time In 149–50
Futility 104, 114

General, The 67, 78, 79
Glory of Women 68
Gododdin, The 178, 182, 184
Goliath and David 85, 90, 91

Hero, The 75
Hymn to the Fighting Boar 25

I have not brought my Odyssey 42–5
In a Café 56
In France 58
In Memoriam 41
In Memoriam S. C. W V. C 41
In Memoriam (*Easter 1915*) 140
In Memoriam Francis Ledwidge 52
In Parenthesis 177–87
Insensibility 104, 110–11
Into Battle 25–7, 30–1
Irish in Gallipoli, The 61

Lament for Thomas McDonagh 50
Laventie 154–5
Lights Out 138–9, 145
Louse Hunting 172

MCMXIV 6
Midnight Skaters, The 124
Miners 103, 108

Ode on a Grecian Urn 120
Ode to David's Harp 161
On Passing the New Menin Gate 81
On Receiving News of the War 15, 162–3
Owl, The 141

Peace 6, 16
Persian Version, The 87
Prayer for Those on the Staff 28
Prelude: The Troops 9

Rain 132, 133
Recalling War 92–3
Redeemer, The 64–5, 72
Returning, We Hear the Larks 167
Rime of the Ancient Mariner 179, 185

Safety 17
Second-Fated, The 94–5

Send-Off, The 115
Sentry, The 104–5
Serbia 55
Sergeant-Major Money 86
Servitude 153
Silent One, The 150
Soldier, The 20, 21, 35
Soldier's Grave, A 51
Song of Modern Mars, The 5
Stand-to: Good Friday Morning 74
Strange Meeting 36, 103, 104, 112–13, 186

Taü here, Mamua 12
"They" 67, 76
They flee from me that sometime did we seek 180
This is no case of petty right or wrong 135, 142
To a Black Greyhound 22, 24
To a Skylark 167–8
To Germany 36, 38
To His Love 148–9, 157
To My Brother 64
To One Dead 49
Towards Lillers 159
Troops, The 9
Two Fusiliers 83
Two Sonnets 40
Two Voices 126

Uriconium, an Ode 96, 98

Virtue 166
Vlamertinghe: Passing the Château, July 1917 119–21

War 54
War Cry, The 7
Watchers, The 124–5
When you see millions of the mouthless dead 36
Who's for the trench 101
Women and the Slain, The 15

Ypres – Minsterworth 156

Zonnebeke Road, The 128